.

MAGIC MOMENTS

THE GREATEST ROYAL PHOTOGRAPHS OF ALL TIME BY THE *SUN'S* ARTHUR EDWARDS MBE, THE WORLD'S NO 1 ROYAL PHOTOGRAPHER

Published by Metro Publishing, an imprint of John Blake Publishing Ltd 3 Bramber Court, 2 Bramber Road, London W14 9PB, England

www.johnblakepublishing.co.uk

Hardback edition published in 2007 First published in paperback in 2008

ISBN: 978 1 84454 635 0

All rights reserved. No part of this publication may be reproduced, stored in a retrieval system, or in any form or by any means, without the prior permission in writing of the publisher, nor be otherwise circulated in any form of binding or cover other than that in which it is published and without a similar condition including this condition being imposed on the subsequent publisher.

British Library Cataloguing-in-Publication Data:

A catalogue record for this book is available from the British Library.

Design by www.envydesign.co.uk

Printed and bound in Italy by Pozzo Gros Monti

1 3 5 7 9 10 8 6 4 2

© All photographs and text copyright Arthur Edwards 2008

Papers used by John Blake Publishing are natural, recyclable products made from wood grown in sustainable forests. The manufacturing processes conform to the environmental regulations of the country of origin.

Contents

Foreword		IX
Chapter One	My All-time Favourites	1
Chapter Two	Princess Diana	57
Chapter Three	Charles and Diana	75
Chapter Four	Prince William	89
Chapter Five	Prince Harry	107
Chapter Six	The Queen	125
Chapter Seven	Prince Philip	161
Chapter Eight	Tender Moments	167
Chapter Nine	The Queen Mother	173
Chapter Ten	Camilla	181
Chapter Eleven	Charles and Camilla	195
Chapter Twelve	Royals in Mourning	211
Chapter Thirteen	The Yorks	217
Chapter Fourteen	You Don't Often See That!	225
Chapter Fifteen	Prince Charles	241
Chapter Sixteen	Charles, Clown Prince	259
Chapter Seventeen	Other Royals	275
Chapter Eighteen	Arthur and the Royals	281

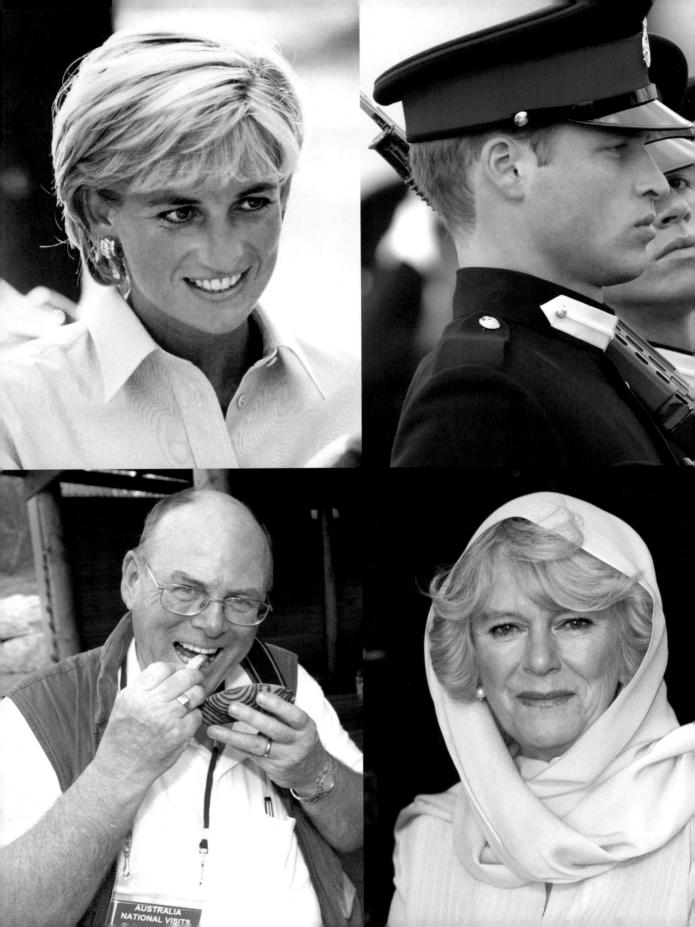

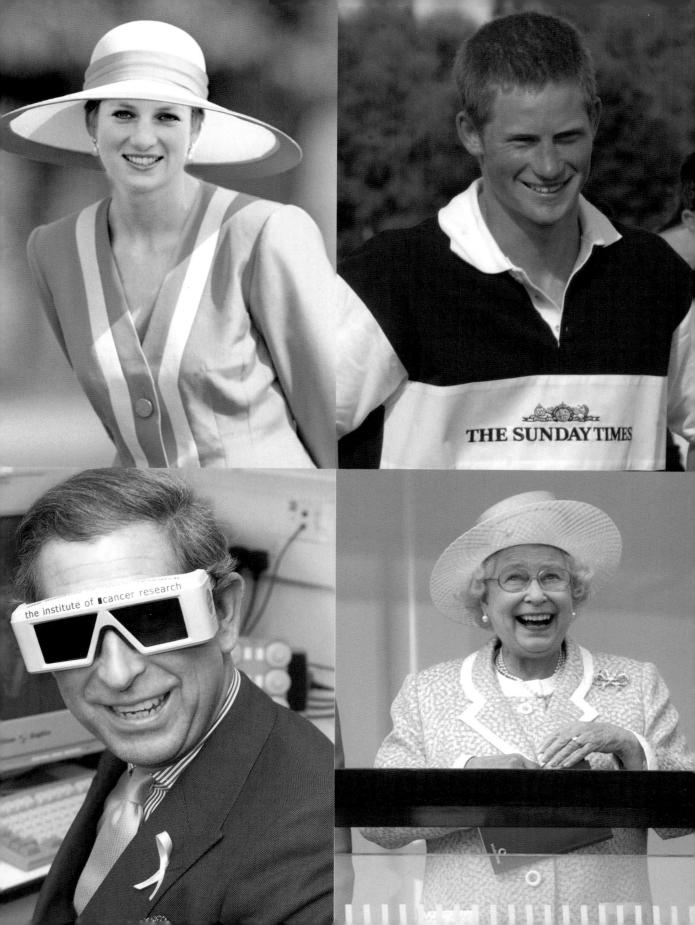

Foreword

Thirty years of covering the Royal Family has been hard work, but tremendous fun. Every day, when I go off to cover a Royal event, the excitement is just as it was on my very first assignment back in 1977. There's no bigger 'A-list' than the Royals. Anything they do that's slightly out of the ordinary is always a big story.

It comes home to me as I look at this archive of Royal pictures spanning three decades just how much has happened to the Family during that time and how much history I have witnessed. The rollercoaster of the Diana years - her fairytale wedding, the birth of the boys, the wonderful clothes she wore, her painful divorce and the tragedy of her early death. I feel great sadness for her, and for the other Royals I photographed who are no longer with us - the Queen Mother and Princess Margaret among them. But there are sources of enormous joy too: I have seen Prince Charles find true happiness with his new wife Camilla, and his boys William and Harry grow into fine young men now embarking on their Army careers. And the Queen is still there doing a brilliant job, as she has done for more than half a century.

The *Sun* has changed so much too. The printing quality now is superb, unrecognisable from the paper of the 1970s. And technology has brought all kinds of new possibilities to the job. When I went on

Prince Charles's tour of India in 1980, I had time to send just one picture a day back to London. Now I could send 100 in the same time. Digital cameras, modern communications and the Internet have made things so much easier.

But one thing hasn't changed: you still have to get the best picture. No one can teach you that – it comes only with experience.

I am indebted to Rupert Murdoch and to the five *Sun* editors for whom I have worked – Larry Lamb, Kelvin MacKenzie, Stuart Higgins, David Yelland and Rebekah Wade – for allowing me to do this wonderful job.

This book could not have been produced without the hard work and dedication of my editor John Perry, and Chris Whalley, Chief Librarian of the News International Picture Library, to whom I am most grateful.

I am dedicating it to my wife Ann and our three great children, John, Paul and Annmarie. One of the last pictures in the book shows our grandchildren Katie, Lucy and Ciara presenting the Queen with some flowers. We have another granddaughter now, Ruby. Hopefully, as soon as she can walk, she'll get to meet Her Majesty too.

ARTHUR EDWARDS

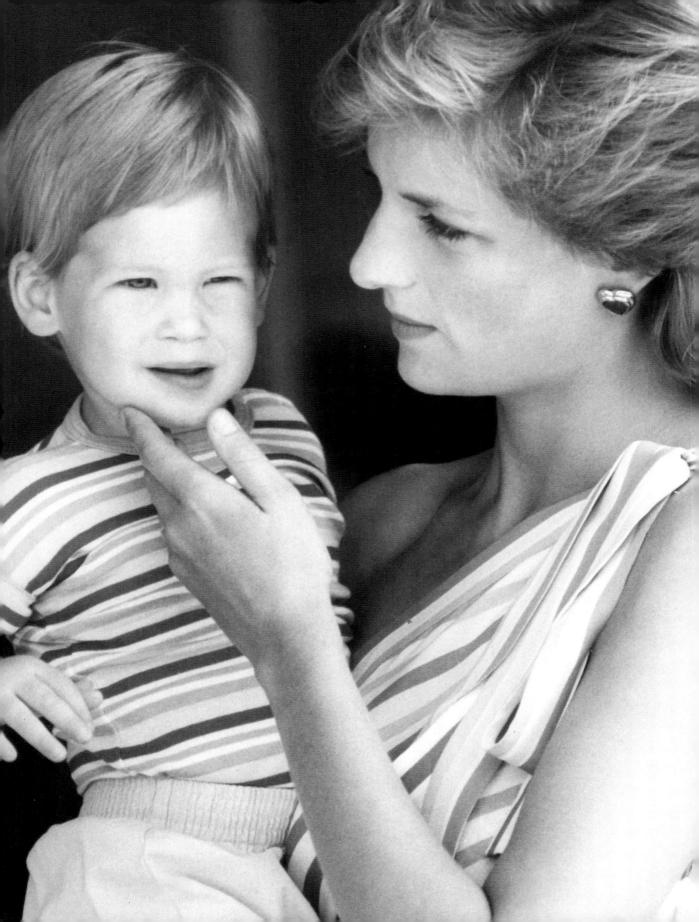

CHAPTER ONE My All-time Favourites

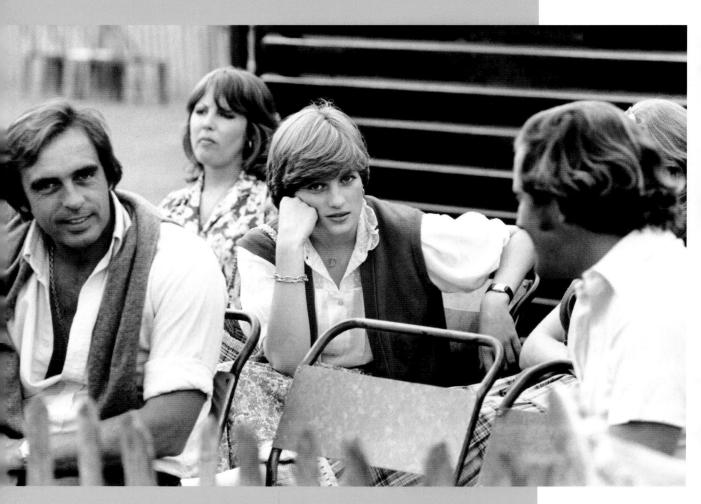

Above: My first encounter with the teenager who would become the world's most famous woman. Prince Charles was playing polo near Midhurst, Sussex, in September 1980 and a good contact told me he had brought a girl named Lady Diana Spencer as his guest. She was staying with him for the weekend at the home of Robert De Pass, whose wife was a lady-in-waiting to the Queen. I didn't have a clue what Lady Diana looked like, but I was walking round the polo field when I spotted this girl sitting alone, wearing a 'D' necklace round her neck. I asked if she was Lady Diana Spencer. She said she was and I asked her to pose for me and she did. The library at The *Sun* later told me she had only just celebrated her 19th birthday and I thought, 'Charles isn't running round with teenagers, surely?' We didn't use the picture that day, we just filed it. But six weeks later I came across Charles fishing on the River Dee, and who was with him? Lady Diana Spencer! The following Monday this was the front page picture with a caption saying: SHE HAS ALL THE QUALITIES TO BE QUEEN.

Opposite: After that it wasn't a question of *if* Charles would marry Lady Diana but *when*. I spent a few hours outside her flat in West London. Then I spent the next 17 years of my life covering this remarkable woman. This picture (*right*) is from 1980.

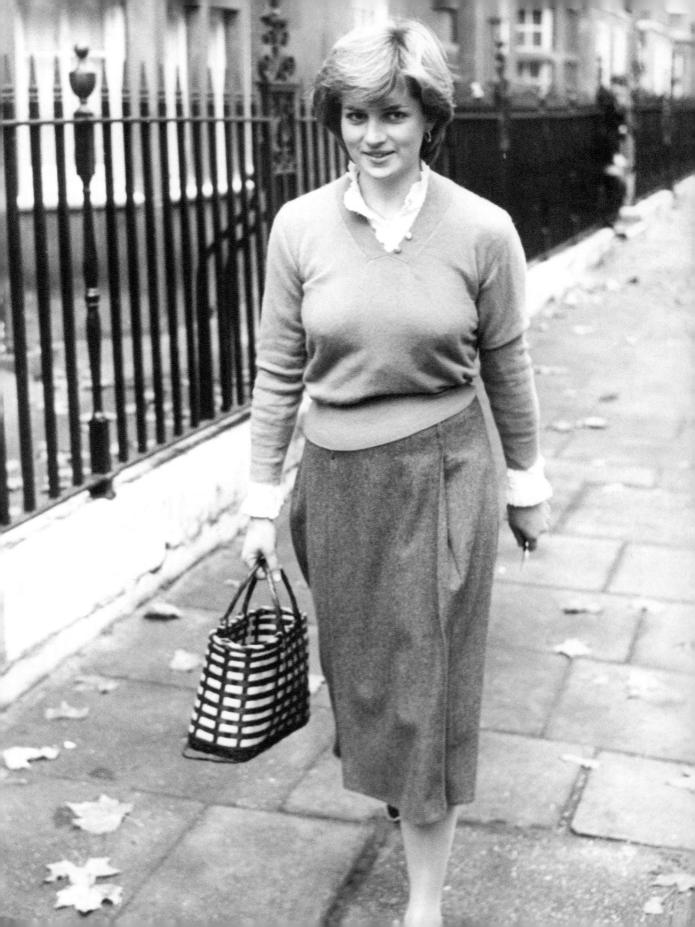

I'd heard that Diana worked as a nursery assistant in the West End. I went to six nurseries before I found her at the Young England Kindergarten in Pimlico. She agreed to pose for me, but only with two children from the school. This picture is remembered for one thing: halfway through the photo session the sun came out and we saw that not only was Diana not wearing a petticoat, but she had beautiful legs too.

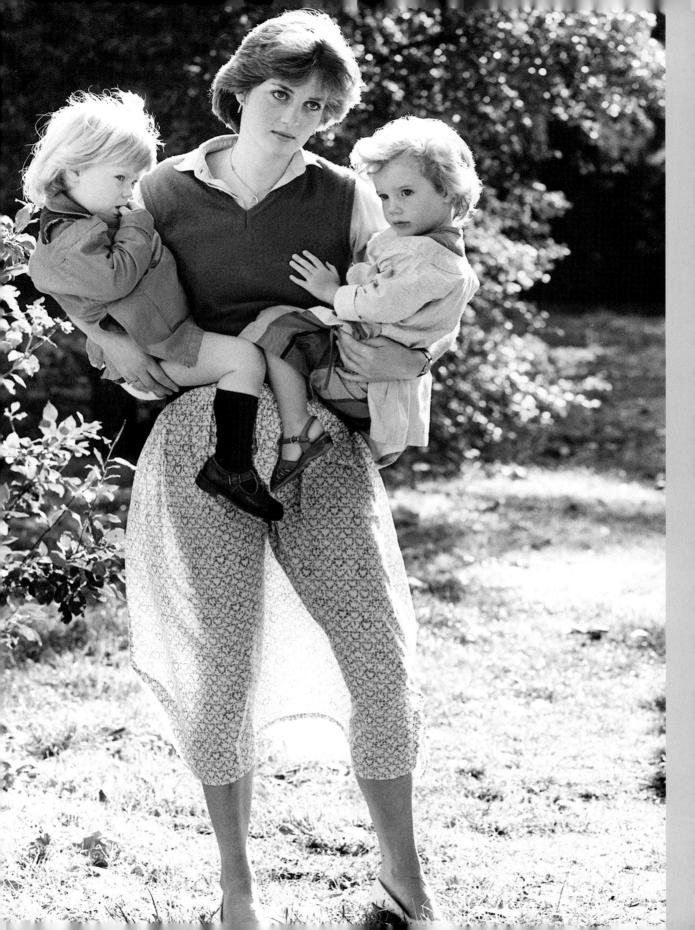

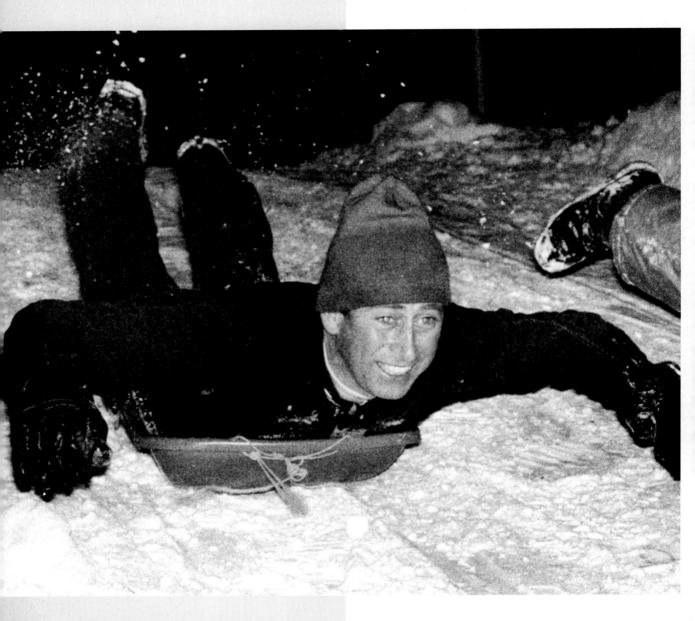

Above: This was in Klosters, Switzerland, in 1980. Everybody needs luck in their job and I got a big slice that night. I had seen Charles safely into his chalet after a day's skiing and was walking back to the hotel with other photographers when I suddenly remembered I had left my camera bag outside where the Prince lived. I walked back, only to discover the Prince sledging down the road on a child's toboggan. I got this exclusive picture and the *Sun* headline the next day was PRINCE OF WHIZZ. *Opposite*: I was on holiday with my family in southern Ireland in February 1981 when the office rang to say Charles and Diana were about to announce their engagement. I gave the car keys to my wife and legged it for the airport to get back for the next morning. I managed to get one of the nicest pictures taken so far of the Princess, as she left her flat wearing her engagement ring for the first time.

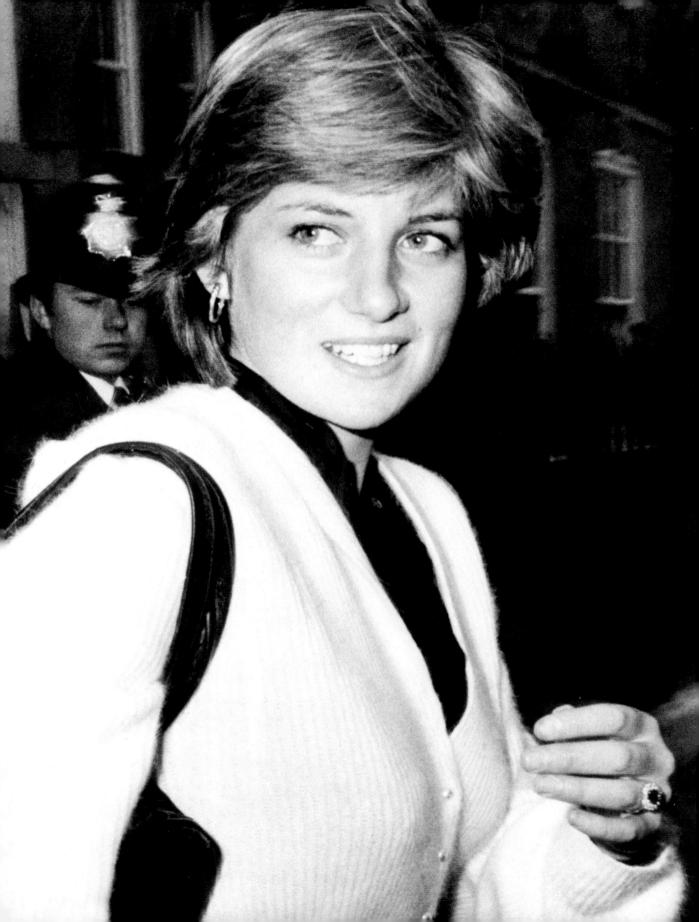

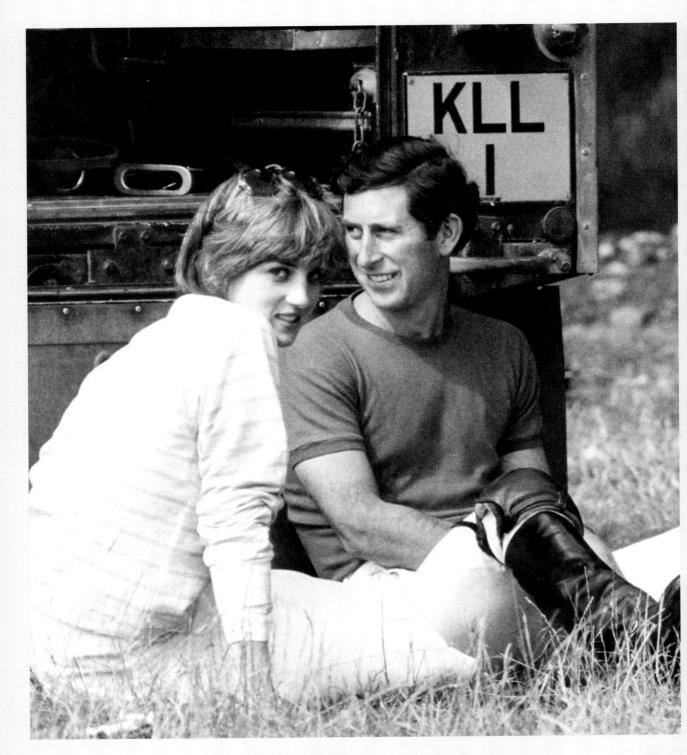

Unusually, I was working on a Saturday and Charles was playing polo in Windsor Great Park. Imagine my delight when Diana turned up to watch him. When they sat down for a break at the end of the match, Diana, as usual, knew where the camera was. This is one of the best pictures taken of them before the wedding in 1981.

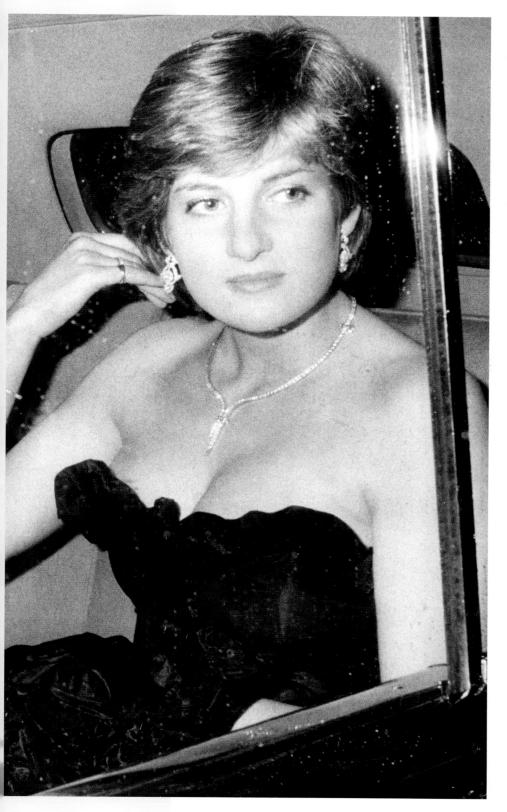

One month after the engagement, Diana accompanied Charles to a poetry reading by Princess Grace of Monaco. As she arrived in the car at the Goldsmith's Hall in the City of London, Prince Charles said to the press, 'Wait till you see what's coming next!' Her dress, by David and Elizabeth Emmanuel, was a sensation. I never saw her wear any dress as revealing as that again.

Charles and Diana married on 29 July, 1981. But a few days before that, good old Arthur's luck was in again! I was driving past St Paul's Cathedral on my way to the Sun's office in Fleet Street and saw Prince Charles's car parked at the bottom of the steps. I leaped out, grabbing a camera, left the car on double yellow lines and rushed across just as the couple walked down the steps after their wedding rehearsal. As Diana saw me she reached out and held Prince Charles's hand. It was a very tender moment and one we didn't see much of over the next 16 years.

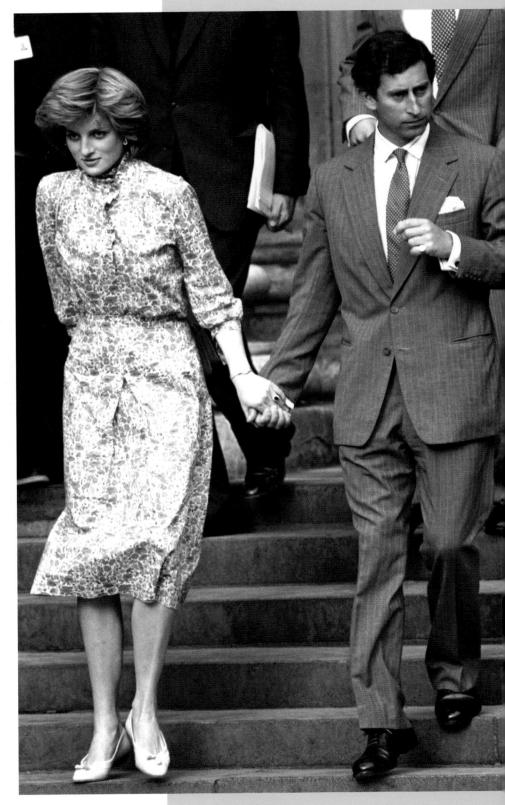

I had a choice of places to photograph from at the wedding but I chose St Paul's rather than Buckingham Palace because I thought the dress would be the story. How right I was. As the Royal couple left the cathedral, we noticed that the train was longer than any bride had worn before. A clever sub-editor at The *Sun* wrote a wonderful headline: THE TRAIN NOW STANDING AT ST PAUL'S ...

Then I want to be

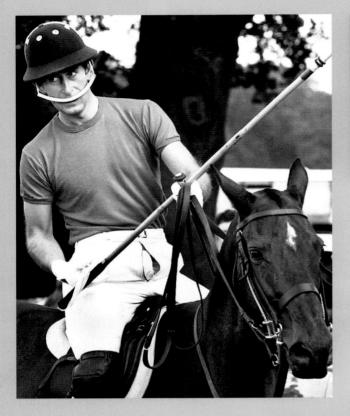

Above: Charles played polo at least three times a week in the summer. Once, in Dundee in 1978, I noticed he was riding with his flies open. I rushed up and said, 'Excuse me, Sir, but your zip's busted.' He replied, 'You can't see anything, can you?' I said, 'No, sir.' He said, 'Right, OK,' and just carried on playing. *Right*: Whenever Charles won a match he would almost certainly give the photographers a cracking picture. Here he is at Smith's Lawn, Windsor, in 1980, pulling a face probably inspired by the wacky humour of the *Goon Show*, his favourite radio programme.

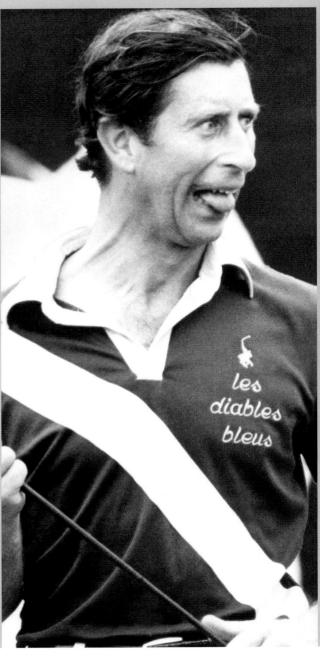

MY ALL-TIME FAVOURITES

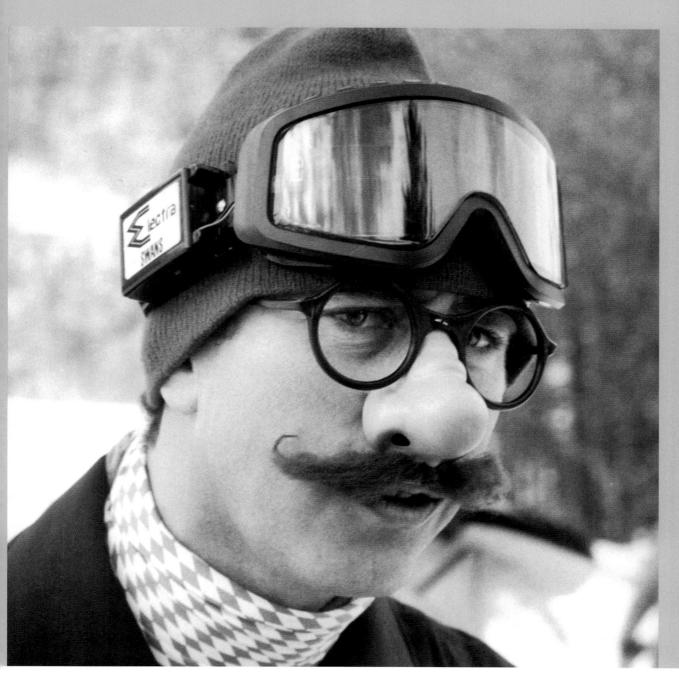

One morning, in Klosters in 1980, Charles's host Patti Palmer-Tomkinson told us, 'My uncle Harry will be joining us for skiing this morning.' It was a joke – when 'Uncle Harry' emerged, he was the Prince wearing a false nose, glasses and moustache. The photographers were like sharks after red meat. Several fell over on the slopes trying to get a picture of the slapstick Prince and many missed it. He had the getup on for less than a minute and it was the last we ever saw of it!

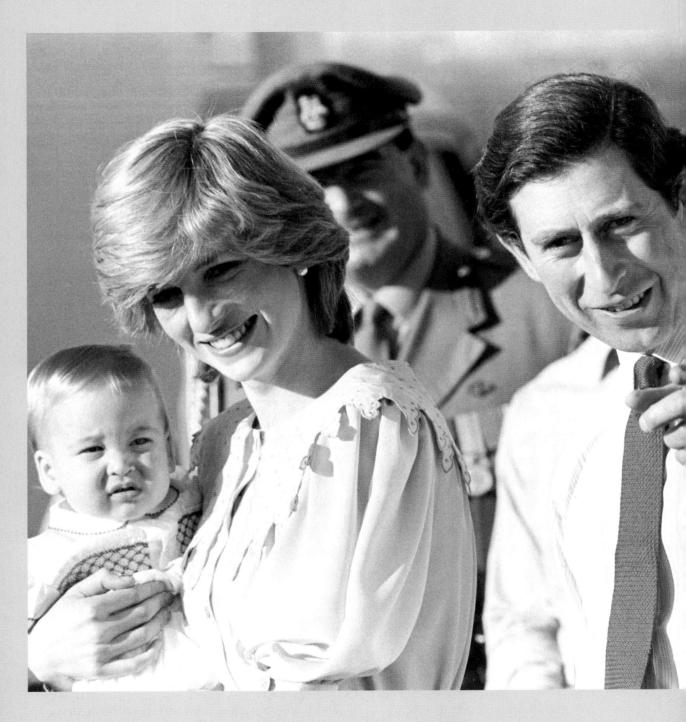

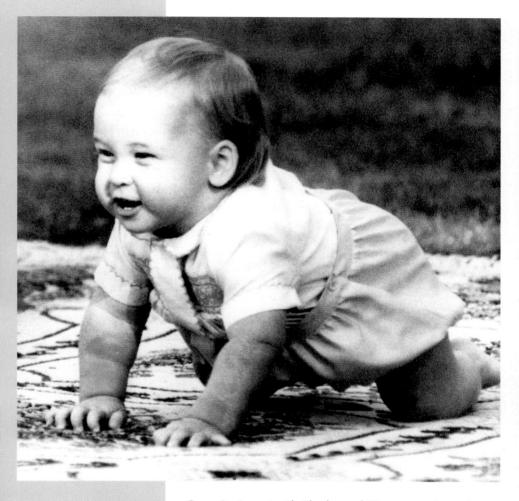

Opposite: I went with Charles and Diana on a six-week tour of Australia and New Zealand in 1983 and the big bonus was that William, a babe in arms, went too. When they arrived in Alice Springs, Charles pointed out to William the photographers who would be part of his life forever. When I rang The *Sun*'s Picture Editor, he said, 'Have you got the Aussie fly landing on William's face?' I had to admit, 'No, it's on Di's hand in my picture.' It was one I had missed!

Above: New Zealand's Prime Minister Robert Muldoon organised a photocall for William, Charles and Diana at Government House in Auckland and, of course, William was the star. Muldoon arranged it for a Saturday morning, for the Sunday papers in New Zealand, but because they are 13 hours ahead of London I was able to get my pictures in the last edition of The *Sun* on the Friday night. I really love this picture: William crawling for the first time. I look back fondly at those days in 1983 when he was just nine months old.

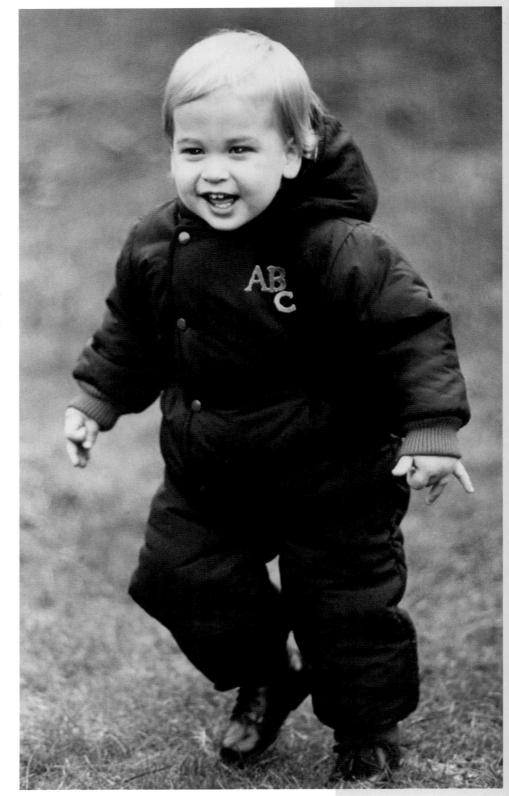

Diana was so proud of her little chap that when he walked for the first time in 1983 she invited us to Kensington Palace to witness it. He turned up wearing a romper suit with ABC on the front. The *Sun* bought a batch of them and gave them away to the first 100 readers who rang in.

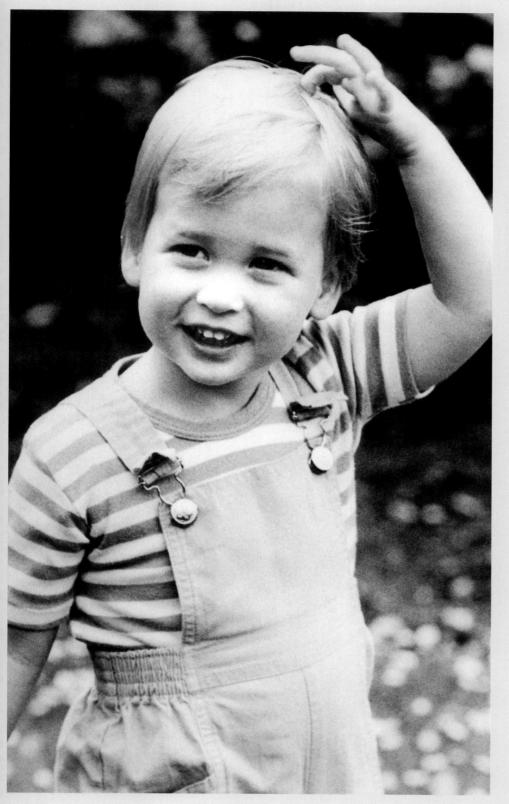

We all got invited to Kensington Palace again in 1984 when William talked for the first time. What was wonderful about this picture was that he scratched his head with his left hand. *Sun* reporter Harry Arnold said he reckoned William was left-handed. And how right he was . . . nine years later I saw him sign a visitors' book in Cardiff with his left hand.

This was a terrific evening. Fergie, the Duchess of York, launched a charity, Children of Courage, and during a fund-raising dinner in 1993, which I was invited to with my wife Ann, she organised a raffle with a difference. Jeremy Beadle, the Master of Ceremonies, did it by elimination of the guests. One of the things they had to do was stand on their chairs. I thought Fergie standing on a chair was a good picture, so I grabbed my camera from under the table and walked briskly to the front of the room where she was standing. By the time I got there, Jeremy had ordered all the men standing to drop their trousers. The chap next to Fergie was a Swiss millionaire. Fergie, seeing me take the pictures, was screaming at Jeremy, 'What the hell are you doing?' It was all great fun.

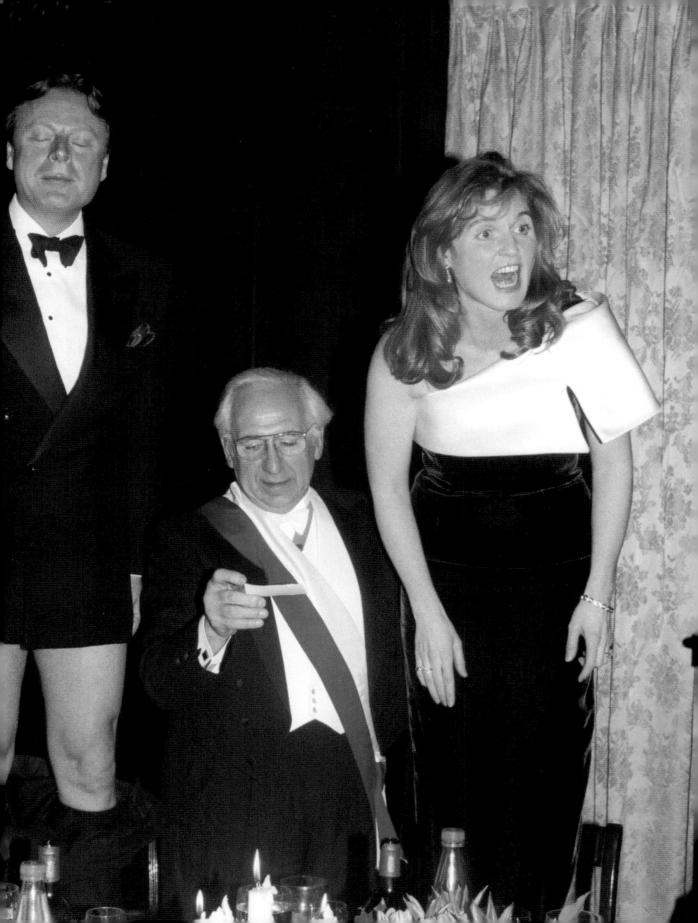

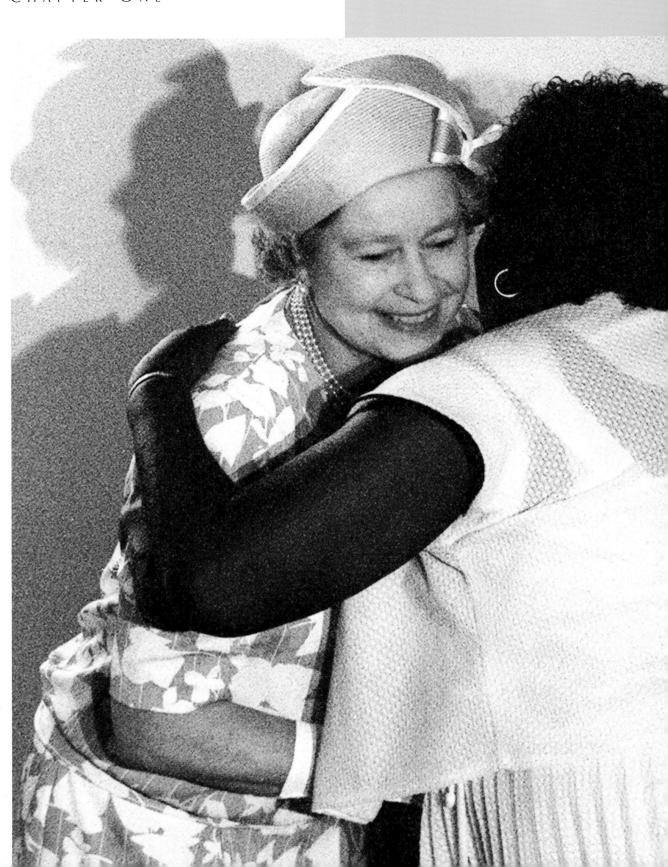

MY ALL-TIME FAVOURITES

This embrace took everyone by surprise. The Queen was visiting one of the poorer parts of Washington DC in 1991 and was invited into the new home of Alice Frazier. Before Her Majesty arrived, the secret service briefed everybody that on no account were they to speak to her unless spoken to first, or offer their hand for a handshake unless she offered hers. But, as soon as the Queen walked in, Alice rushed across from the doorway and hugged and kissed her. It just felt the natural thing as far as she was concerned. Everybody was taken unawares, including the secret service, but I raised my camera and got one snap. As I was the 'pool' photographer, this was used on every front page in America and Britain. Except one, that is: my own paper, The *Sun*! For some reason the Editor didn't fancy it.

Diana's death caused the Royals to open up a bit more. The Queen, visiting a mosque in Islamabad, Pakistan, in 1997, decided all the photographers should be allowed in to photograph her. What makes this one of my favourite pictures is her thick blue ankle socks. They look like they were borrowed from her private secretary!

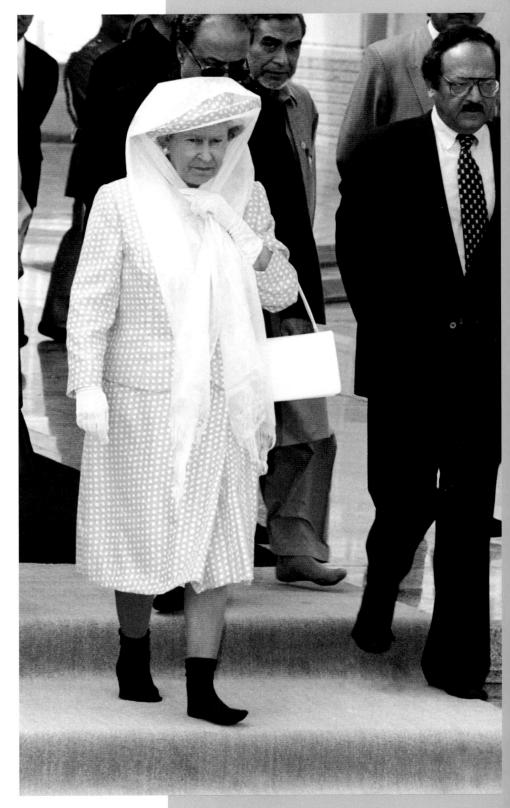

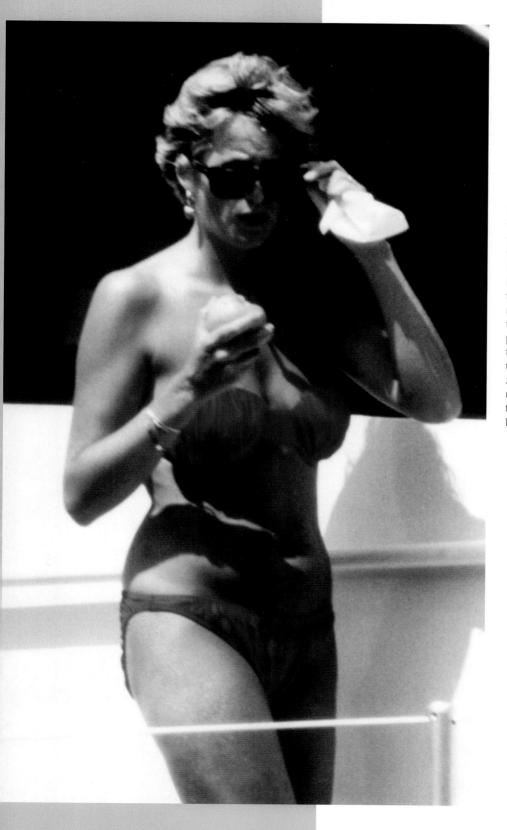

Diana was on holiday with Charles in Majorca with the Spanish royal family in 1987, and the King often took them out on his yacht to a remote part of the island. One day we rented a boat and followed them. Diana, seeing the photographers, stood up to get an apple and I got this picture using a huge zoom lens. Our boat was rocking like mad and even today I don't know how I managed it.

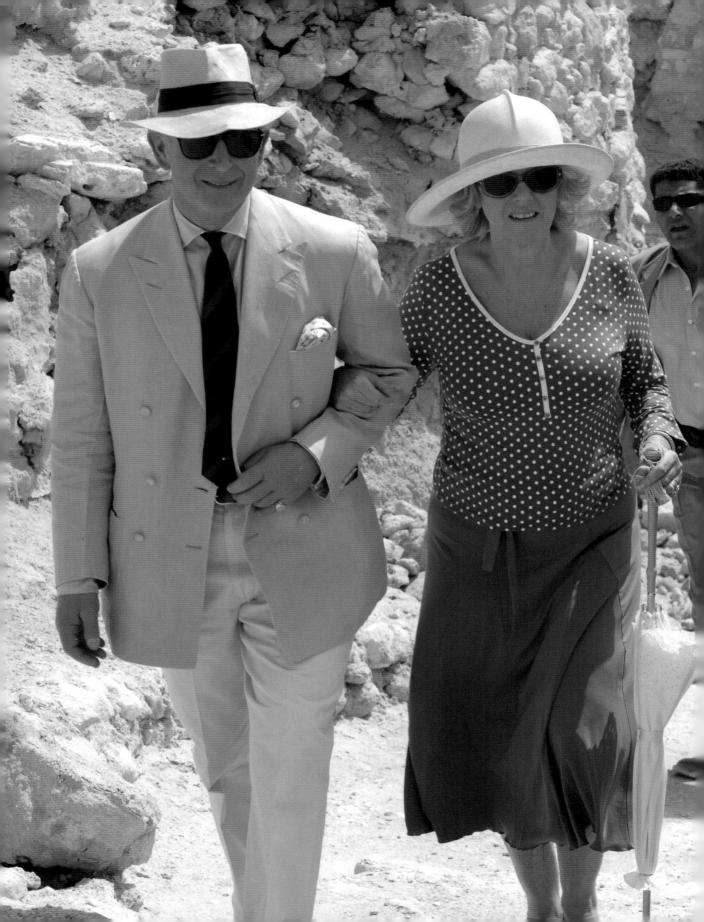

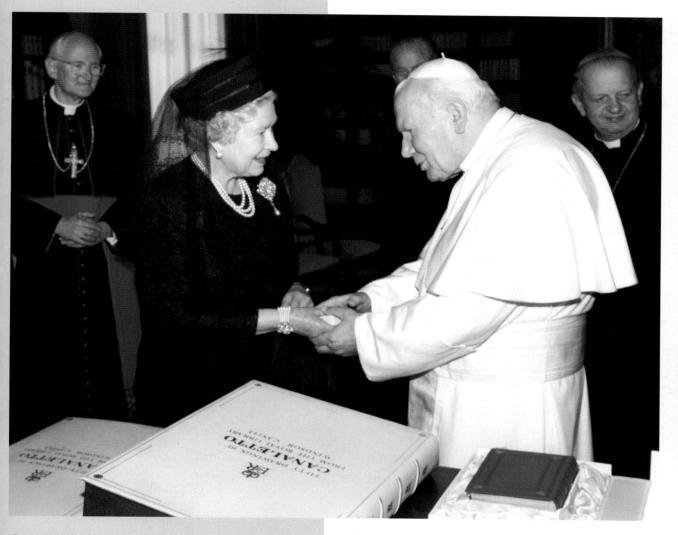

Opposite: Charles and Camilla nicknamed themselves Gladys and Fred in the 1970s. And this to me is a real Gladys and Fred picture. It was taken as they visited a temple in Siwa, Egypt, in 2006. The climb up the hill became a little tiring for the Duchess and she held on to the Prince for the final 100 metres. Above: When the Queen met Pope John Paul II in his private office at the Vatican in 2000 he was very frail and could only walk with a stick. The Queen gave him some bound volumes of Canaletto paintings from the Royal collection at Windsor Castle. In return, the Pope gave her an antique copy of the New Testament and some rosary beads. This picture shows the great warmth between them as they said goodbye for the final time.

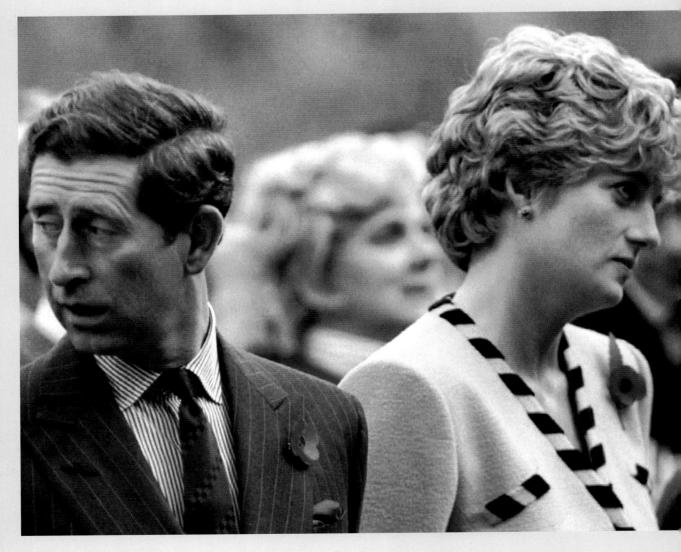

Charles and Diana went to Korea in November 1992 and it was obvious from day one that they didn't want to be together (*above*). At a remembrance service at a memorial to the Glorious Glosters who died in the Korean War, Di's heart and mind were elsewhere, as this picture shows. But we still had no idea this would be their last tour together.

This picture was dubbed 'The Kiss That Missed'. It was taken in Jaipur, India, in 1992 and it was the moment we all realised the marriage was doomed. The Prince had just played in a polo match and Diana was presenting the prizes. Traditionally, they would kiss on the lips, and that was the picture everybody wanted. But she turned her head as he tried to kiss her and we knew they were in trouble. I remember that day well. I have never been, before or since, so physically crushed while trying to take a picture. If I hadn't had the camera to my eye when the moment happened I simply couldn't have raised it at all. Diana in a beautiful beach dress during a holiday with the children in 1991. They were guests of Richard Branson in his palatial villa on the Caribbean island of Necker.

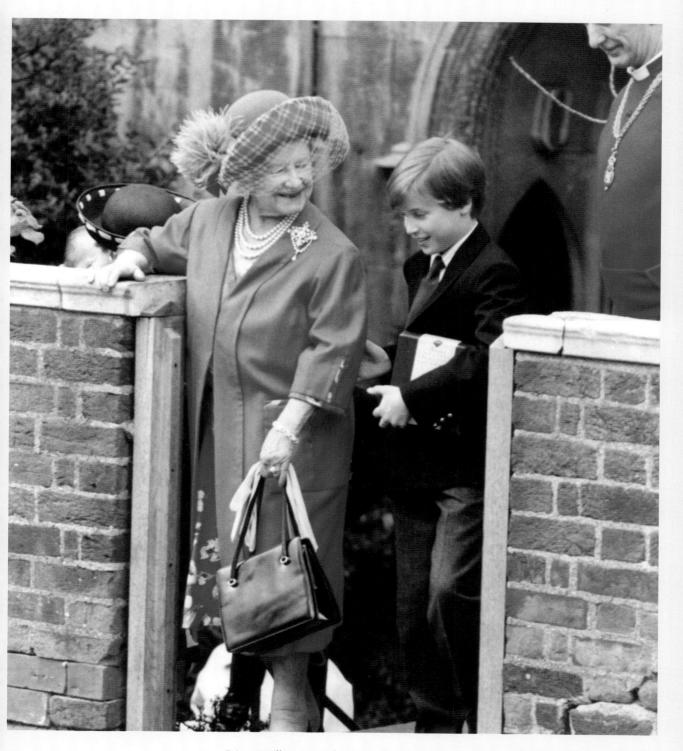

Prince William says this is his favourite picture of his great-grandmother. I took it in 1992 at the Easter service at Windsor Castle as the young Prince helped the Queen Mother up the steps of the Dean's house by the chapel. The approving look she gives him makes this special for me, as it obviously does for William.

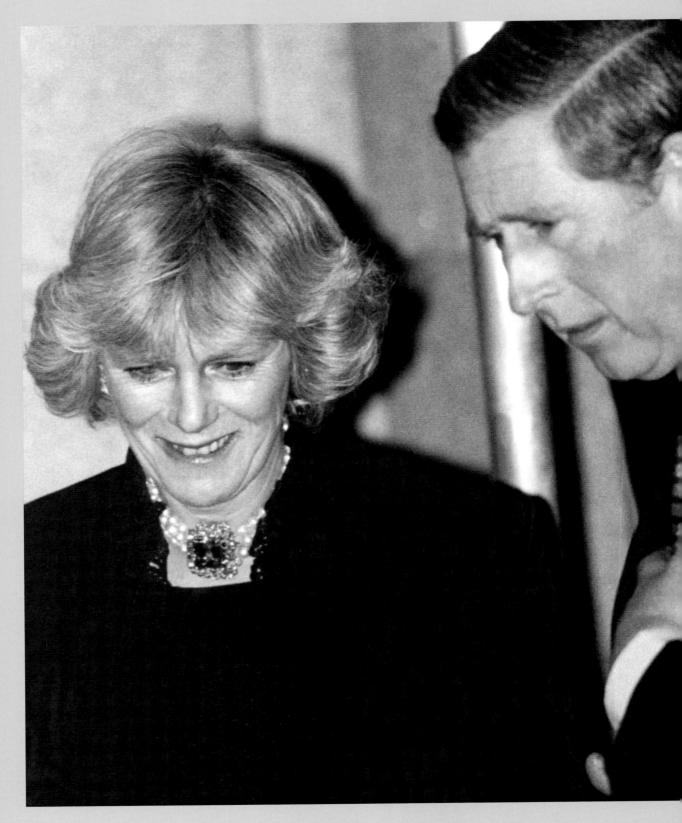

The first picture of Charles and Camilla out together as a couple would have been worth a fortune. There was £100,000 on offer for anybody who could get it. So the Prince decided to defuse the situation completely, by tipping off the favoured few that he would be taking Mrs Parker-Bowles to her sister's birthday party on Thursday, 28 January 1999, at the Ritz hotel in London. I put my ladder down outside the Ritz at 10am on the Tuesday morning and by Thursday night there were more than 200 photographers there. I booked into the Ritz for two nights, with a room overlooking the ladder. No one moved it, I am pleased to say! The walk Charles and Camilla took from the hotel to the car lasted just seconds, but thousands of flashes went off - so many that the TV companies could not show the footage without warning epilepsy sufferers. For once, Fleet Street triumphed over the TV firms.

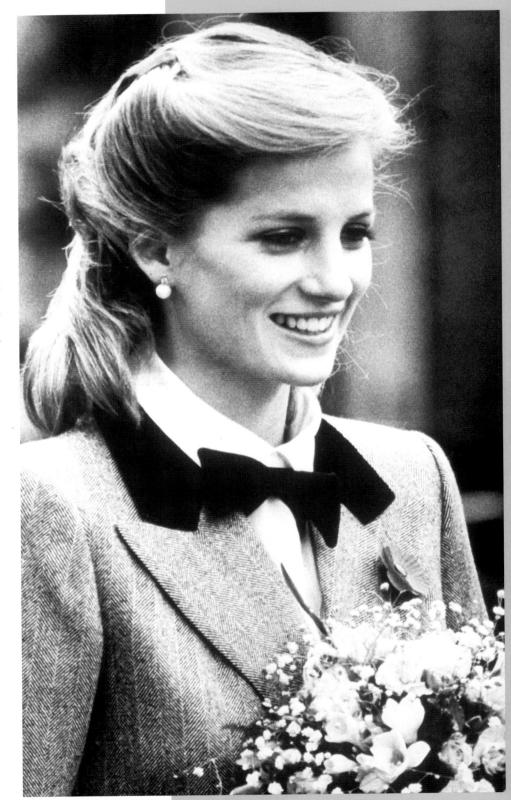

One of the reasons you never missed a Diana engagement was because you might never see the same look again. In this case in 1983 she visited a school in Newham, East London, wearing an Edwardian jacket, a bow tie and her hair swept up like a 1950s film star. She never repeated that style.

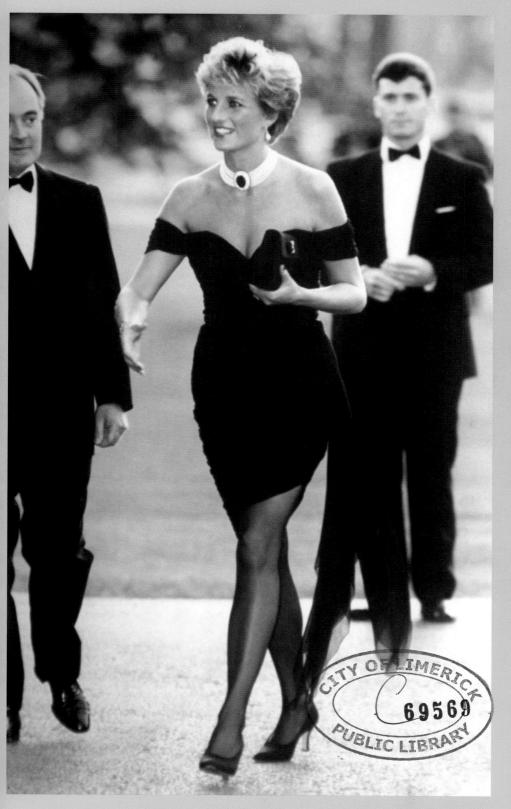

What a dress! On the same day in 1994 that Prince Charles made his TV confession to Jonathan Dimbleby about his adultery with Camilla, Diana was due to visit the Serpentine art gallery in Hyde Park. I was there from 6 a.m. and had a front-row position. When she stepped out of the car the sun had just set and the golden light lit up her hair. But that was not what staggered everybody . . . it was the dress which had everyone gasping and she strode confidently into the gallery smiling as though nothing had happened.

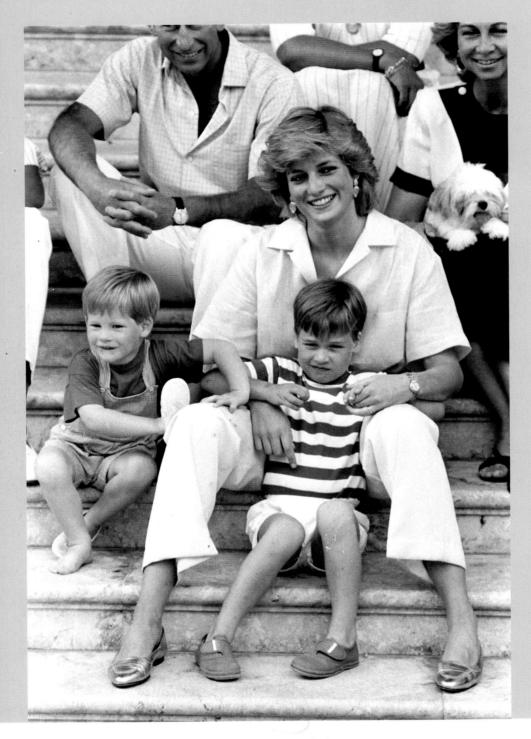

Charles and his family went on holiday to Majorca with the King of Spain in 1987 and gave a photocall on the palace steps. Halfway through the session the King and Queen's dogs got into a massive fight. You can see her dog growling in the picture. Servants managed to separate the warring mutts.

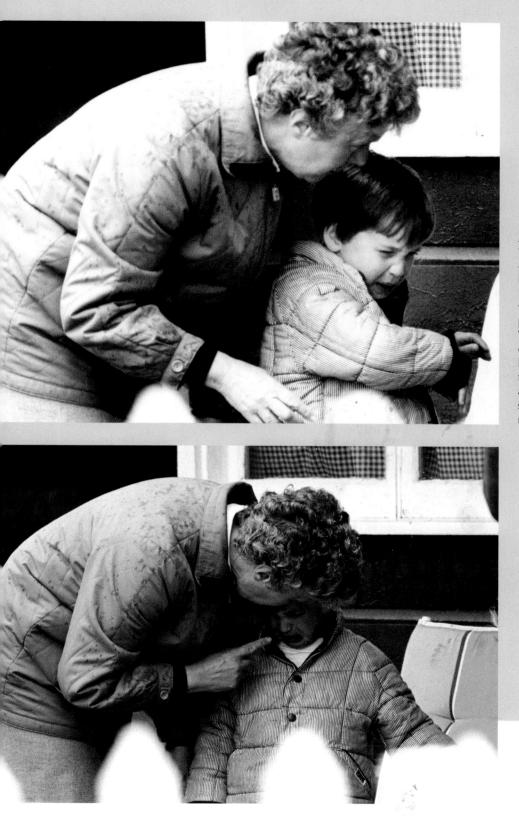

Just like any kid, William was quite capable of getting a good telling-off. He had been told by his nanny Olga Powell not to go too near where his father was playing polo at Smith's Lawn, Windsor, in 1987. When he did, Olga ticked him off and he threw a wobbly and ran to his mother. She gave him a kiss and cuddle and they sat together to watch the rest of the match.

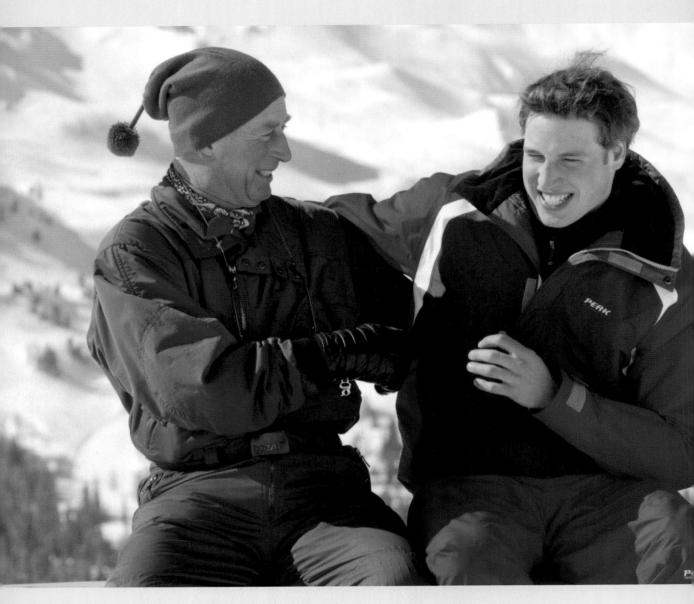

I love this picture of William and his father on holiday in Klosters in 2004. For many years, Charles was considered a cold, detached father. I always knew it wasn't true. He loves those two boys of his more than anything in this world, and they playfully take the mickey out of him continually. On this occasion, the roles are reversed and Prince Charles is tickling William in the ribs. It's a wonderful, relaxed family picture.

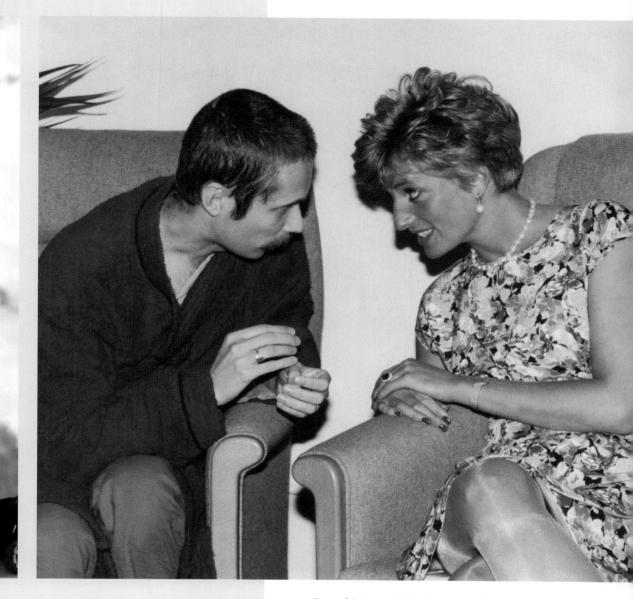

One of Princess Diana's great achievements was almost single-handedly taking the stigma out of AIDS. When she visited the AIDS clinic at the Middlesex hospital in 1991 she sat and listened, engrossed, as the patients told her their problems. She went on to cuddle AIDS babies in Rio de Janeiro and Harlem and everybody in the world got the message that AIDS victims were not to be feared. The Princess has to be commended so much for this.

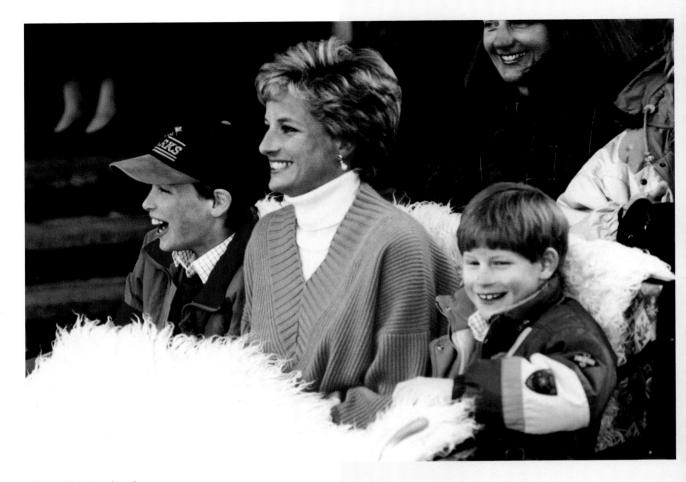

Above: This is a lovely picture of Diana and her two sons on a sleigh ride in the picturesque village of Lech, Austria, where she took them to learn to ski in March 1994.

MY ALL-TIME FAVOURITES

Diana went to Angola in January 1997 to highlight the terrible damage landmines inflict on civilians. She put on a protective body suit and mask and walked through a minefield. But she knew, and I knew, that there were no landmines where she walked and I think she saw the funny side of it. The fact that most of the world has signed up to ban these awful weapons is one of the Princess's great legacies.

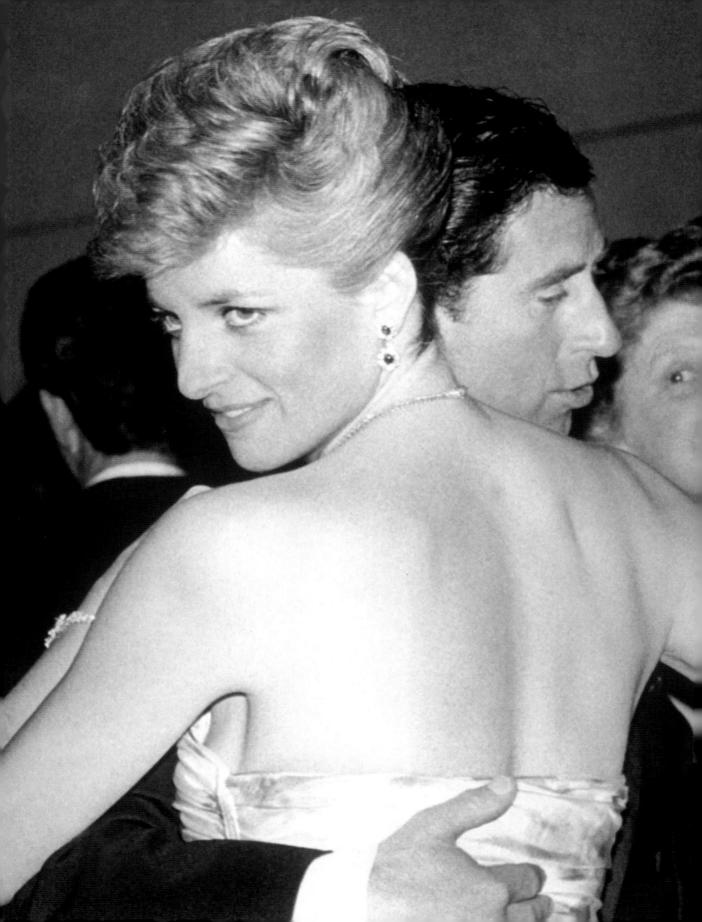

Charles and Diana were to lead the dancing at a state banquet in Melbourne, Australia, in 1988. The song they danced to was 'The More I Want You' and for me this was a wonderful picture because Diana looked so foxy as she spun round the floor. While Charles is engrossed in getting his feet right, Diana is looking for the photographers! And what makes this picture particularly special to me is the other woman in the frame, who has eyes only for the Royal couple.

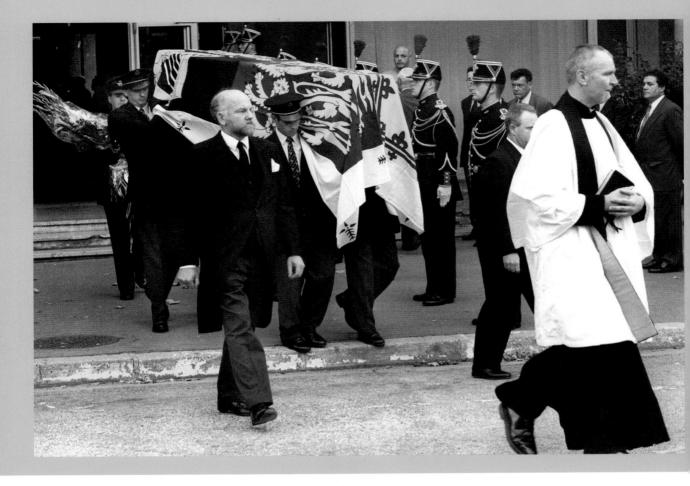

The saddest picture I ever took. On 31August 1997, I was sent straight from a wedding in Kent to Paris where Diana, we had heard, had been in a car crash. As the private plane landed in Le Bourget, outside the French capital, the office rang to tell me she had died. I carried on, photographed the scene of her death and managed to get into the hospital to see her body leave with the Royal undertakers and presidential guard on parade. As the coffin came out of the hospital my wife phoned my mobile and asked how I was coping – and I burst into tears as I saw the coffin, knowing the Princess was inside.

MY ALL-TIME FAVOURITES

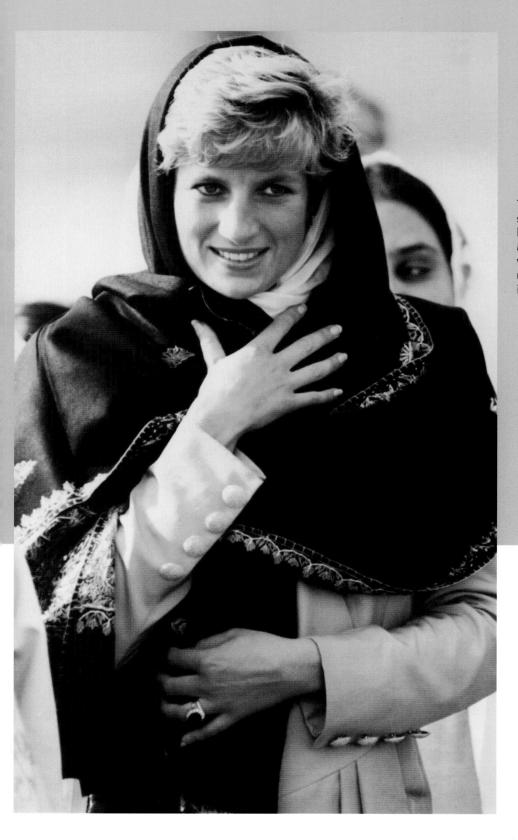

The Princess looked stunning in this fabulous headscarf, observing Muslim tradition at what was then the world's largest mosque in Lahore, Pakistan, in 1991.

Prince Charles, then single, visited that great temple of love the Taj Mahal in 1980 and was asked: 'Would you bring your wife here one day?' He said he hoped to. But then, talking about the problem of choosing a bride, he said to me: 'I've got to get it right first time. I can't live with a woman for two years like you could. And if I don't get it right you will be the first to criticise me.' Twelve years later, on Charles and Diana's tour of India in 1992, the Princess went to the Taj Mahal alone. The Prince had flown to another Indian city to witness the signing of millions of pounds' worth of British contracts. Diana was left to cope with virtually every photographer from Britain and India while no one, just no one, went with the Prince. So he brought his wife to India, but not to this monument to love.

MY ALL-TIME FAVOURITES

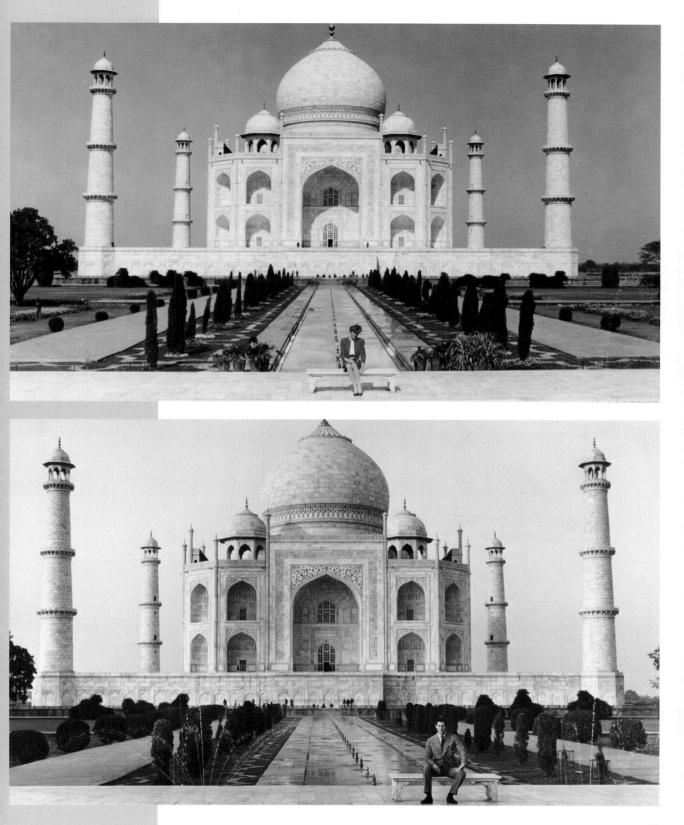

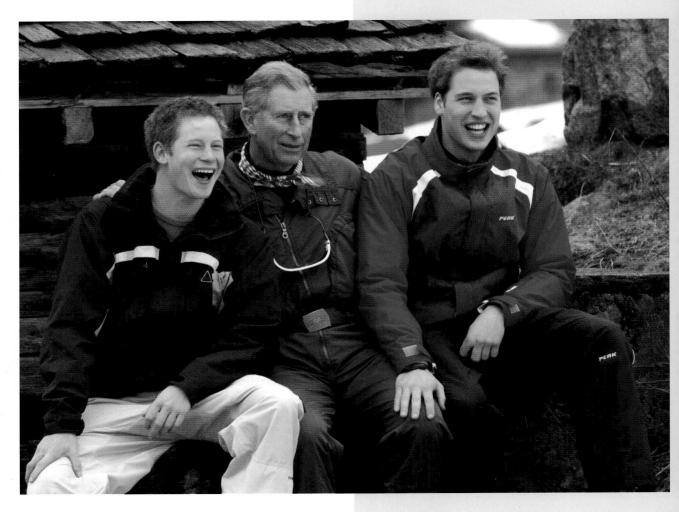

Charles, William and Harry are very close and this picture illustrates that well. They were posing for photographers at the start of a skiing holiday in Klosters in 2005.

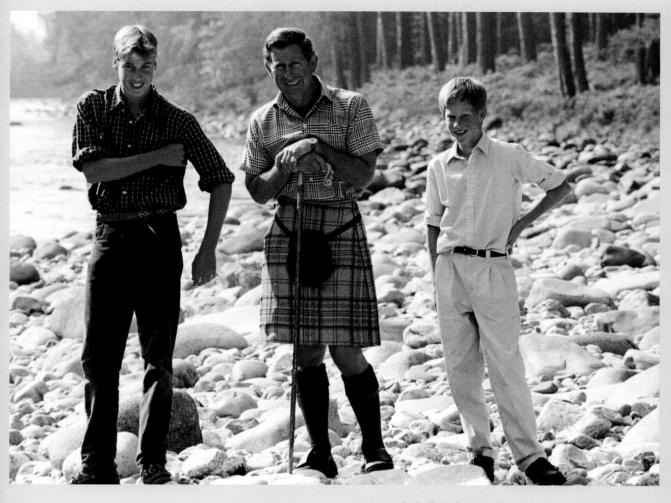

Two weeks before their mother's death, William and Harry pose with their dad on the banks of the River Dee at Balmoral. To my knowledge, William and Harry have never yet worn a kilt. But, when he becomes the Prince of Wales, William will have to wear the Scottish national dress on visits to the far north.

When Prince Harry passed out at Sandhurst in April 2006 he was inspected by his grandmother, the Queen. When she said, 'I think I know this cadet', and smiled at him, Harry blushed. But he was so proud. He always wanted to be a soldier from when he was a young boy and here he was, Second Lieutenant Harry Wales, being inspected by the sovereign. Many people thought he wouldn't be able to keep up with the course, but he had finally cracked it.

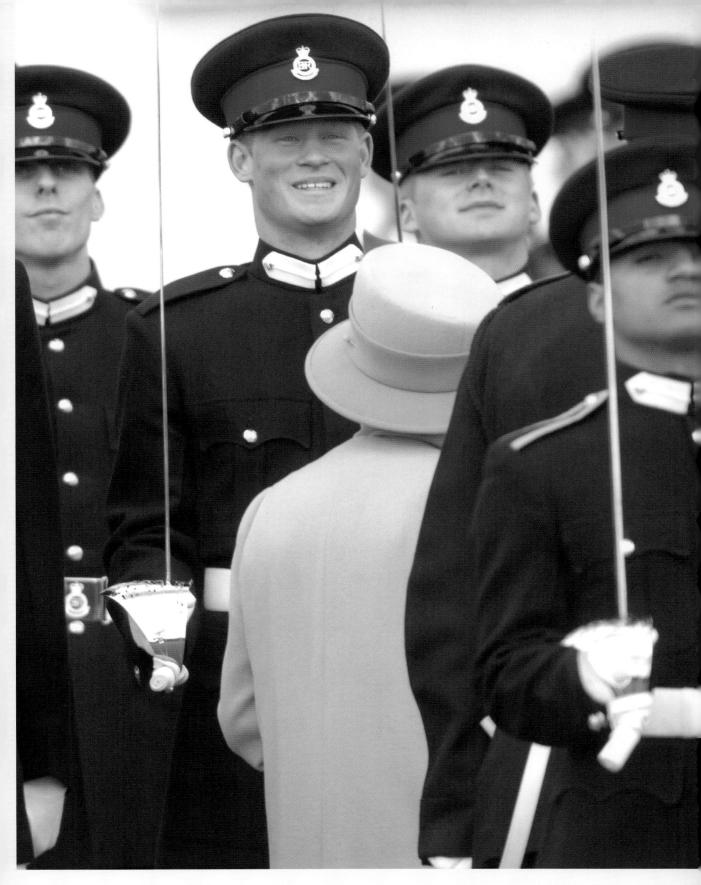

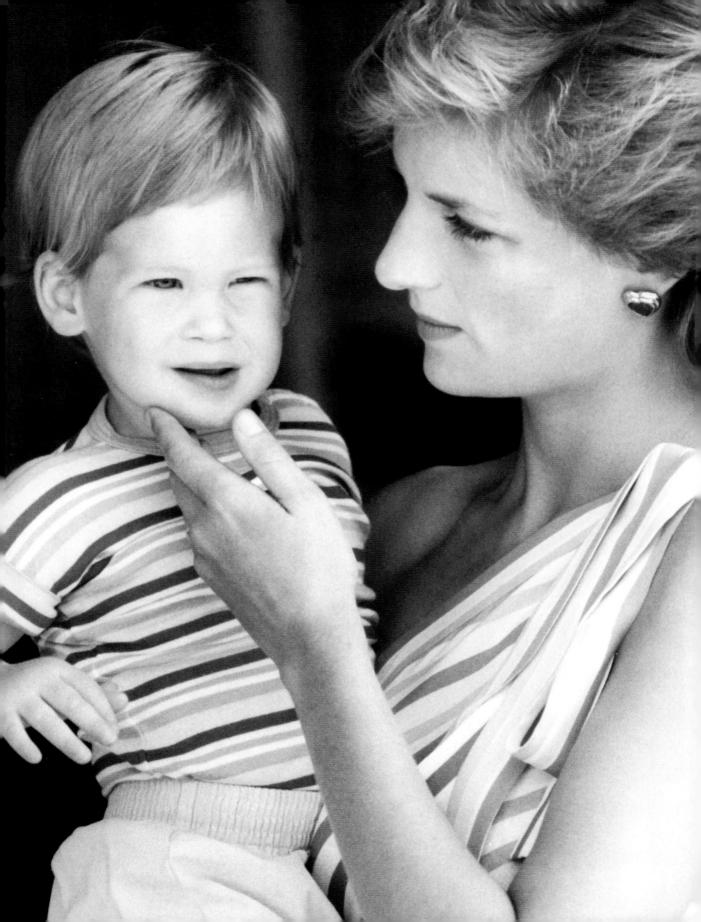

Princess Diana holds her two-year-old son Prince Harry up for photographers in 1986. What makes this picture special for me is the loving look she has for her younger son and the way she touches his chin. Diana was a wonderful mother. She looked painfully thin here, though.

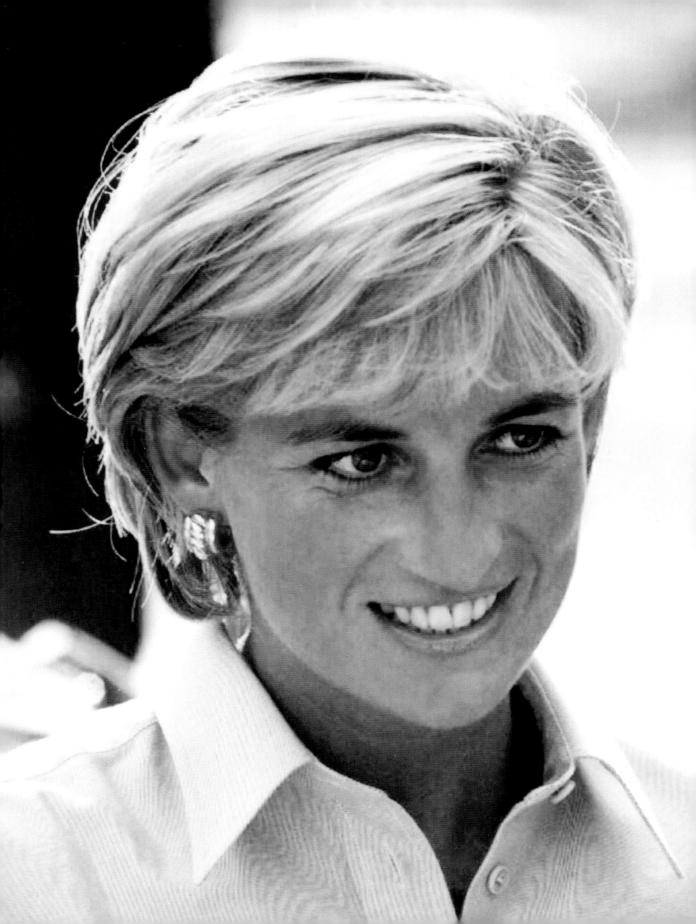

The last portrait I took of Diana was in Tuzla, Bosnia, in 1997. It was 6 p.m. and the sun was setting as I arrived outside the house she was visiting. It was my first foreign trip with a digital camera and I shot this picture, rushed to my hotel room nearby and sent it to London. It was a Page 1 picture, of course, and has since been used more than 100 times in The *Sun*. Diana died three weeks later, and I had many requests from readers for this picture afterwards.

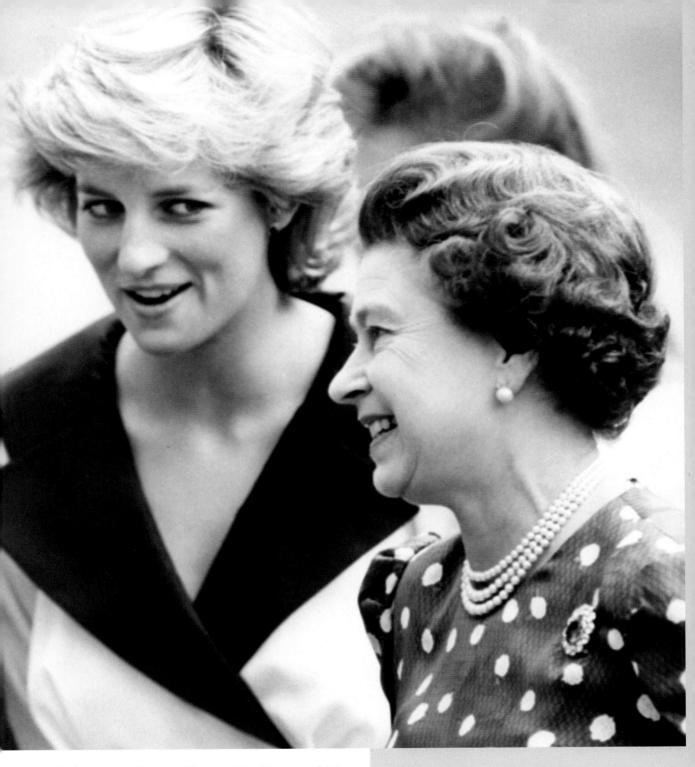

A lot has been said about Diana and the Queen not hitting it off. The Queen, I think, felt Diana was too popular among the public and Diana thought of her mother-in-law as too set in her ways. This picture is from 1987.

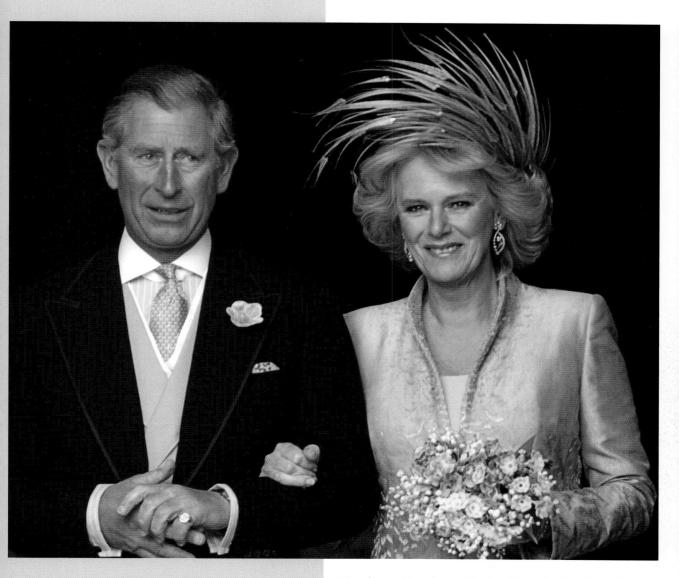

People used to ask me whether I thought Camilla and Charles would marry and I always said, 'Yes. But I don't really see what's in it for her.' Like many other Royal watchers, I just thought she would be pilloried by the public for being the infamous 'third person' in the marriage. But I was staggered how beautiful she looked when she left St George's Chapel, Windsor, after the wedding in 2005 and how my concerns were so wrong. I have never heard a nasty word against her or seen anyone raise a placard in protest at the Prince's wife. She has been the reason why Prince Charles is now so happy with his Royal duties. This man only fulfils his full role in life when his mother dies. He could be into his 70s before he becomes King, fulfilling his destiny when he should be putting his feet up - so he has a life no one should envy. But finally he has married a woman to put a spring in his step and support him forever.

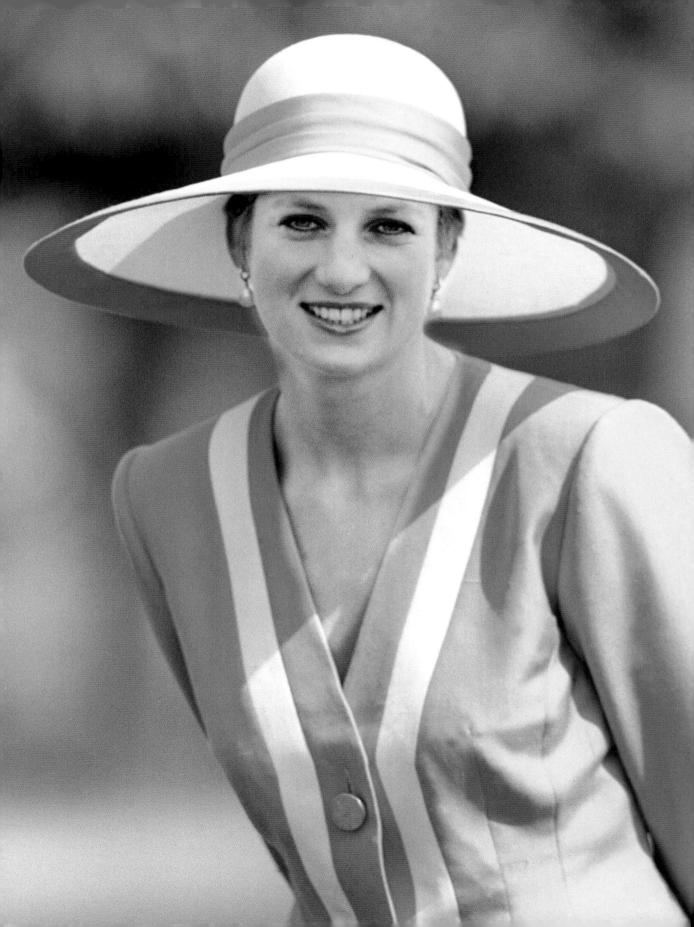

CHAPTER TWO Princess Diana

CHAPTER TWO

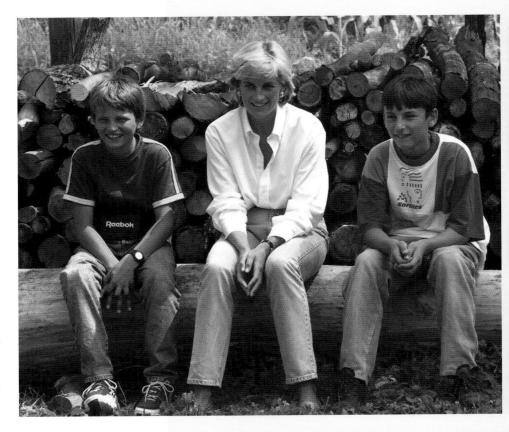

Above: A few weeks before her death in August 1997, Diana visited Bosnia and is seen here posing with two young landmine victims. It was pictures like this that enabled her almost singlehandedly to get antipersonnel landmines banned throughout much of the world.

Below: Diana hugs a young child in 1996 at Chicago's famous Cook County Hospital – the hospital on which the TV series *ER* is based.

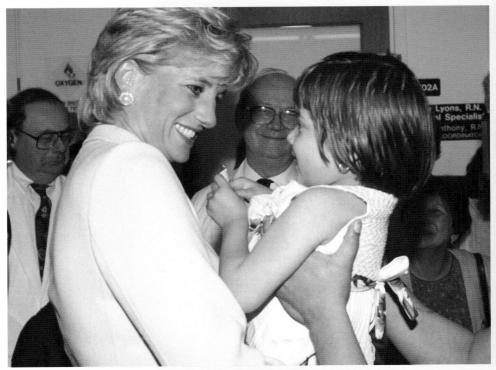

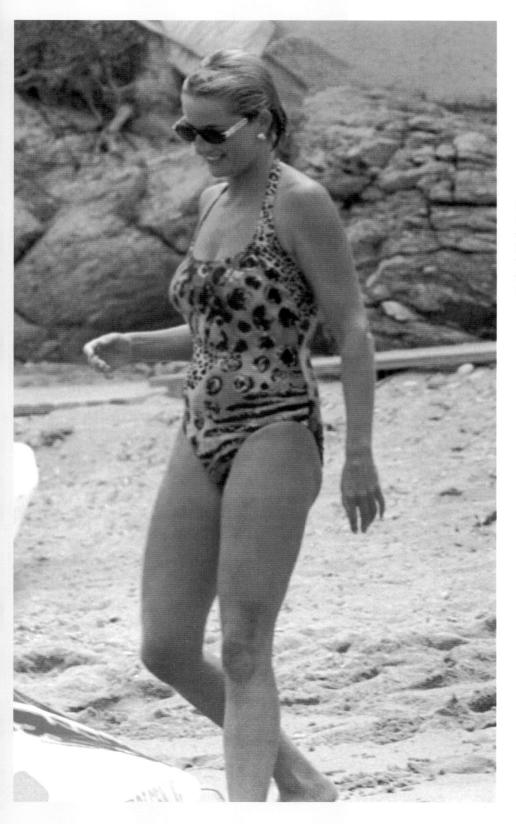

Diana strolls into the Mediterranean for a swim, wearing a leopard-skin bathing suit, in July 1997. The Princess was on holiday with William and Harry in St Tropez, South of France.

CHAPTER TWO

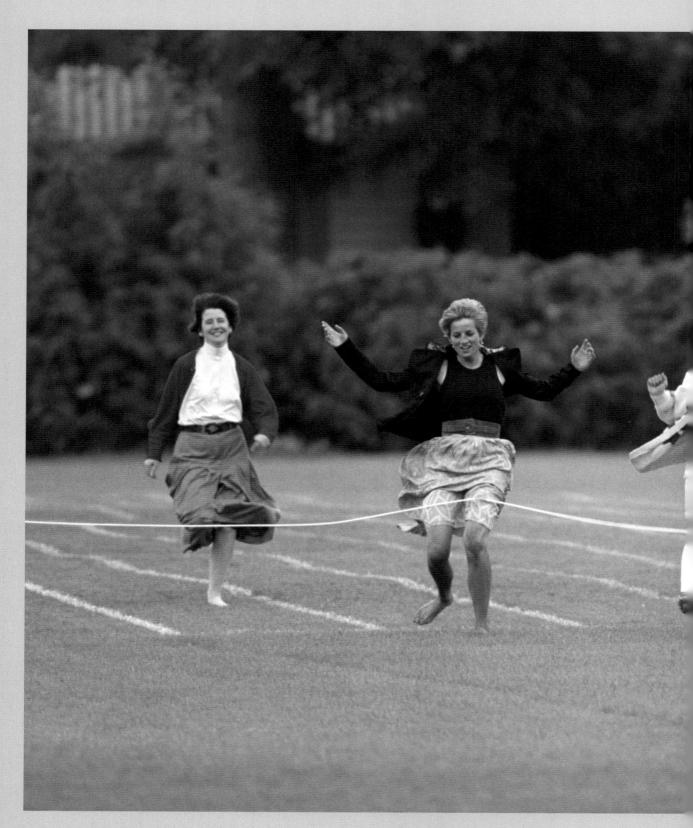

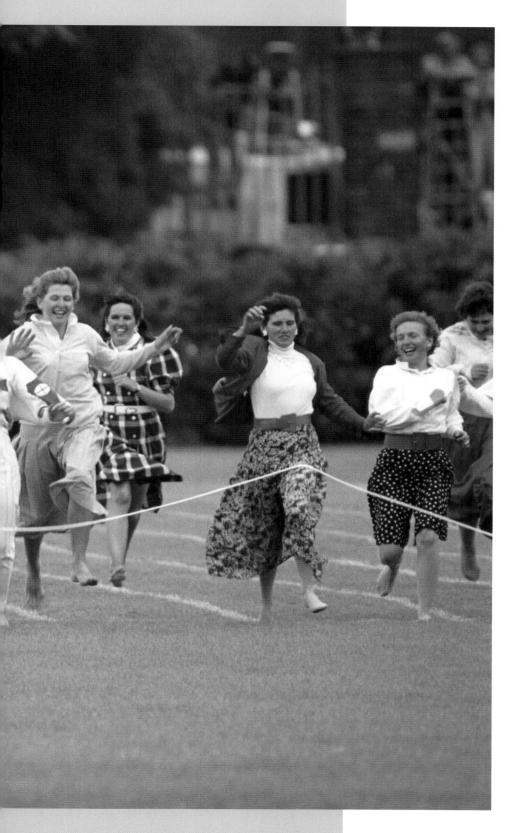

One of Diana's favourite annual events was the mothers' race at the boys' school sports day and here she is, winning it, at the Richmond rugby club in June 1991. Well, the Princess always claimed she won it . . . my picture shows the lady second on the right touching the tape at the same time, so I reckon it was a dead heat.

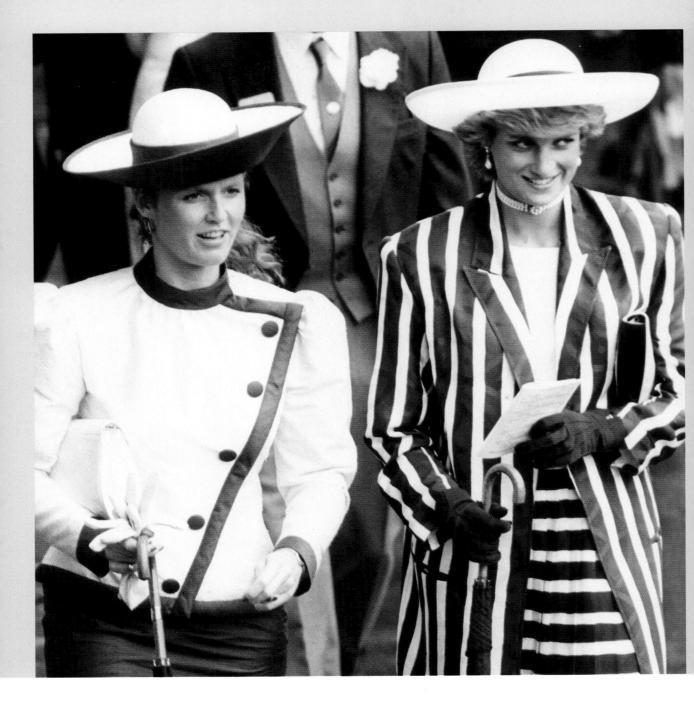

The hottest couple at Royal Ascot in 1987 was Sarah Ferguson and Princess Diana, and here they are walking through the Royal enclosure wearing extremely bright outfits. When Diana died, she and the Duchess had not spoken in months. They fell out over something Fergie wrote in her autobiography. Fergie regrets this bitterly. They were very, very close for many years. In fact, it was Diana who introduced the Duchess to her future husband Andrew at an Elton John concert.

PRINCESS DIANA

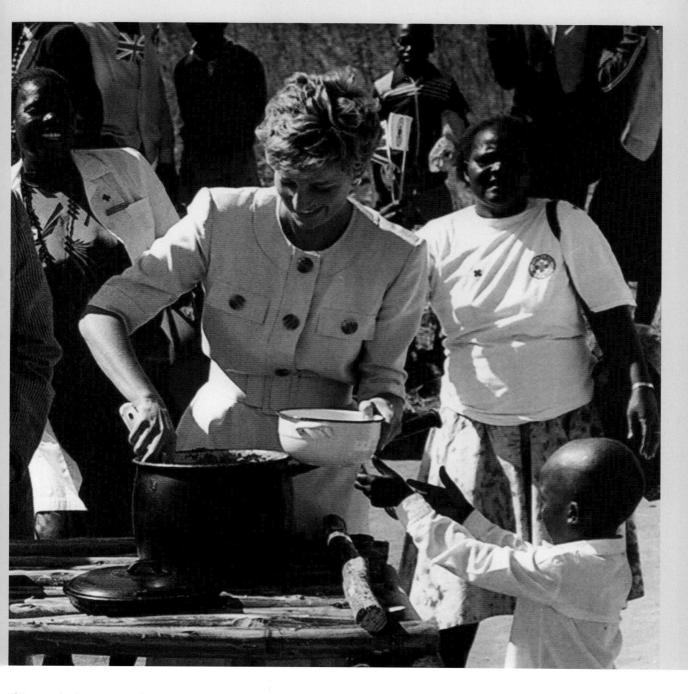

This was the best picture from Princess Diana's Zimbabwe trip in 1992. We were at a feeding centre for children set up by the Red Cross. Diana didn't do this for the picture though – she served every single child who came to the centre that day. Diana did so much for the Red Cross, including her personal crusade to ban landmines. She flew economy on that trip and at one point sat with the reporters and photographers on the stairs of the British Airways plane. We chatted through the night.

CHAPTER TWO

Diana, in June 1997, looking fantastic in a light-blue dress at London's Royal Albert Hall for a gala performance of *Swan Lake*. She was patron of the English National Ballet.

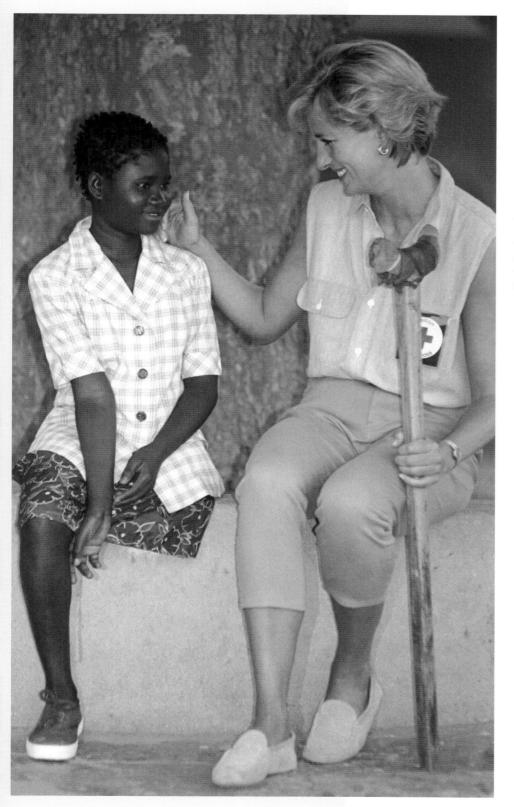

Diana went to war-torn Angola in 1997 to highlight the brutality that landmines inflict on children. Here she posed with a young amputee in the capital Luanda.

CHAPTER TWO

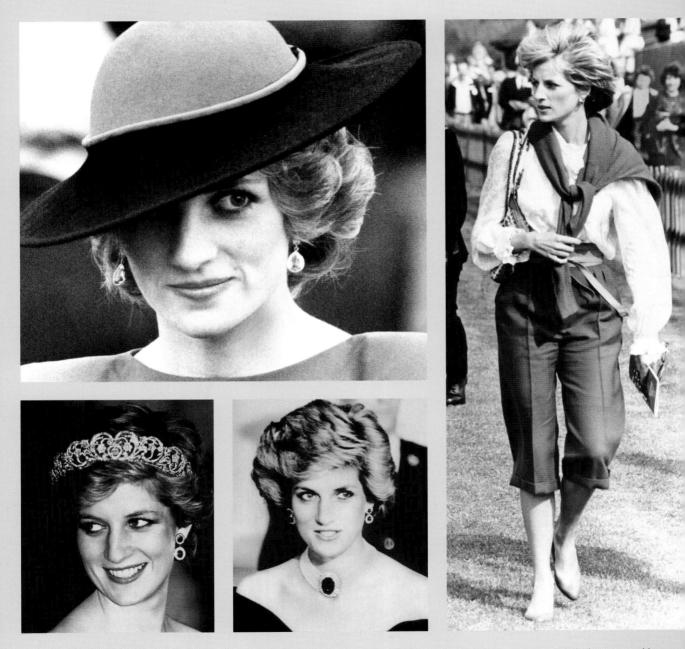

Clockwise from top left: I love this picture of Diana, taken at a friend's wedding in Norfolk in 1985 – mainly because of her beautiful diamond earrings and the fabulous tilt of her hat.

Diana had great legs, and showed them off by wearing pedal pusher trousers while watching Charles play polo in Windsor in 1983.

Diana attended a White House dinner hosted by President Reagan and wife Nancy in 1985 and wore an amazing dress that later sold at a Christie's auction for more than \$200,000. That night I also photographed this amazing choker around her neck and matching earrings.

Dazzling in diamonds, Diana attends a banquet in Lisbon, Portugal, in 1987.

PRINCESS DIANA

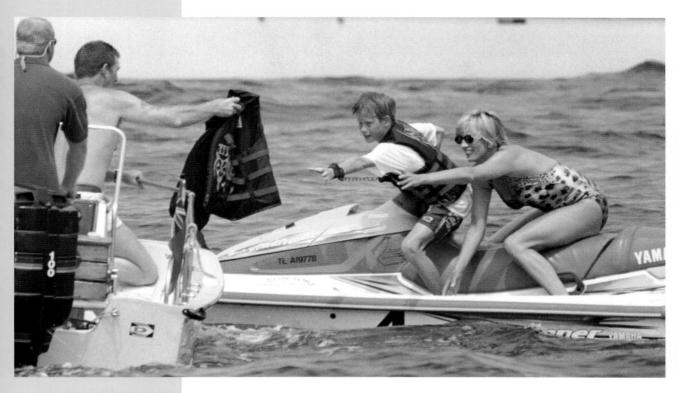

Clockwise from top: Harry reaches out to grab a lifejacket for his mother at St Tropez in 1997. He then gave her a trip to remember as he hurtled through the sea.

The Princess looks so radiant while sitting in her deckchair watching Charles play polo in Windsor in 1982. She was expecting Prince William at the time.

Diana pats a beautiful little girl on the head while strolling through a Welsh village in Gaiman, Patagonia, on her visit to Argentina in 1995.

CHAPTER TWO

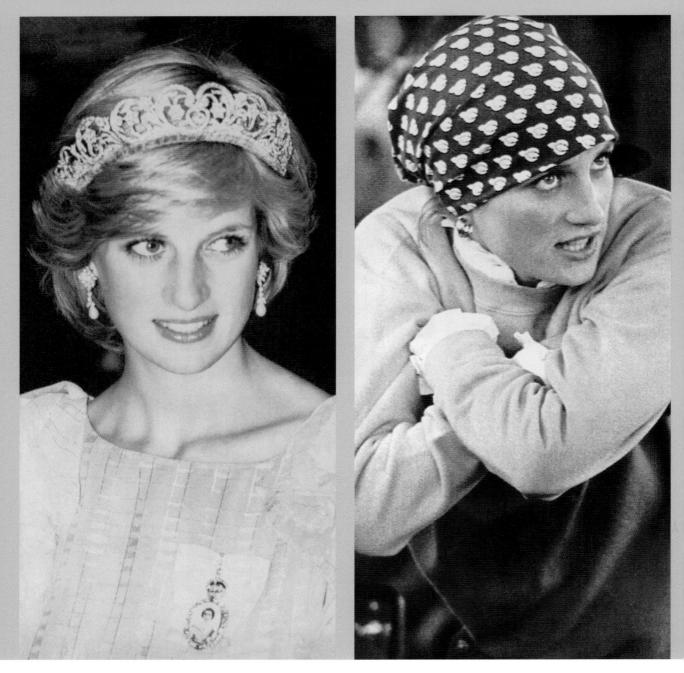

Above left: Diana celebrated her 21st birthday during her second overseas tour to Canada in 1982. Here she is, wearing a fabulous tiara, at a state dinner in Ottawa.

Above right: Whatever she wore, she looked good. Diana was wearing a headscarf when she turned up to watch Prince Charles play polo in Cirencester, Gloucestershire, in 1986. I had to work so hard to get this frame but it was worth it. She looked fantastic.

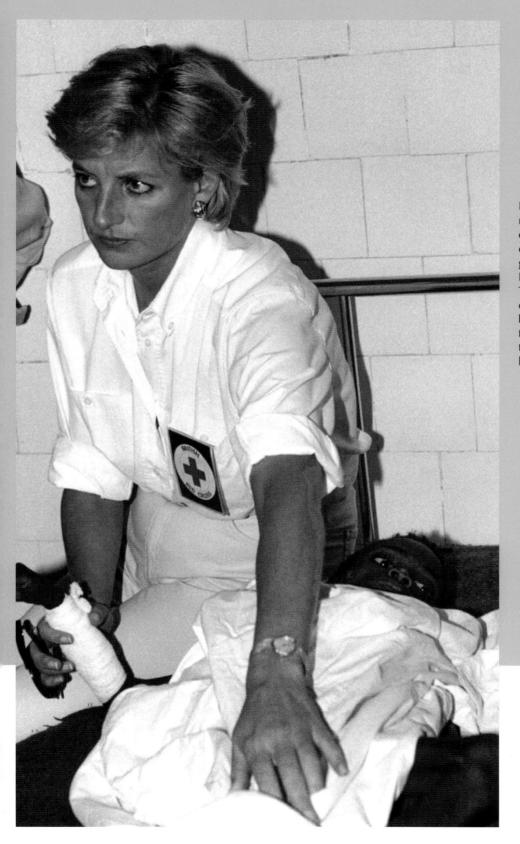

I rarely saw Diana more moved than at this moment during her landmines crusade in Angola. This little girl, lying in hospital in Huambo, is a pitiful sight. The Princess covers the child up and holds her bandaged arm. Her eyes are full of tears as she listens to the doctor describe her horrendous injuries.

CHAPTER TWO

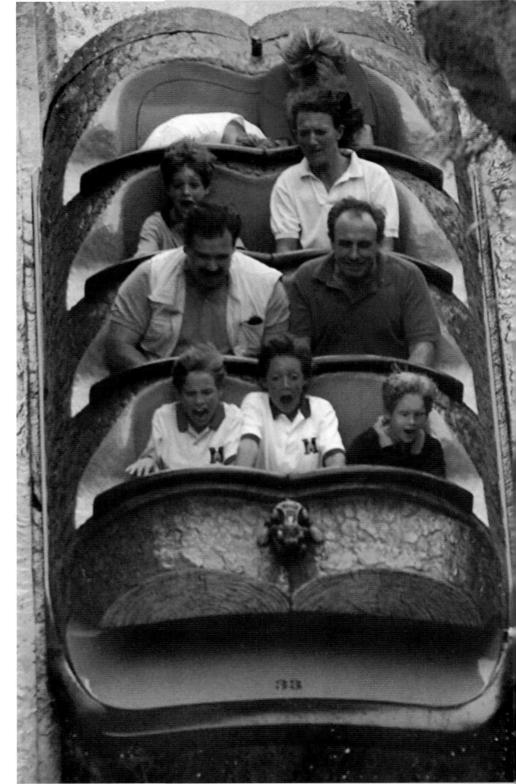

The Princess took William and Harry to Disney World in Orlando, Florida, in 1993. She was so terrified on the log flume ride she had to duck down in the back seat. The boys sat in the front and were terrified too – but I bet they enjoyed every minute.

PRINCESS DIANA

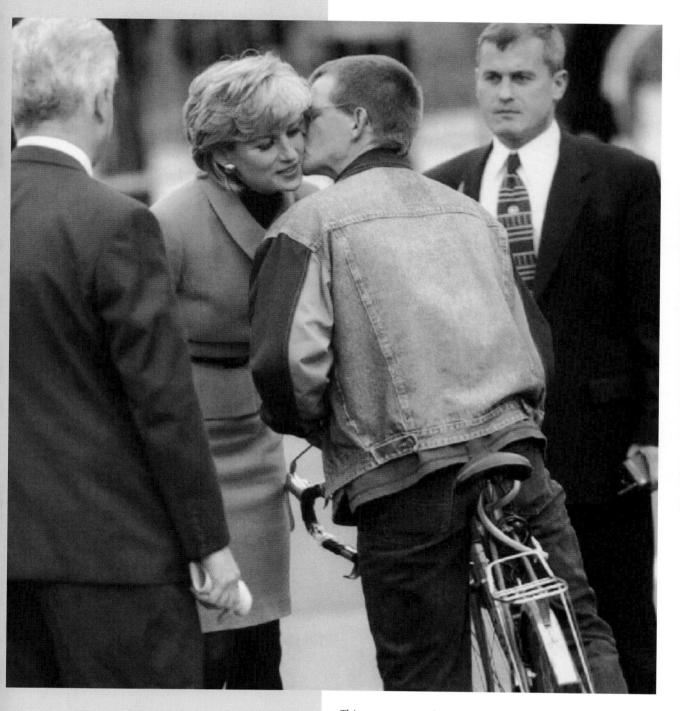

This was an amazing moment on a visit to Toxteth, Liverpool, in 1995, when a lad rode up on his bike, stopped and asked Diana for a kiss. She obliged, offering her cheek. Standing either side were two of Merseyside's finest, ready to jump into action should he have taken it any further.

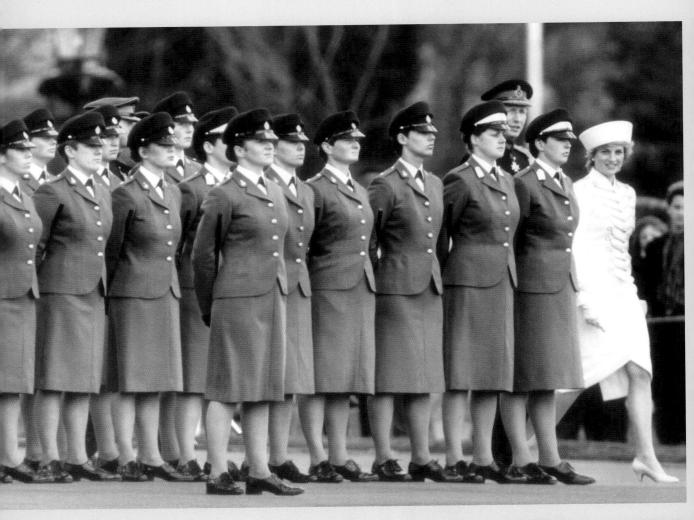

Above: I'm very proud of this picture. Diana took the sovereign's parade at the Royal Military Academy at Sandhurst in 1987 and wore a military-style outfit and hat as she reviewed the soldiers passing out that day. With the aid of a 600mm lens I was able to capture the moment the Princess appeared at the end of the ranks of women soldiers. The white contrast to the military uniforms makes her stand out, although she looks perfectly in line.

Right: Doesn't Diana look young in this picture? She was 19-year-old Lady Diana Spencer when it was taken shortly before her wedding in July 1981. She was watching Charles at yet another polo match.

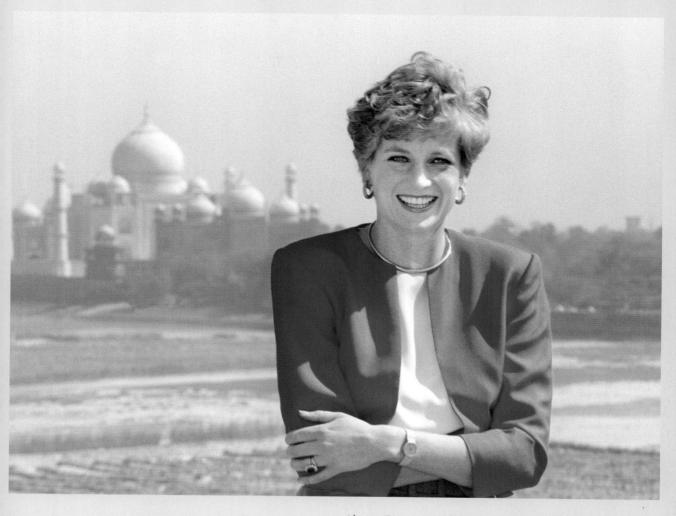

Above: Diana visited the Red Fort in Agra, India, in 1992. In the background of my picture is the Taj Mahal, which she visited after that. As she stood in front of this magnificent tribute to love, she turned to me and said, 'Where do you want me to stand, Arthur?'

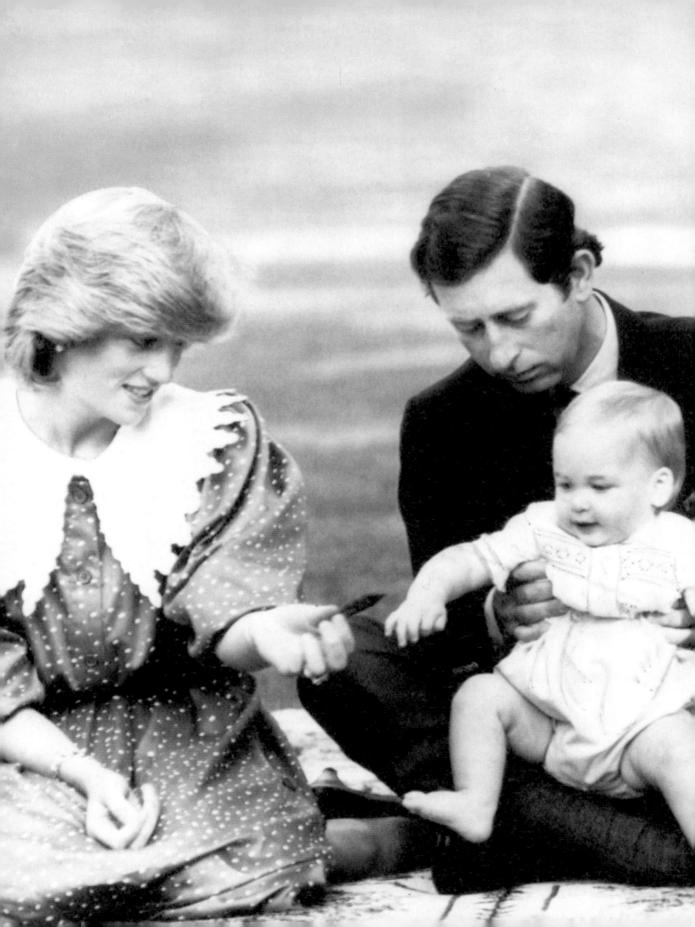

CHAPTER THREE Charles and Diana

CHAPTER THREE

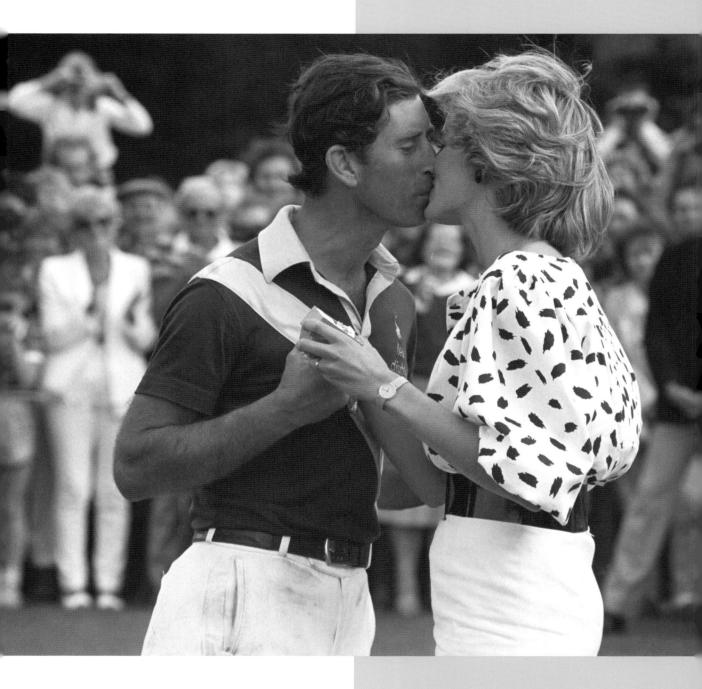

Opposite: There was the famous 'kiss that missed'. But here's one that didn't – Charles and Diana at a polo match in Adelaide, Australia, in 1987.

Above: This photo inspired a great *Sun* headline. It was 1983, and Charles and Diana were touring Australia and New Zealand. Just before they said farewell to this Maori chief in Gisborne, on New Zealand's North Island, Charles patted his wife on the backside. The headline in next day's *Sun* read: CHARLES GIVES DI A PAT DOWN UNDER.

CHAPTER THREE

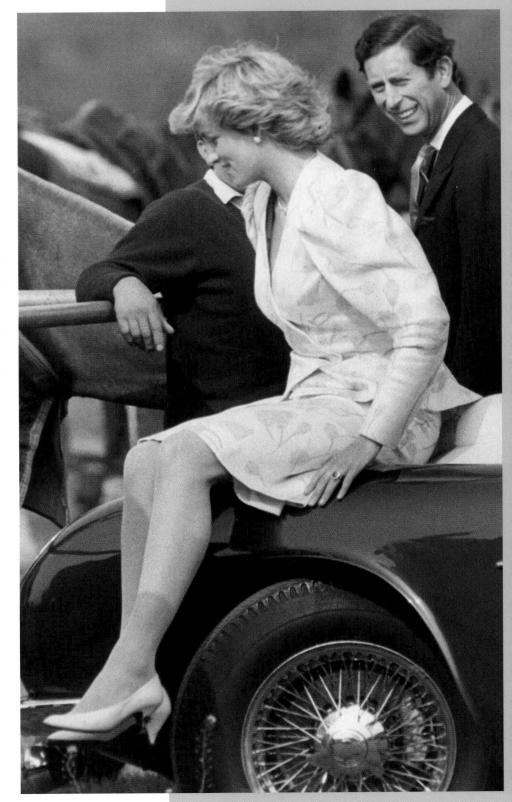

Oops! Diana sat on the bonnet of Charles's Aston Martin Volante in 1987. The supercar was a 21st birthday present from the Queen, and Charles treasured it. He politely asked Diana to get off the car and she did. Luckily, the slight dent she left sprang back into shape.

CHARLES AND DIANA

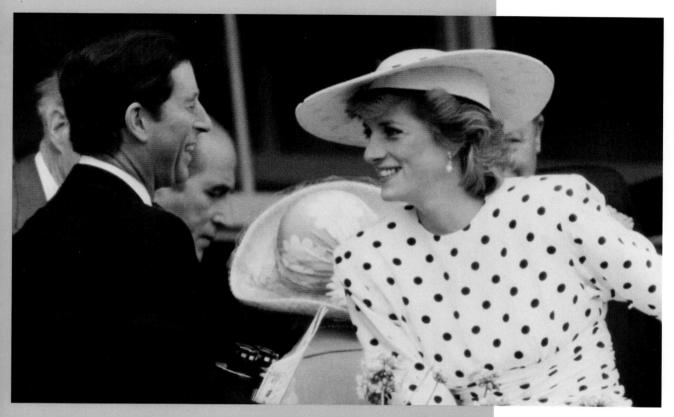

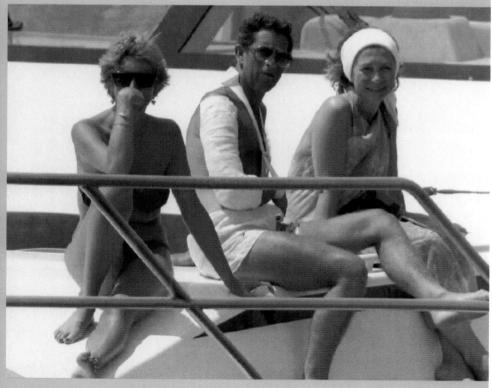

Above: I believe Diana and Charles were genuinely happy during the first few years of their marriage. They were having a lot of fun together in this picture at the 1986 Derby at Epsom.

Below: In 1990, Charles had broken his arm playing polo and was on holiday with Diana in Majorca as guests of the King and Queen of Spain. Here they are, relaxing on the King's yacht.

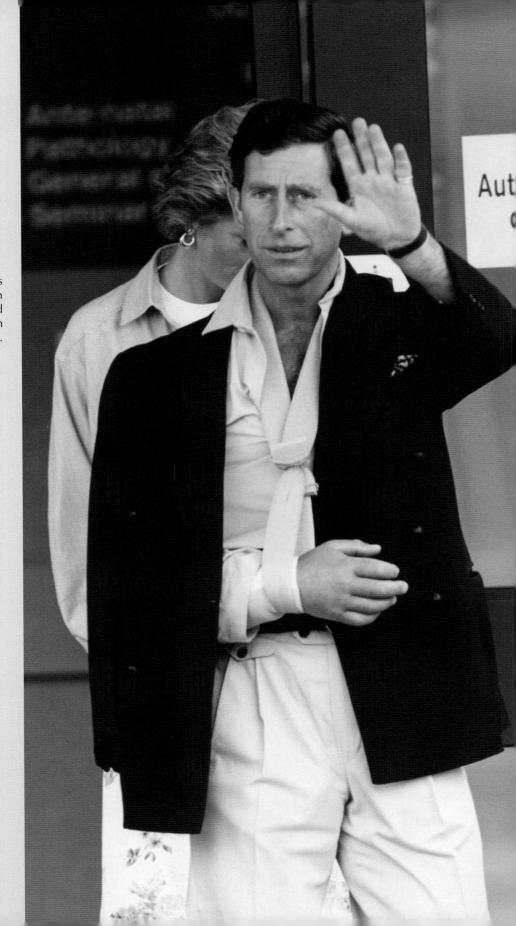

The moment Charles emerged from hospital in 1990, with Diana behind him, after breaking his arm playing polo.

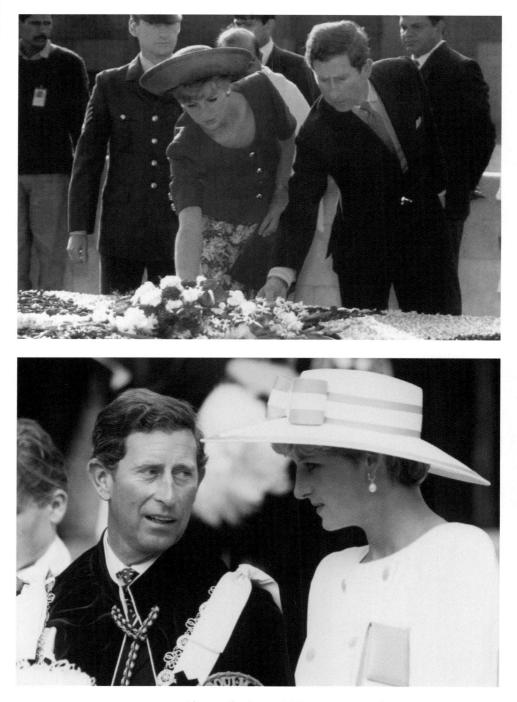

Above: Charles and Diana went to India in 1992 and, like all visiting dignitaries, one of their first visits was to the memorial to Mahatma Gandhi in New Delhi.

Below: The couple seemed so indifferent to each other as they stood together on the steps of St George's Chapel in Windsor in 1992 at the garter service.

CHAPTER THREE

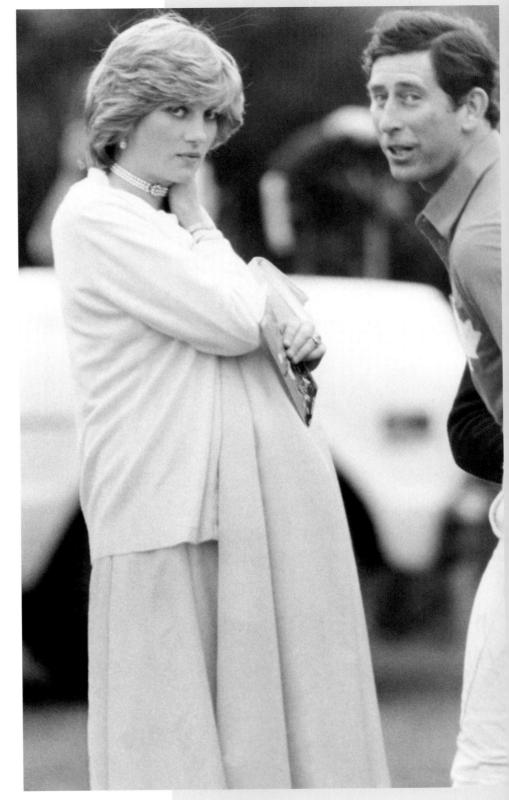

Diana watches Charles play polo after the Ascot races in 1982. Prince William was born just a few days later.

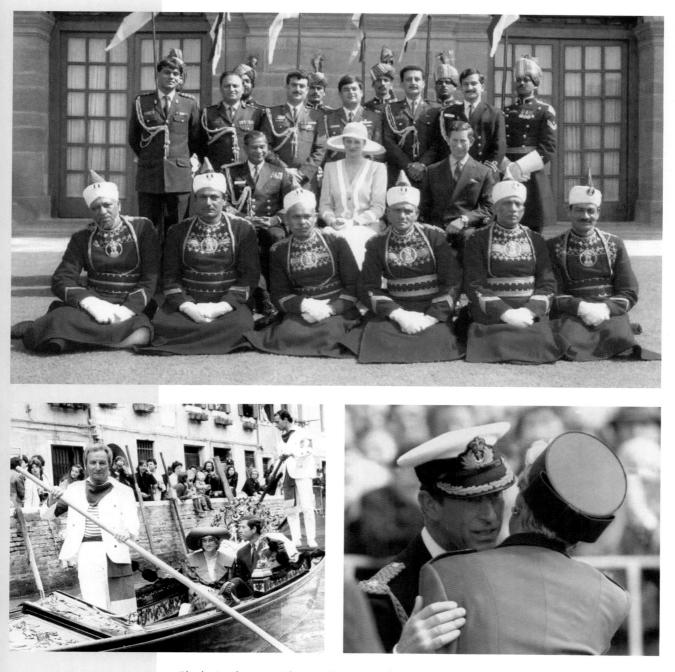

Clockwise from top: The couple pose with the presidential guard at the presidential palace at New Delhi in 1992 during their visit to India.

Charles gives Diana a goodbye kiss during a visit to Czechoslovakia in 1991 before going off to separate engagements.

She didn't make many fashion blunders, but this was probably Diana's biggest. She wore a stupid hat while taking a gondola ride with Charles on the canals of Venice in 1985. No one ever, ever saw that hat again.

CHAPTER THREE

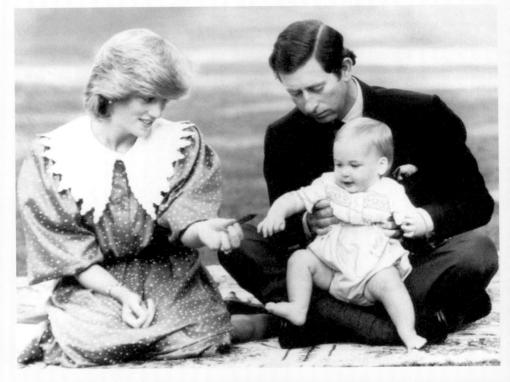

Above: The first major photocall for Prince William, then just ten months old. This was at Government House in Auckland, New Zealand, in 1983 and Charles and Diana were keen to show him off.

Below: Charles and Diana show off William, now 18 months old, in 1983 at Kensington Palace.

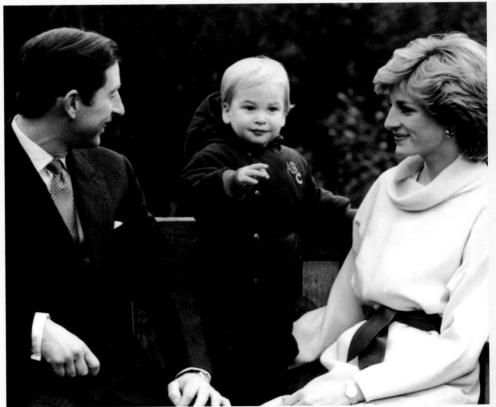

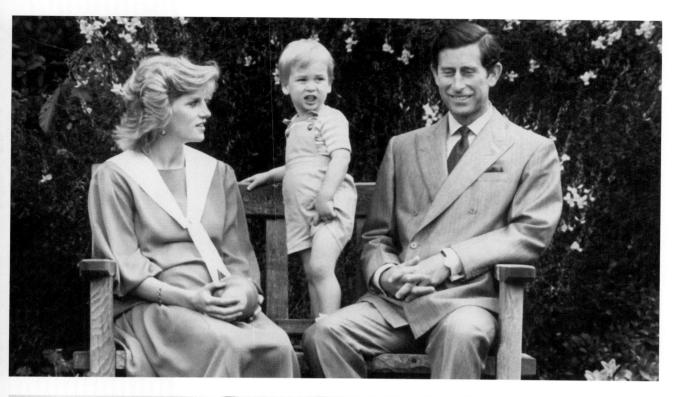

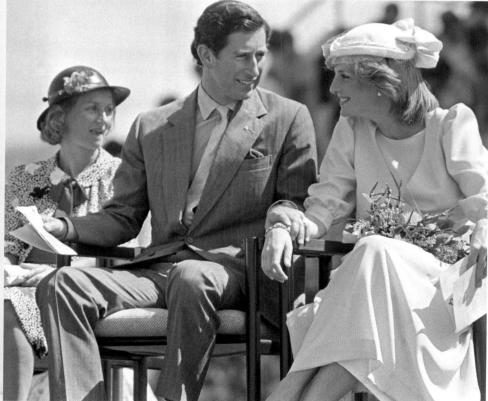

Above: The young Prince poses with his parents in the gardens of Kensington Palace in 1984.

Below: It was an extremely hot day, so Charles placed his hand on Diana's wrist and comforted her during a visit to Maitland, New South Wales, Australia, in 1983.

CHAPTER THREE

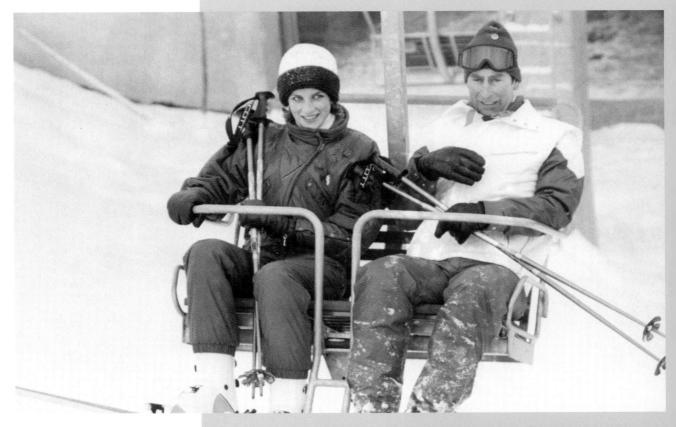

Above: Charles and Diana looking very happy together on a ski lift in Klosters, Switzerland, in 1984.

Below: By 1991 the marriage was in its final stages, but you wouldn't know it from this picture. The couple looked extremely happy together at an opencast mine in the middle of the Amazon, Brazil, in 1991. I guess they were putting a brave face on their troubles.

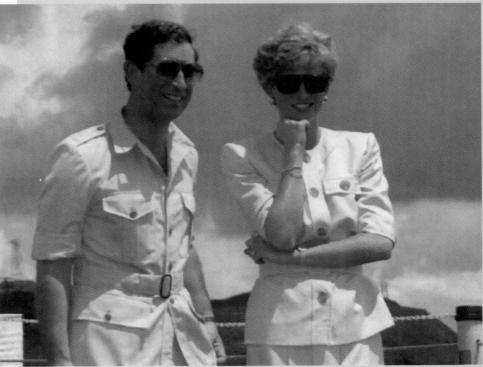

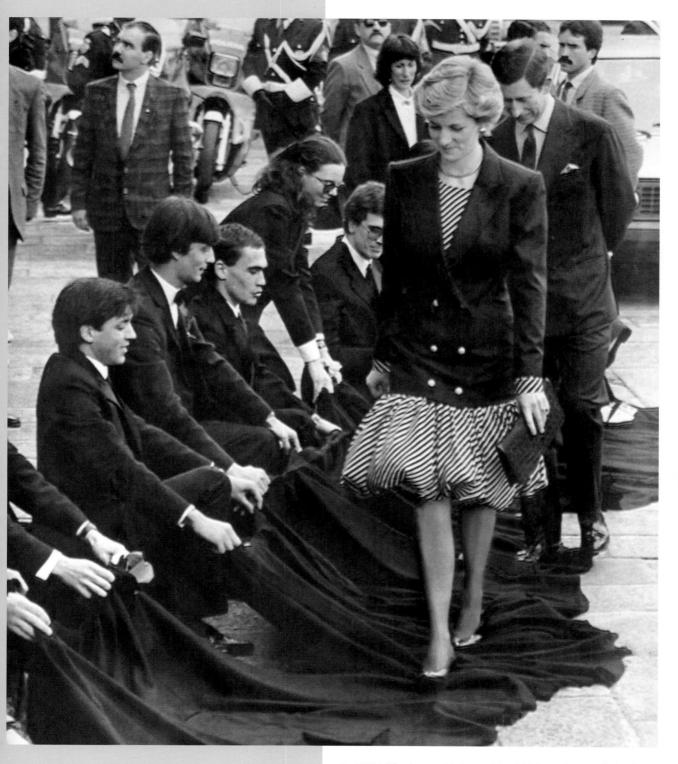

In 1987 Charles and Diana visited Lisbon, Portugal. Students at the University of Oporto laid their cloaks on the ground for the Prince and Princess to walk over.

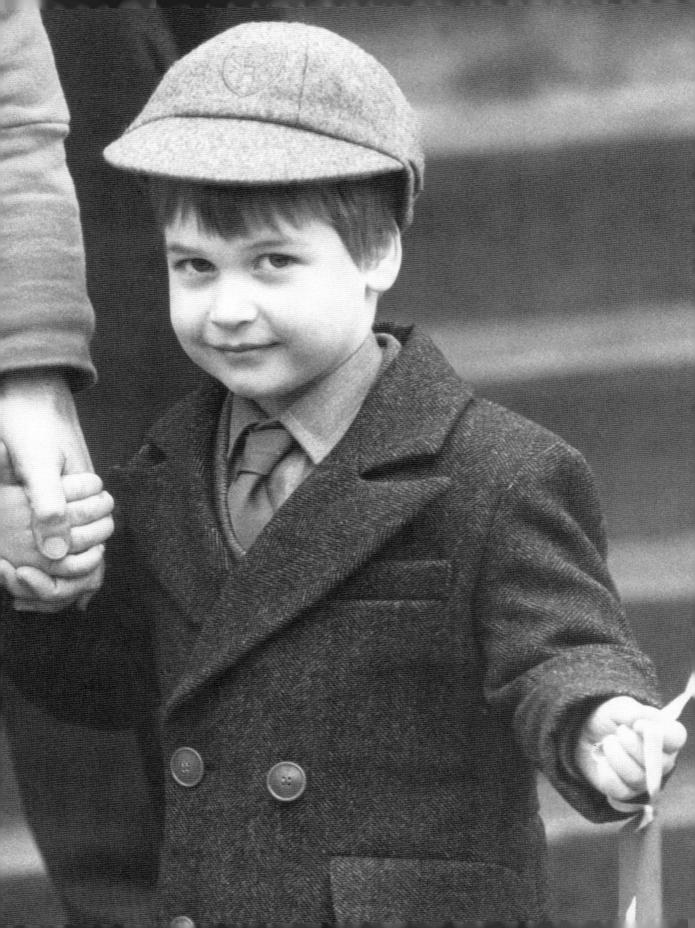

CHAPTER FOUR Prince William

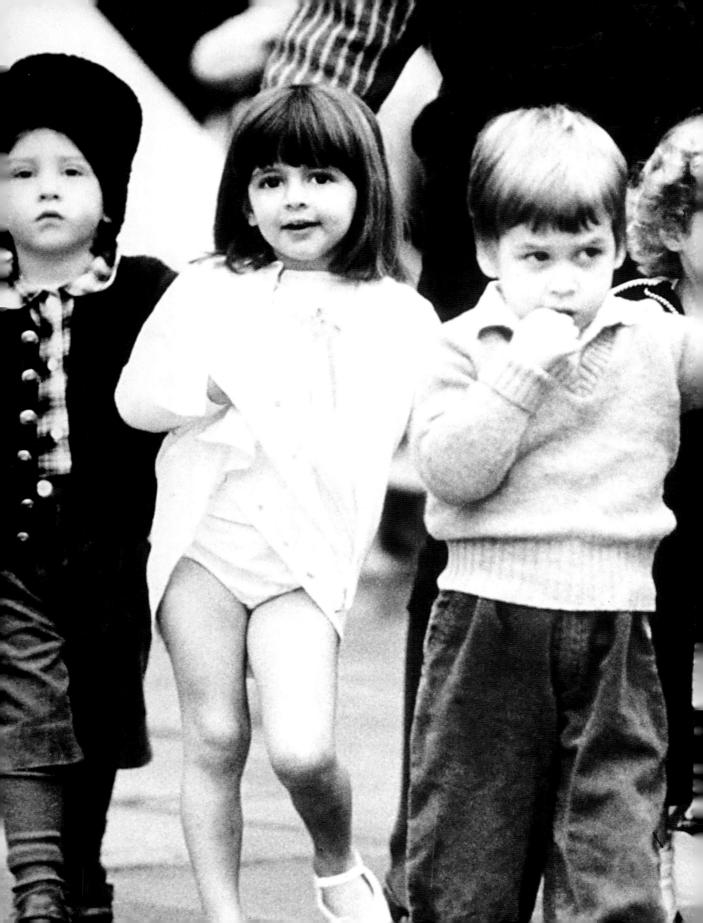

PRINCE WILLIAM

I won an award with this 1987 picture of Prince William in his first school Christmas play. As the children walked across the road from their nursery to the hall for the performance, one of the 'actresses' lifted her skirt to stop it getting wet where it had rained earlier. It appeared in The *Sun* the next day with a sub-editor's fantastic headline: PRINCE WILLIAM'S FIRST PANTIE MIME.

CHAPTER FOUR

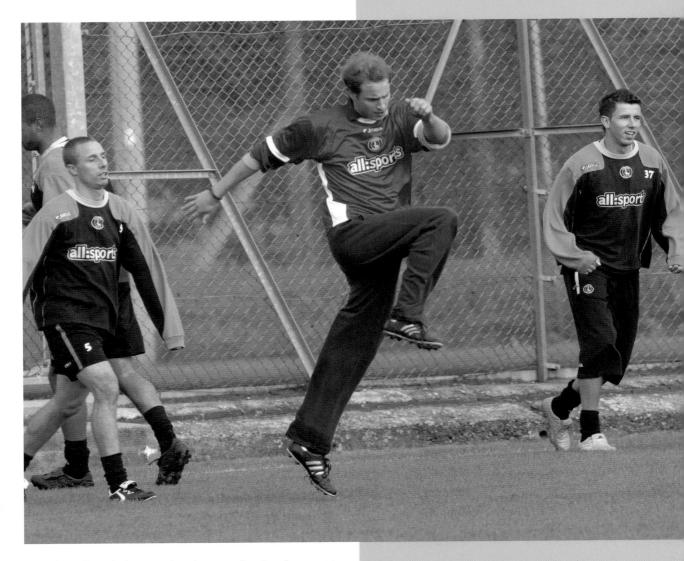

William thought he was already pretty fit when he went to train for the day with the Charlton Athletic football team in 2005. But afterwards he said, 'By God, I'm knackered.' He was breathing heavily and sweating profusely, but the Charlton pros looked like they'd been for a stroll. Still, at least William put 100 per cent effort in. Prince William loves football. Here he is as a toddler playing with his father in the grounds of Kensington Palace in 1984. Although he played rugby at Eton, he plays football for the Buckingham Palace household in the annual Christmas match against the Sandringham staff. He is also patron of the FA, which, he once told me, gets him free World Cup tickets!

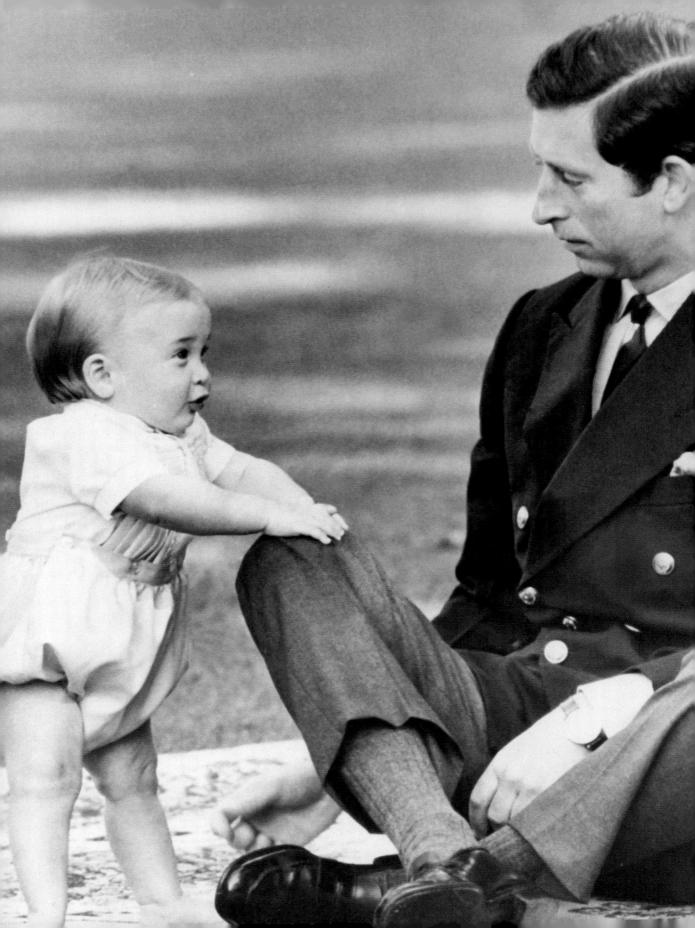

PRINCE WILLIAM

Two pals together on the lawn of Government House in Auckland, New Zealand, in 1983. Charles watches William stand, holding on to his leg. In those days Charles was never relaxed in public with his kids. It gave him a very reserved image, which was unfortunate because behind the scenes he was always a loving, warm parent. Charles's main job in life is to mould William into a good King and he's doing a brilliant job. Of course, back in 1983 William had no idea of his destiny. When I went back to Auckland with him in 2005, I showed him the spot where I photographed him publicly standing and crawling for the first time. He told me that officials had kept a little toy he played with in 1983 and put it in his bedroom 22 years later.

CHAPTER FOUR

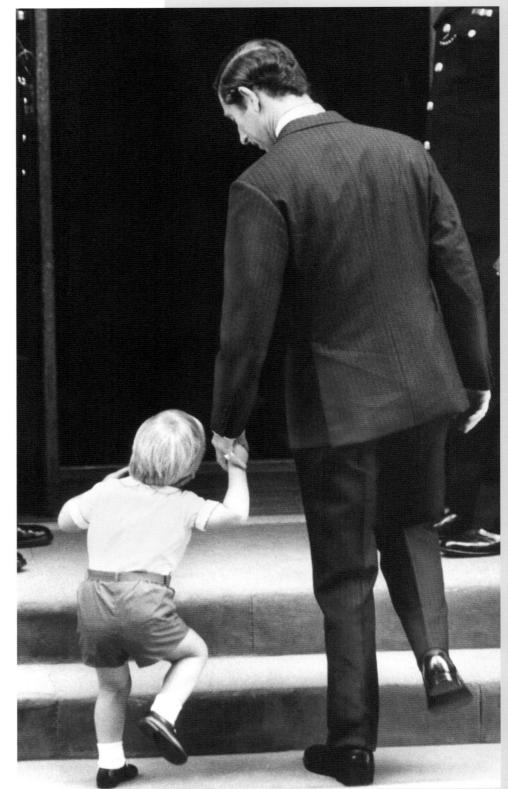

Charles and William were the first visitors after Prince Harry was born at St Mary's Hospital, Paddington, in September 1984. The Palace announced his name that day: Prince Henry of Wales, to be known as Prince Harry.

PRINCE WILLIAM

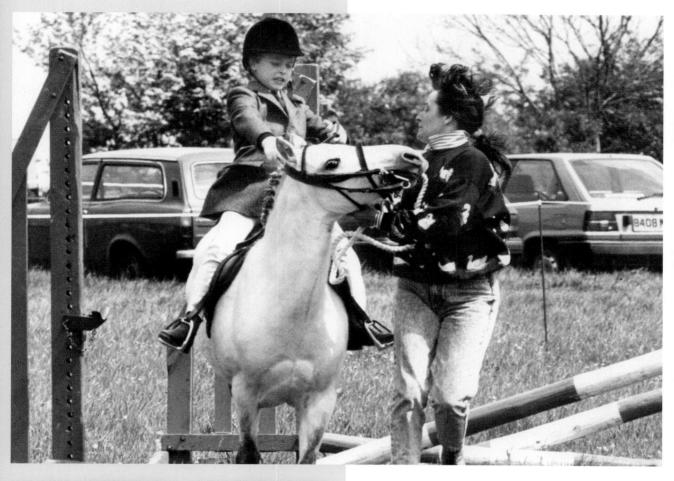

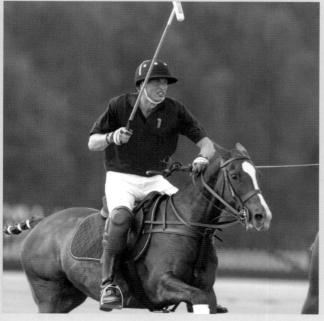

Above: These days William is an expert horseman, but in 1989 I photographed him at his first gymkhana at Ascot racecourse. Although he had the Queen's groom to help him over the fences, he was struggling to keep control of the pony.

Below: William is a great polo player, though he never takes the crazy chances Harry does. The brothers and their father briefly played in the same team but now Charles has given it up completely it's up to the boys to maintain the profile of the sport – first played by their grandfather Prince Philip. This photo is from 2005.

CHAPTER FOUR

William with Harry on Harry's first day at Wetherby School in Notting Hill, West London, in 1989. Harry was so proud to pose with his elder brother and mother. I wonder what he was carrying in his sack – it can't have been his lunch!

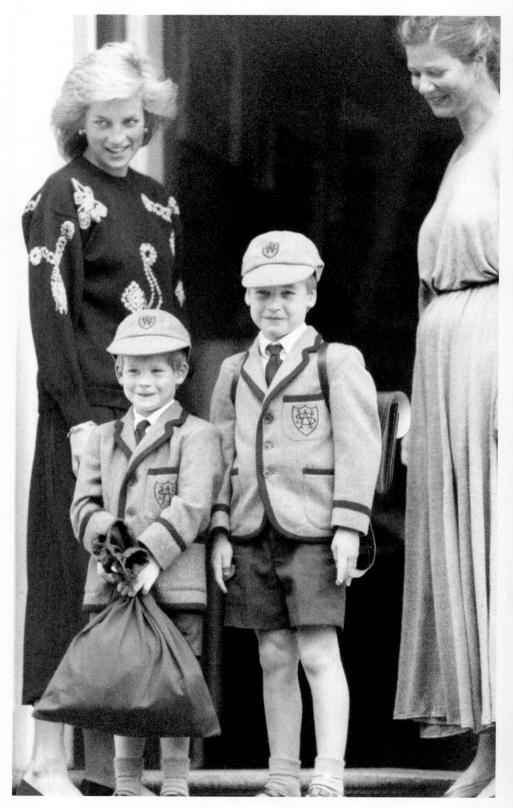

PRINCE WILLIAM

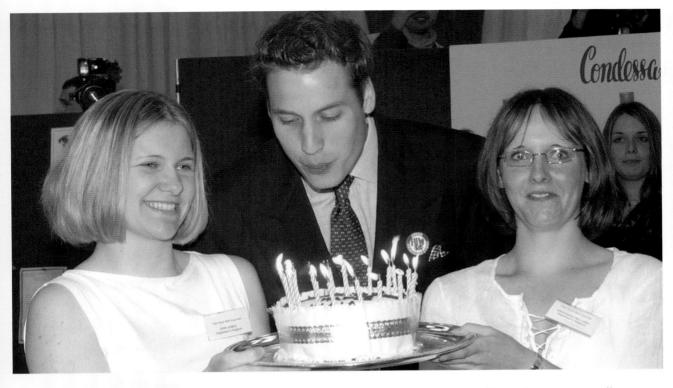

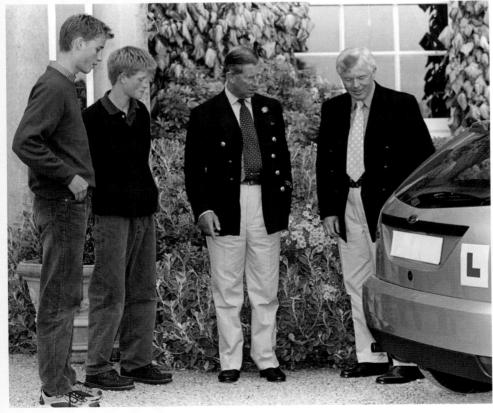

Above: Prince William blowing out the candles on his cake while celebrating his 21st birthday at a food fair in Anglesey, North Wales. He was touring this exhibition with his father Prince Charles, but all eyes were on William on this milestone day.

Below: William passed his driving test first time at 17. Here he is with Harry, Charles and the police driving instructor afterwards.

CHAPTER FOUR

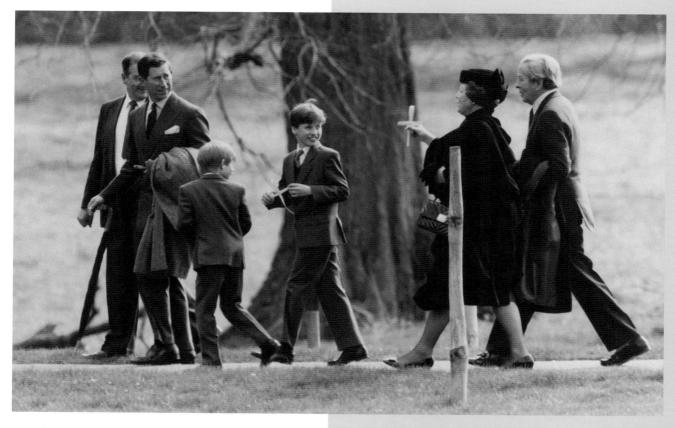

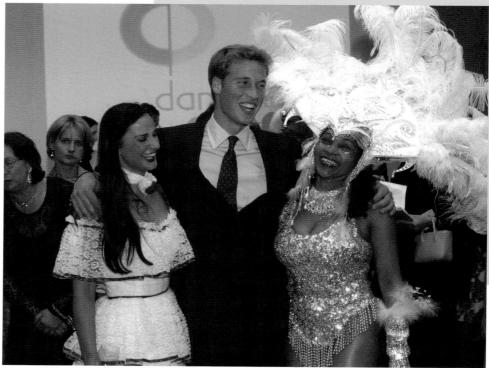

Above: A boy born to be King looks back and jokes with Queen Beatrix of the Netherlands while strolling back from church on the Sandringham estate, Norfolk, on Palm Sunday in 1992. Unlike any other tenyear-old boy in Britain, it did not faze William in the slightest to engage in casual banter with a monarch from another country.

Below: William attended a dance studio in Edinburgh with Prince Charles in September 2001, the day before he started at St Andrews University. I asked him to pose with these exotic dancers, so William hugged them and really made this picture work.

PRINCE WILLIAM

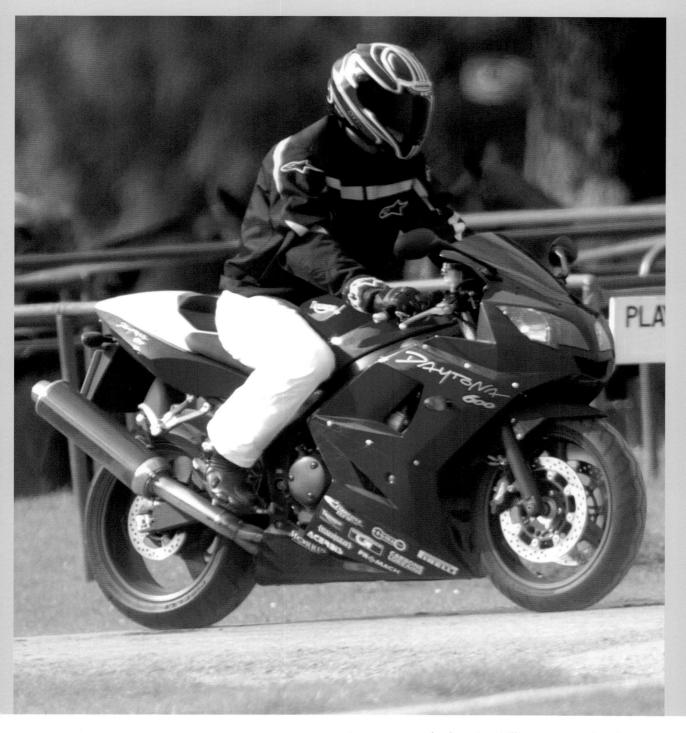

It scares me to death seeing William roar round on his powerful 600cc motorbike. I loathe those fast machines but he is apparently well trained. His policemen have had to be trained by the Metropolitan Police driving school to keep up with him. This picture is from 2005.

CHAPTER FOUR

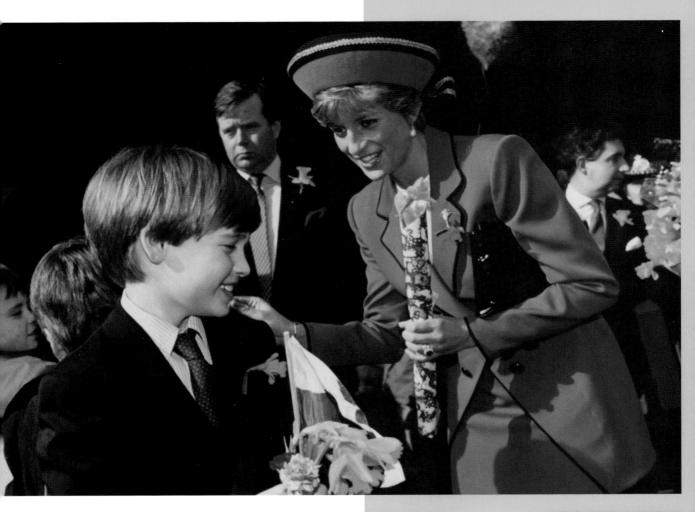

Above: Prince William's first official engagement was in Cardiff in 1991. Here he is on a walkabout, receiving flowers from well-wishers, and Diana is telling him what a brilliant job he's done. She was so proud of him. It was this day I discovered William was left-handed as he signed the visitors' book at the end of the day.

Below: William is a superstar – and heartthrob – all over the world. Until he's married he's also the world's most eligible bachelor! A student put this cheeky notice up in her window when the Queen visited a girls' college in Toronto, Canada, in 2005.

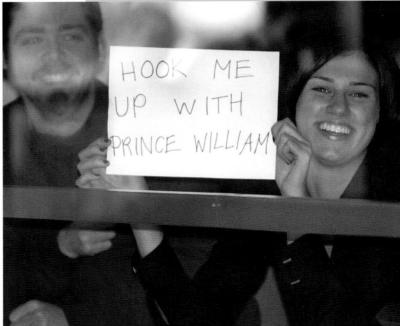

PRINCE WILLIAM

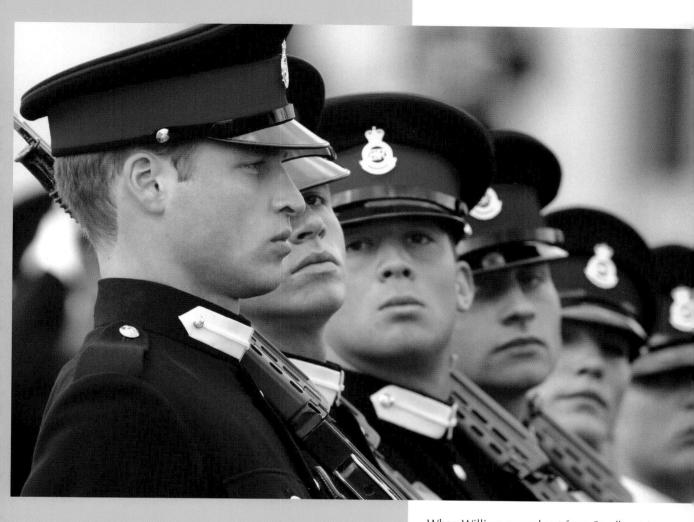

When William passed out from Sandhurst in December 2006 he fulfilled the first part of his plan after university. As Prince of Wales he will one day be Colonel in Chief of many regiments, and as King he will be the head of the armed forces, so he will have to have served somewhere to feel comfortable in that role. His grandmother, the Queen, was in the Army during World War Two and his father Charles captained his own ship in the Royal Navy.

CHAPTER FOUR

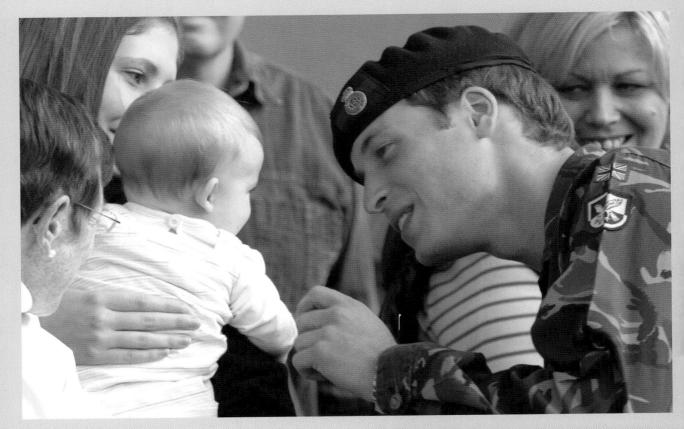

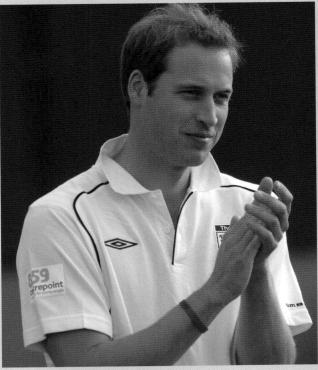

Above: I was reminded of his mother Diana when I saw William's tenderness with this baby at the Faslane naval base in Scotland in October 2007. He leant forward and stroked the girl's cheek with his forefinger, just as his mother might have done. I had an action shot of William from the same visit, but a moment of true tenderness like this will trump that any day of the week.

Below: This is one of the luckiest pictures I've taken. It's a fairly routine shot from February 2008 of William applauding young players at a football training session in Newcastle. The next day I was asked, 'Did you get him with his Help For Heroes wristband?' Fortunately I was able to say Yes. He, like Harry, has been keen to support this fantastic charity for injured servicemen.

PRINCE WILLIAM

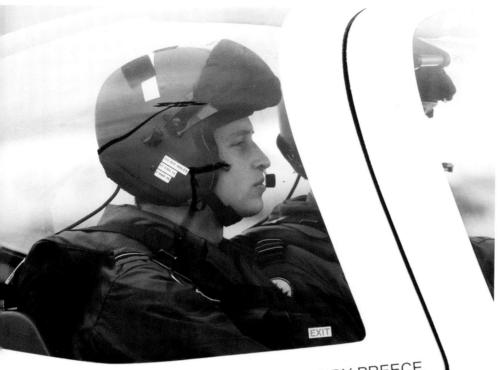

DISPLAY PILOT - FLT LT ANDY PREECE

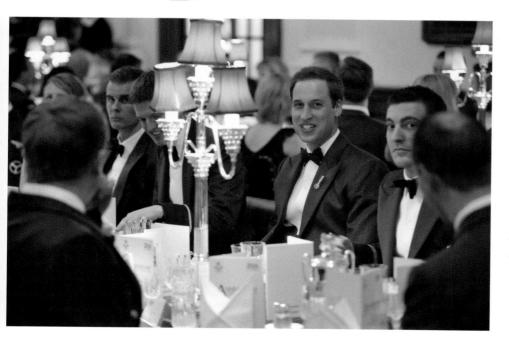

Above: Part of William's training to be King is to serve in the Army, Navy and RAF. One day he'll be their commander in chief. William earned his wings and flew solo in record time after an intensive 12-week course. In January 2008, he flew for the Press at RAF Cranwell, Lincolnshire, where he later received his wings from his very proud father.

Below: I'm very proud of this picture from 11 April, 2008. It was at the 90th anniversary dinner at RAF Cranwell. Charles and Camilla were guests of honour, but William was way down the end of the table. As I left, I said 'William' and he looked over, gave me a magnificent smile and I took what I think is a lovely picture of him among his fellow students. It may well be that when the base celebrates its centenary, William will be guest of honour at the top table. Here he was just another guest.

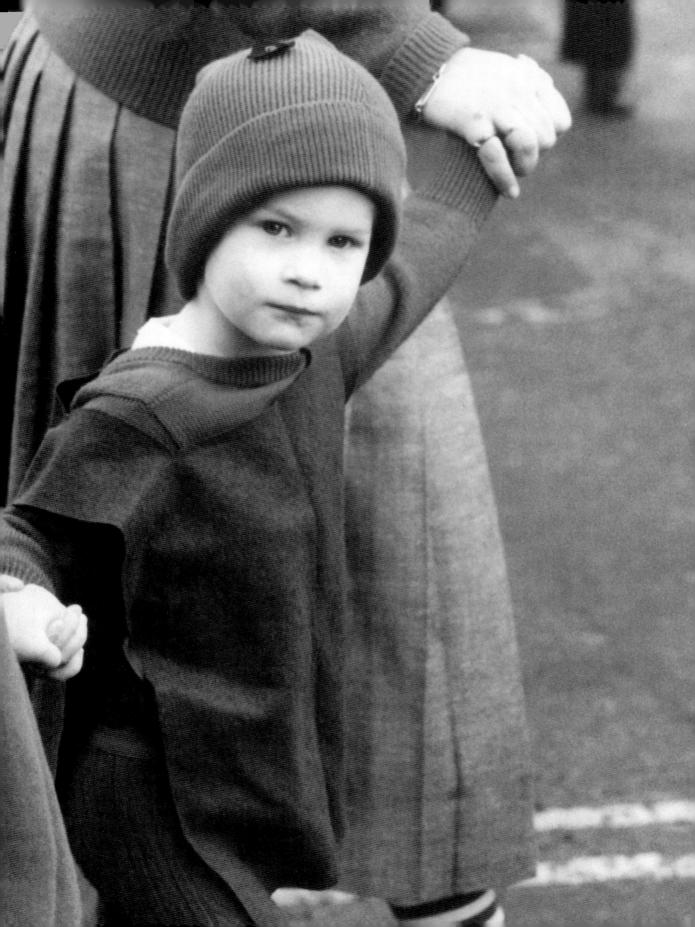

CHAPTER FIVE Prince Harry

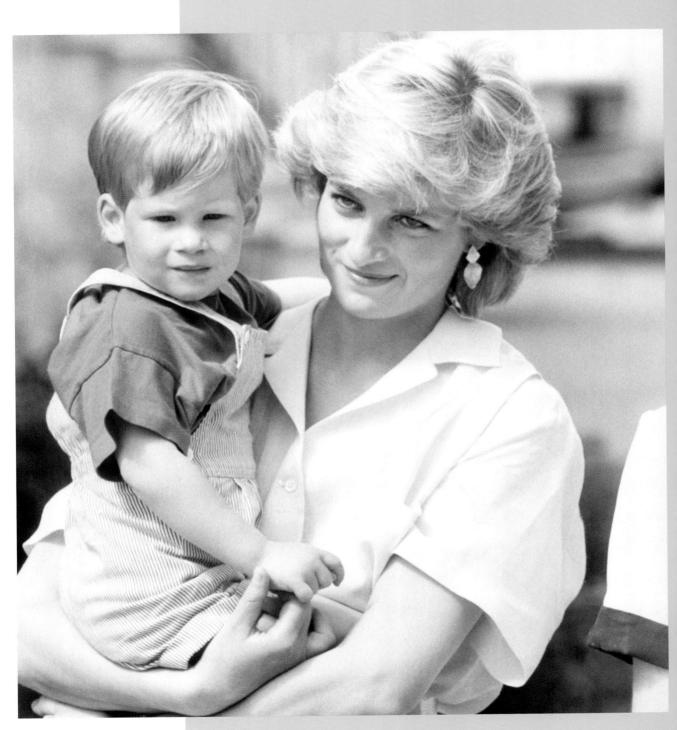

Princess Diana took young son Harry to watch Prince Charles play polo in Windsor in 1987. Harry went on to become a very good polo player himself.

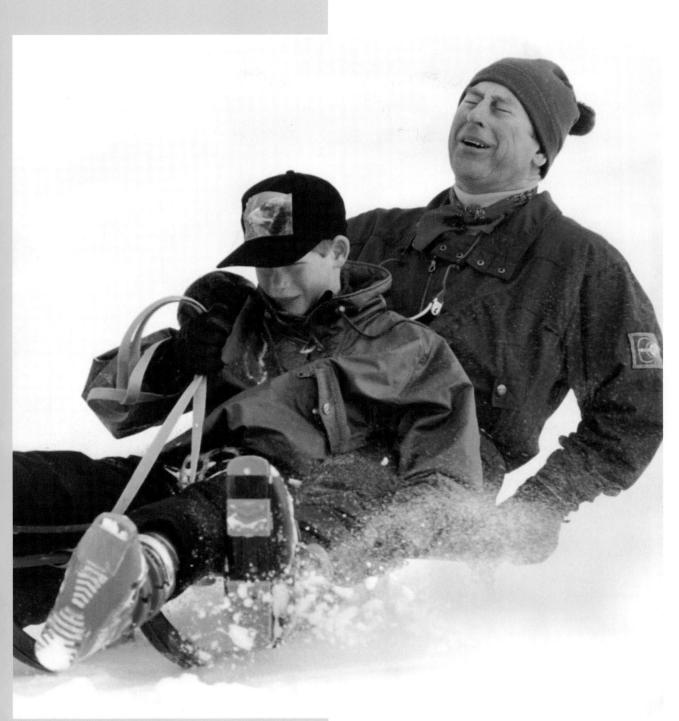

I think Prince Charles always regretted giving the newspaper photographers this photocall in 1997 while he was sledging in Klosters, the Swiss ski resort, with his young son Harry. Just before the pair came to a halt, the sledge hit a chunk of ice and the Prince, who has a well-documented bad back, was in agony. I think it will be the last time he does that!

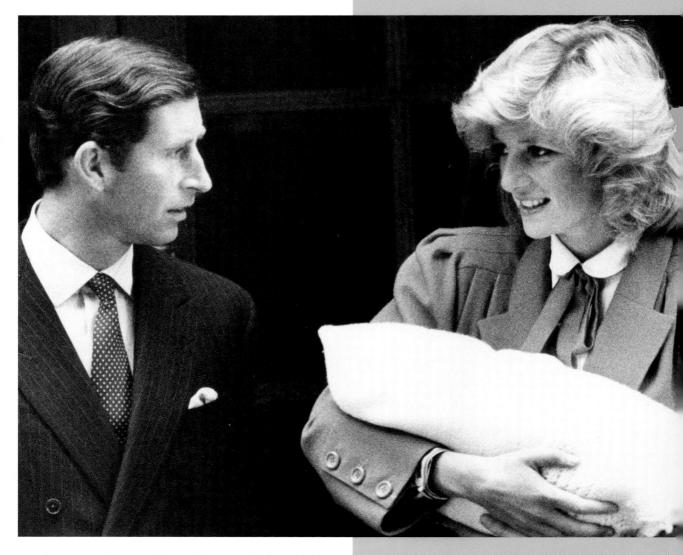

A moment of history. Prince Charles and Princess Diana leave St Mary's Hospital, Paddington, with Prince Harry in September 1984, two days after he was born.

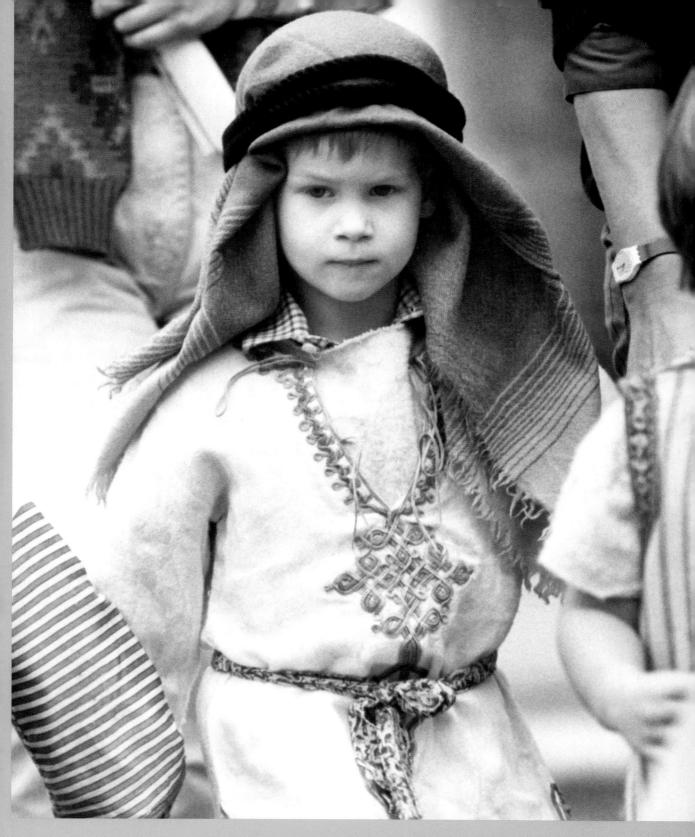

Harry dressed as a shepherd for a nativity play at his kindergarten in Notting Hill in 1988. He doesn't look too happy with his casting! Harry today is a fearless horseman who rides his polo ponies flat out. But everyone has to learn and here he is in 1989 at a pony club event, looking less than confident.

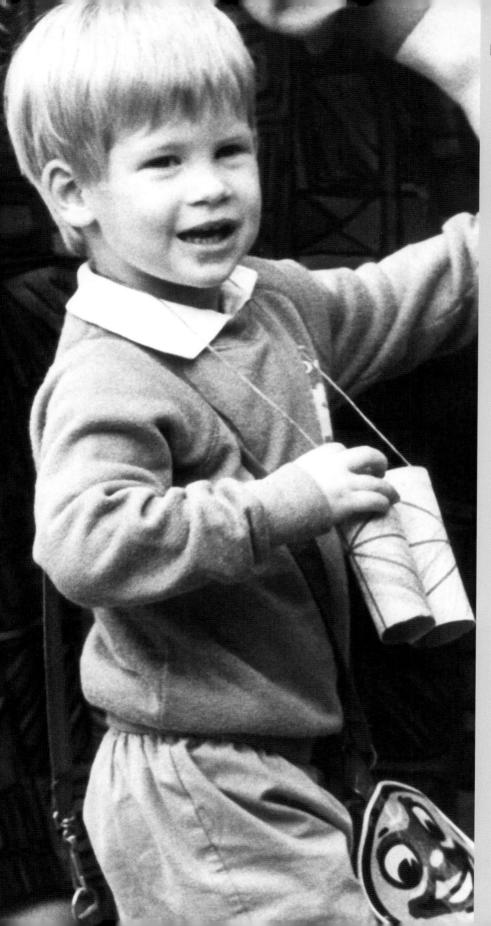

A big smile from Harry as he leaves nursery school in 1987 with a pair of binoculars he made in the classroom.

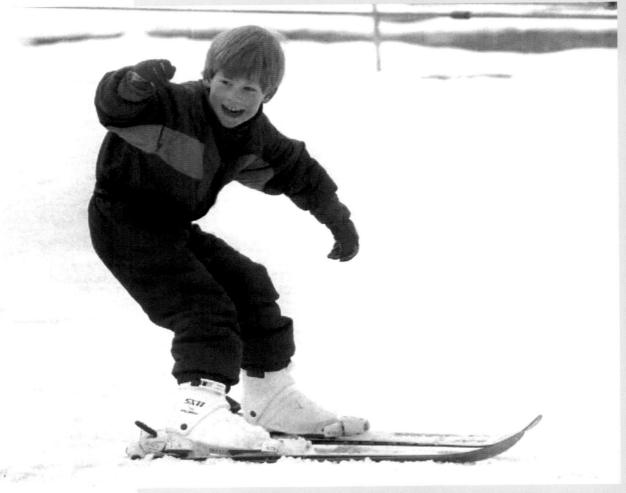

Above: What a great day this was. It was the day Harry learned to ski in 1991. The young Prince took to the slopes in Lech, Austria, like a duck to water – although William struggled. Within 20 minutes Harry was skiing on his own and the instructor told me later, '1 had to hold on to him. He knows no fear.'

Below: Showing his usual daredevil nature over anything sporting, here is Harry on a jet ski in St Tropez, South of France, in 1997.

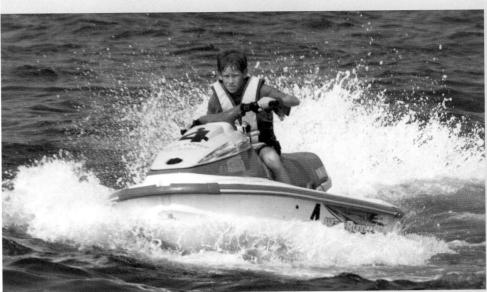

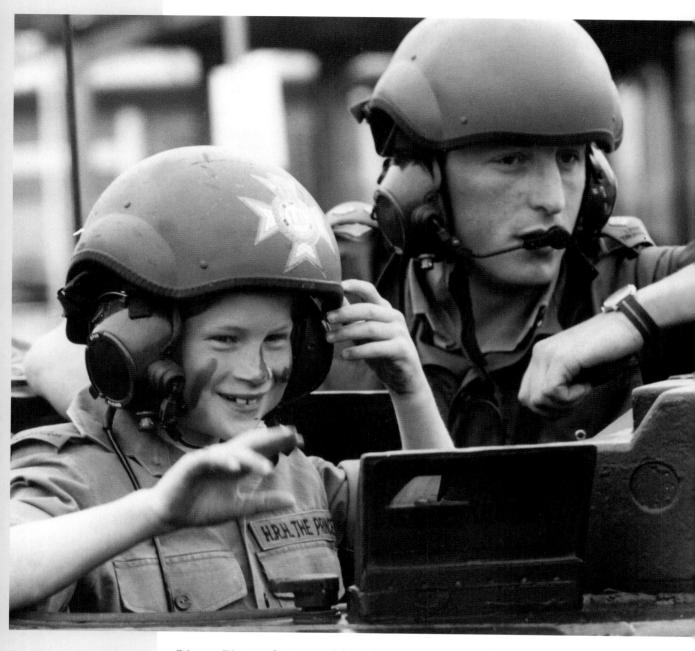

Princess Diana took Harry with her when she visited our soldiers in Germany in August 1993. Even at that young age he was dead keen to join the Army. Here he is in a Scimitar armoured vehicle. Later he would command one of his own in the Blues and Royals.

Harry's first day at Wetherby, after leaving his London nursery school. This is him meeting his new headmistress Fredrika Blair-Turner in September 1989.

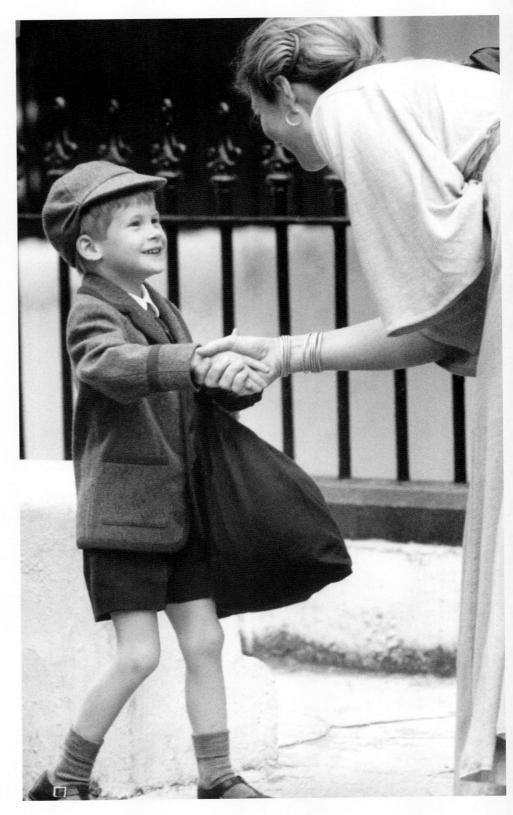

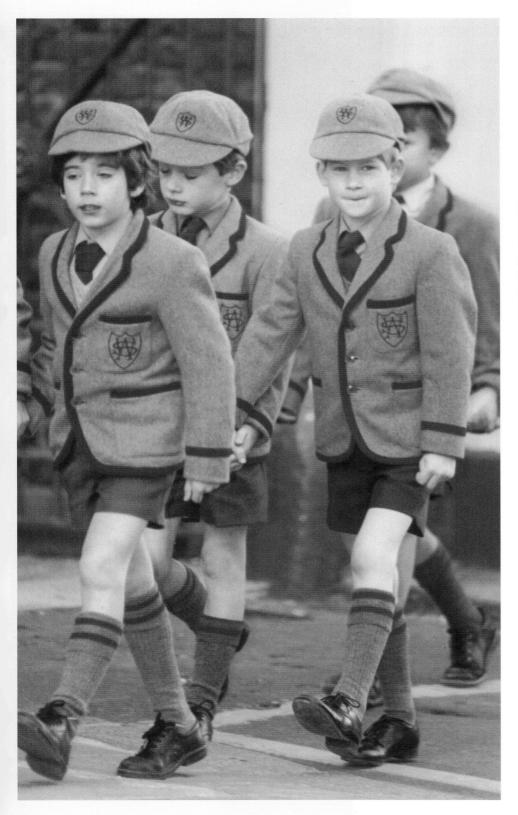

Harry at Wetherby School in Notting Hill, West London, in 1991. His brother William was two years ahead of him there. Harry then followed William to Ludgrove School, near Wokingham, Berkshire, and later, of course, to Eton.

Harry looks dashing in his pinstripe trousers and Eton tails on his first day at the top public school in 1998. He excelled at sport there, but academically he wasn't, shall we say, in the top ten.

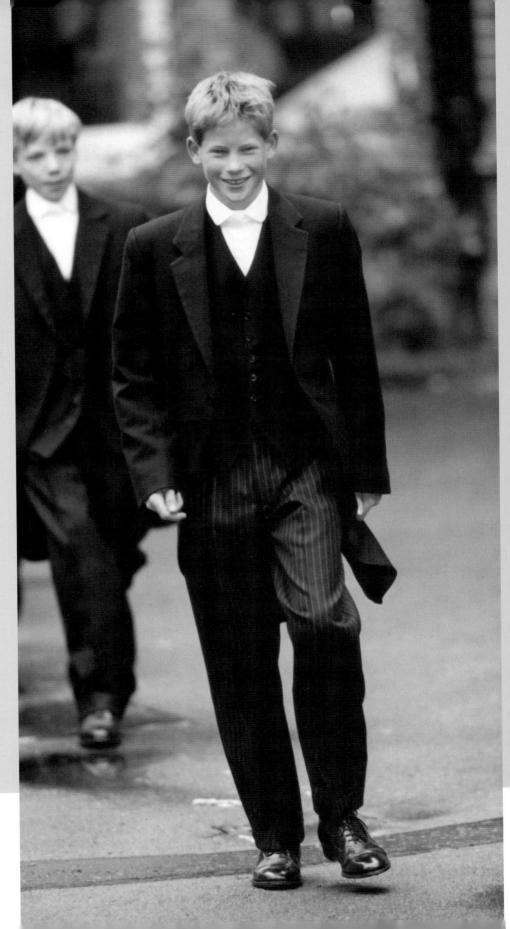

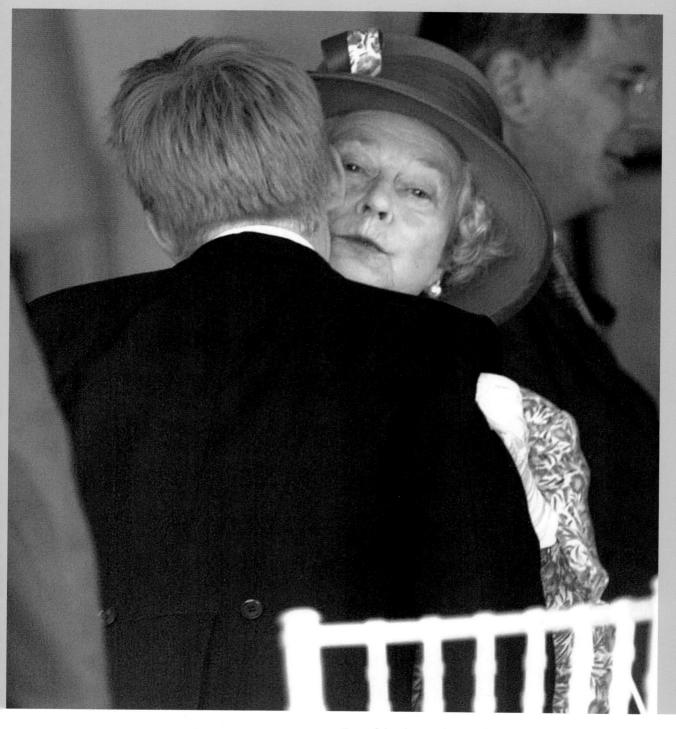

One of the duties of senior boys at Eton is to give a tea party for the Queen and members of the Royal Family at the Guards Polo Club during Ascot week. Here is Harry in 1999, giving his grandmother a lovely kiss on the cheek before he served her tea and scones.

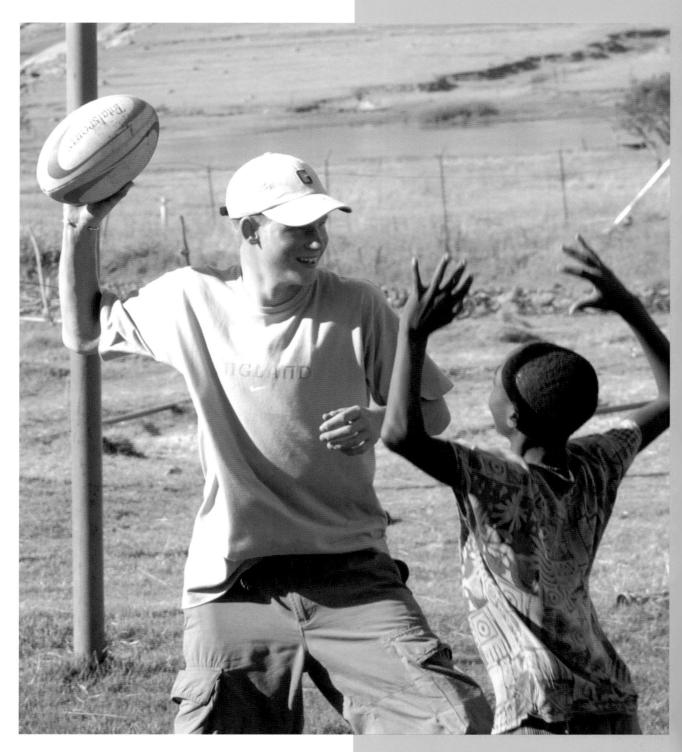

Prince Harry went to work with underprivileged children in Lesotho, Africa, in 2004. He helped build fences and taught young people gardening. Here he is teaching a young girl how to play rugby.

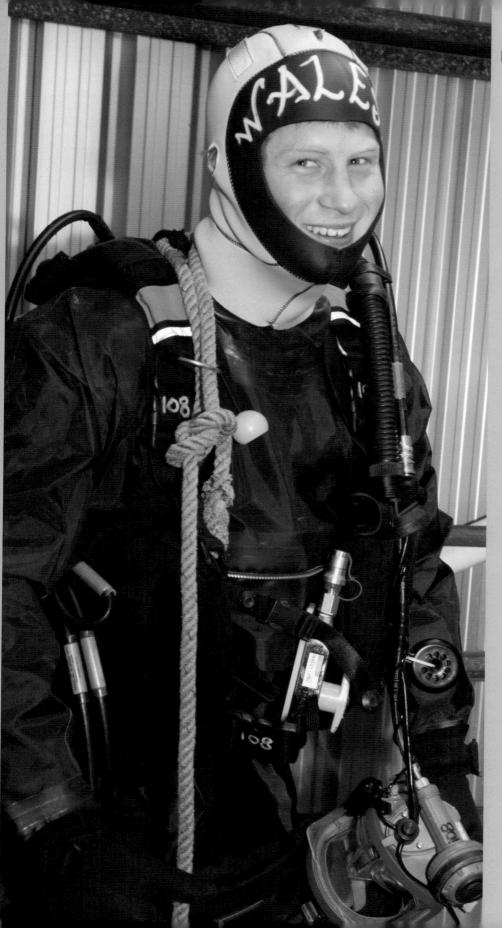

Harry is Commodore in Chief of the Royal Navy diving school at Horsea Island near Portsmouth. In this picture from November 2007, they'd fitted him with a personalised diving suit with Wales across the forehead. I said, 'Harry, let me see!' He turned round grinning, knowing I was only interested in the words emblazoned on his forehead.

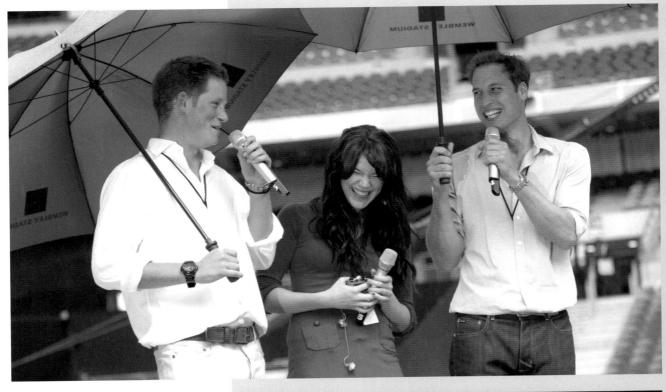

Above: The Wembley Stadium concert for the tenth anniversary of Diana's death was Harry and William's idea. Among the stars was the gorgeous singer Joss Stone. She apparently never wears shoes and the Princes tried to keep her dry as well as themselves during the photocall the day before the concert. Harry looks like he is accompanying her, too – and with mixed results. Don't give up your day job, Harry!

Below: This means a lot to me. The age-old gossip about Harry looking enough like Diana's one-time boyfriend James Hewitt to be his son is often put to me. It's absolute rubbish. For starters, Diana didn't meet Hewitt until Harry was two. And when you see his first cousin, Diana's sister Sarah's son George, you realise how that look runs in their family. If George, who teaches sport in South Africa, lost three stone he'd be Harry's double. This was at the memorial service for Diana on 31 August, 2007, at the Guards Chapel in London.

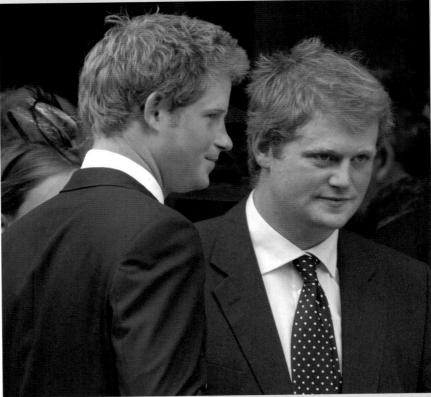

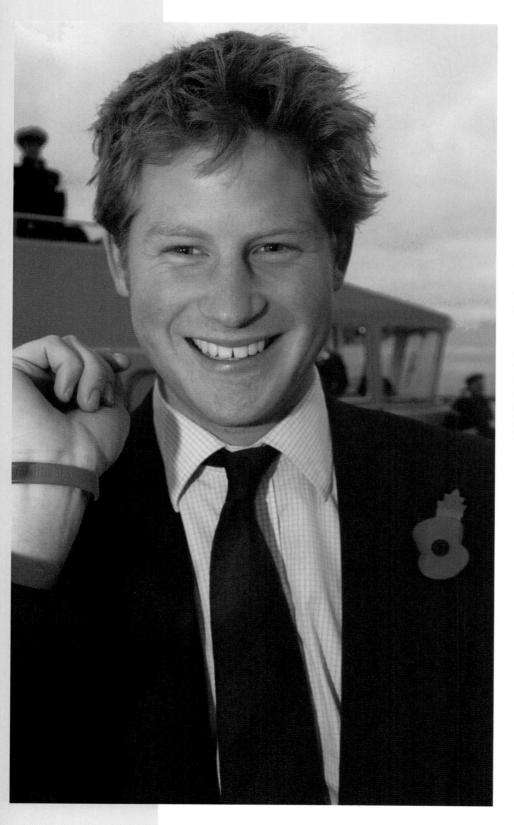

The Sun has been heavily involved in the Help For Heroes campaign on behalf of our injured soldiers from the wars in Iraq and Afghanistan. Harry was only too pleased to lend his support. In Portsmouth in November 2007 I handed him the charity's wristband and he said, 'What do you want me to do, Arthur?' I said, 'Put it on, Harry, and show the readers.' He was delighted to oblige. He himself served in Afghanistan in 2008, of course.

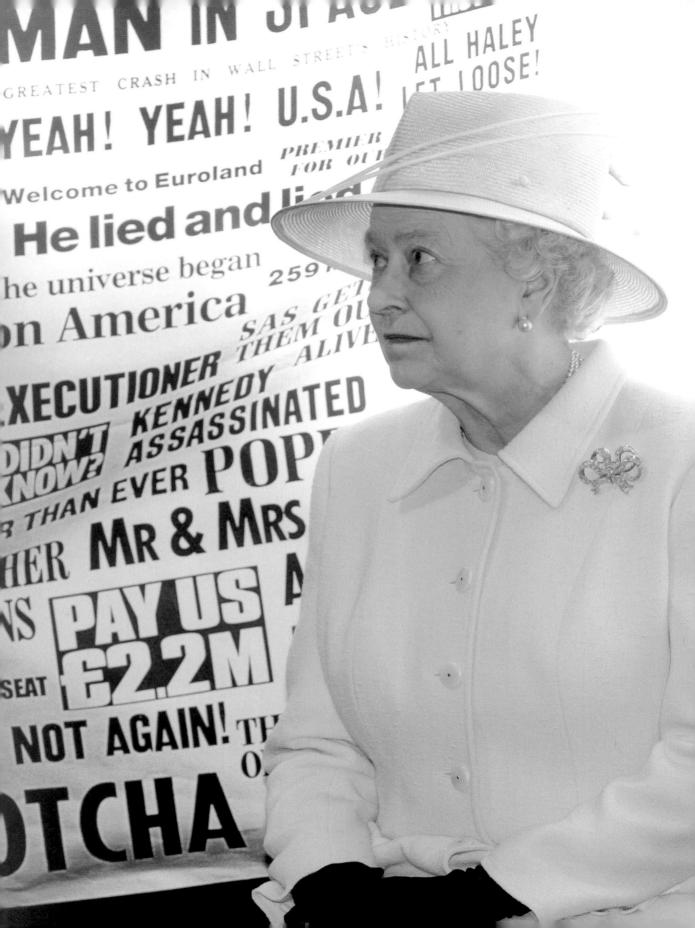

CHAPTER SIX The Queen

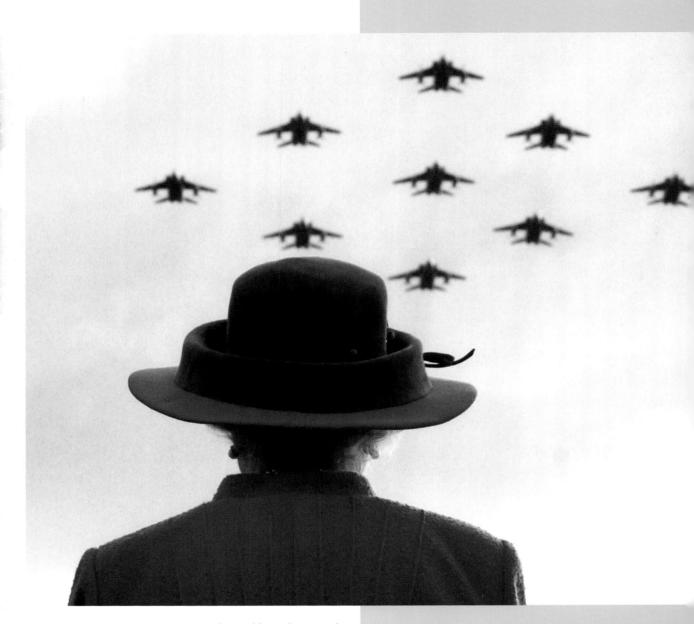

I got an interesting picture in the end here, but it took some imagination. The Queen was watching a flypast of RAF Jaguars at RAF Coltishall, Norfolk, as the base marked its 65th birthday in 2006. I decided to photograph her from behind her head as she watched them – everyone would know it was her after all. I only had one chance – but thankfully I had watched the rehearsal and knew exactly where she would stand.

THE QUEEN

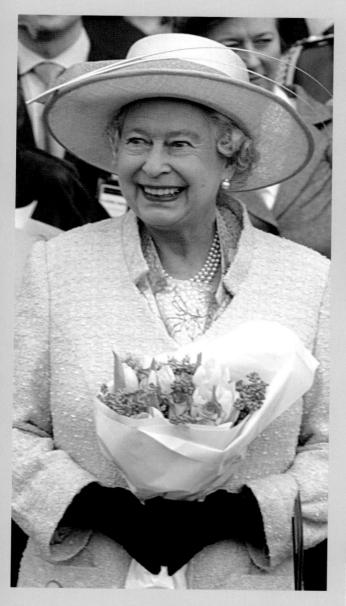

The Queen, leaving the Louvre museum, Paris, in 2003, is all smiles . . . until a paparazzi photographer runs in front of her, that is. Within seconds the smile turns to a scowl. When the Queen smiles she lights up a room. But, when things don't go according to plan, she puts on a look that can kill!

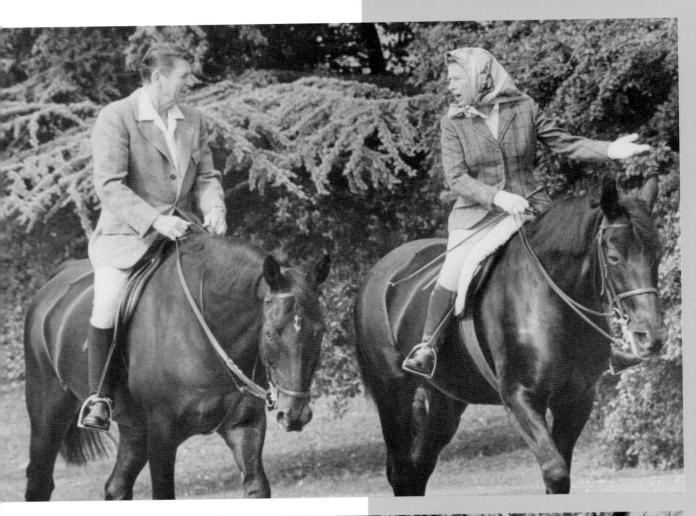

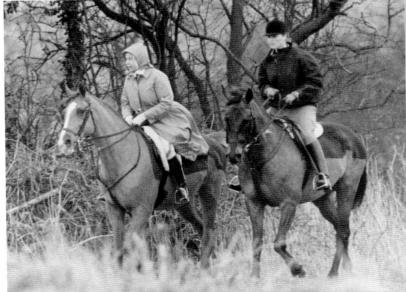

Above: Two great figures of modern history. President Reagan made a state visit to Britain in 1982 and stayed with the Queen at Windsor Castle. For the photocall, they decided to take a horse ride around the Windsor estate.

Below: Even in her 80s, the Queen still rides at weekends in Windsor, Balmoral or Sandringham. Here she is back in 1987, riding through the woods on the Sandringham estate with the Duchess of York.

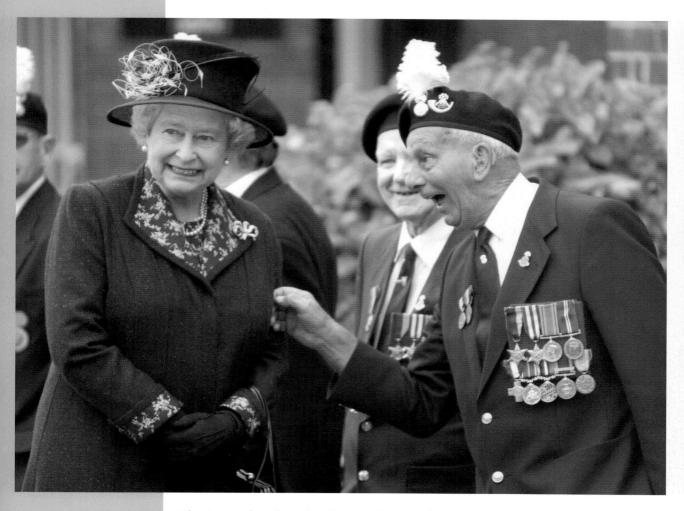

This is one of my favourite pictures. It happened in 2004 as the Queen visited an Army barracks in Wrexham, North Wales. She met Private John Bellis, an 87-year-old D-Day veteran, and he tapped her on the arm, indicated a large Army vehicle parked nearby and asked whether she'd be able to drive it. The Queen had spent two years as an Army driver during the war, but she laughed and said, 'They were a bit smaller than that!' I love the expression on John's face, the beautiful array of his medals and the fact he is touching the Queen's arm.

CHAPTER SIX

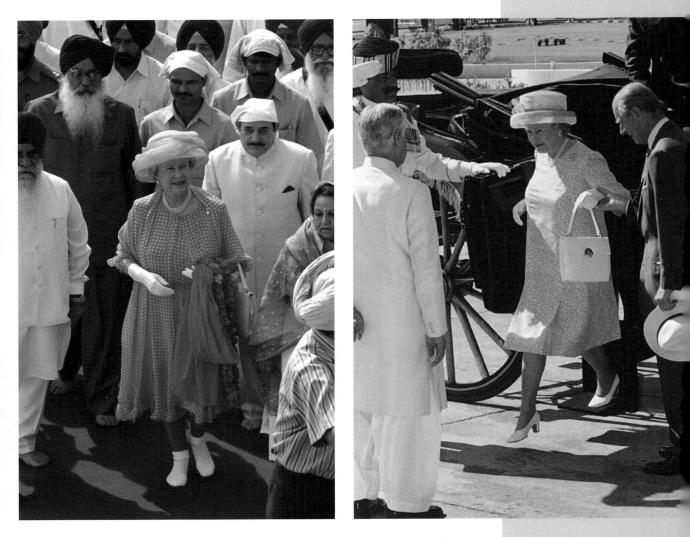

Above left: The Queen was wearing a pair of pristine white socks when she visited the Golden Temple of Amritsar in 1997 – we saw them when she had to remove her shoes at the Sikh holy shrine.

Above right: The Duke of Edinburgh helps his wife from their carriage at Parliament House in Islamabad, Pakistan, in 1997. The Queen made a speech there, during which she claimed she was a little too old for computers.

THE QUEEN

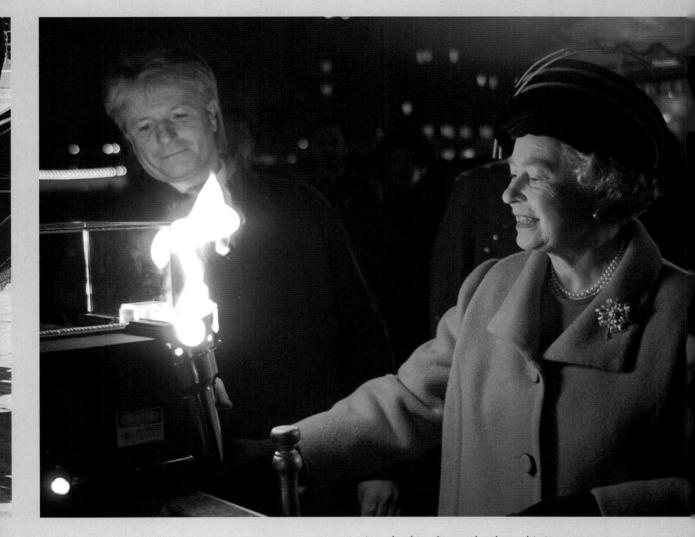

A triumph of modern technology, this image. The Queen was lighting the Millennium Flame on a boat travelling down the Thames on New Year's Eve 1999. I took a risk and photographed it solely using the light from the flame. I was able to send the picture via my mobile phone from the boat to The *Sun*'s office to make the late editions of the paper on 1 January 2000.

SHARP

RECHANDING NO

UNITED MACHESTER

The Queen, touring Malaysia in 1998, signed a football for the Manchester United supporters club in Kuala Lumpur.

THE QUEEN

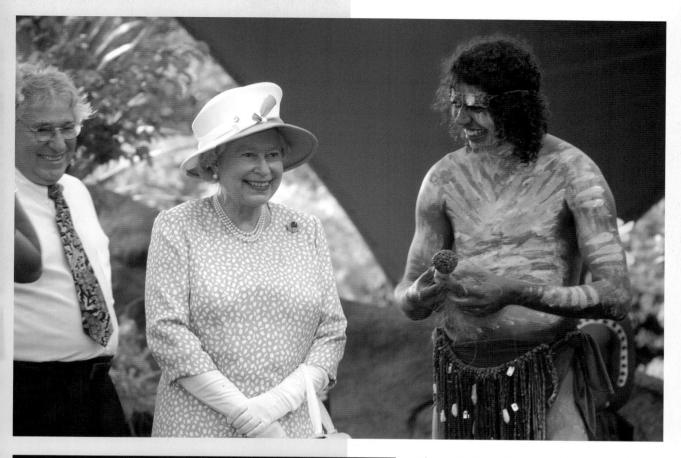

Above: Posing with an aborigine dancer in Australia in 2004. The Queen had seen the dancers performing in Cairns, Queensland.

Below: The Queen toasts the Duke of Edinburgh with champagne on the stroke of midnight on Millennium night at the Dome. In the background are Cherie and Tony Blair and their son Euan.

CHAPTER SIX

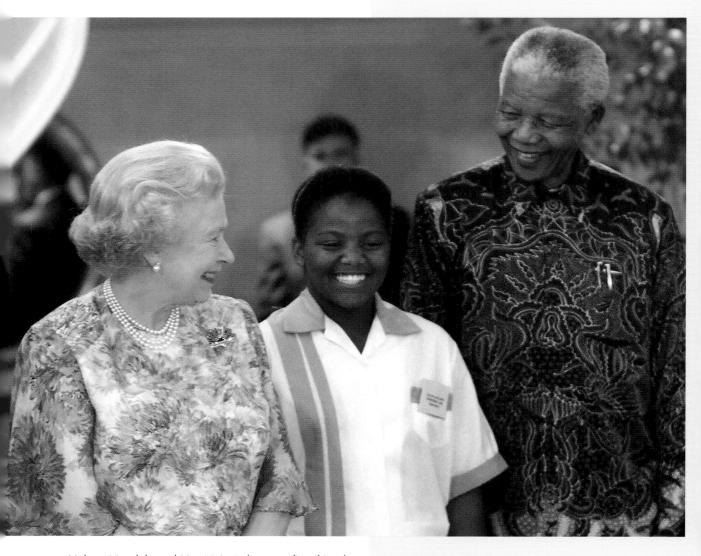

Nelson Mandela and Her Majesty became firm friends during the 1990s after his release from prison. Here they pose with schoolgirl essay winner Chantel Malambo, 15, in Pretoria, South Africa, in 1999. One of the problems with photographing Mr Mandela is that you cannot use flash – his eyes were too badly damaged during his 27-year incarceration and they cannot cope with it.

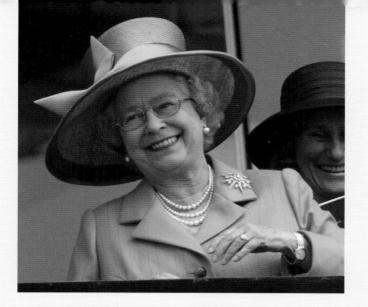

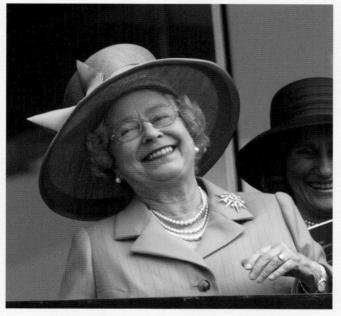

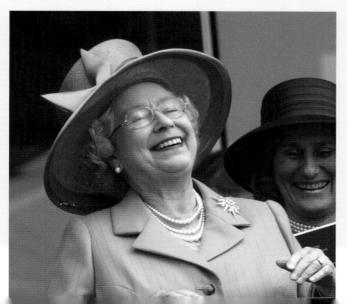

Some of the happiest pictures of the Queen I have taken have been at the Derby, and even though it has moved from Wednesday to Saturday, not normally a working day at the Sun, I still go. The Queen seems to get so wrapped up in the racing and her guests that she seems unaware thousands of racegoers are watching her. I don't know what she found funny in this picture from 2004, but it made her laugh out loud.

Above: The Queen cheering home her horse back in 1991. What makes this picture different is the film cameraman in the background. He was there because she was making a film of her 40 years on the throne. I later learned that they recorded what she was saying by planting microphones among the geraniums.

Below: Her Majesty again, cheering on the horse she picked out in the sweepstake in 1989. Her private secretary Sir William Heseltine looks like he had a few quid on it too.

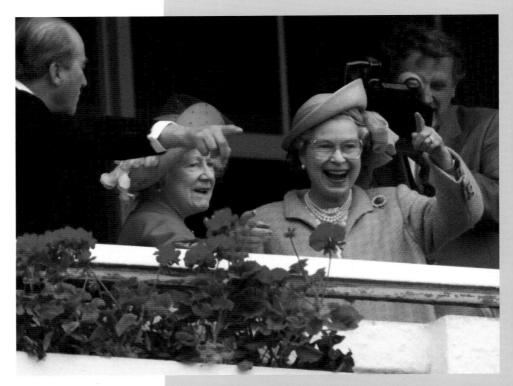

She's obviously backed another winner in this picture from 1980, and doesn't care who knows it!

Using a walking stick after her knee operation in 2003, the Queen arrives to open new ornamental gates at Sandringham.

Princess Margaret using a walking stick and with a bandaged right foot at Clarence House on the Queen Mother's 99th birthday in 1999.

One of my earliest pictures of the Queen out riding, this was taken in 1978 at Sandringham. Princess Anne was with her, both refusing to wear riding helmets.

This shot from 1983 always looks to me as though Princess Anne is suggesting a horse for her mother to back, but the Queen, from the dismissive wave of her left hand, has got eyes for another runner.

Above: On the balcony at Buckingham Palace waving to the crowd below, Jubilee 2002.

Opposite: The Queen laughs out loud as a young boy, having just presented her with flowers outside Sandringham Church, Norfolk, on Christmas Day 2007, walks away with a clown's hat emblazoned with the Union flag.

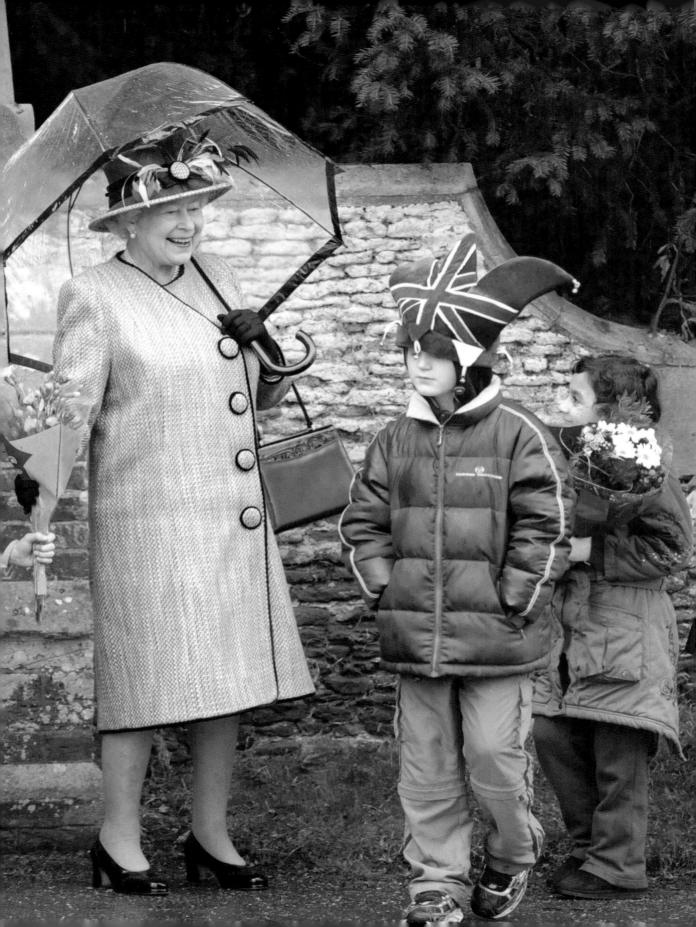

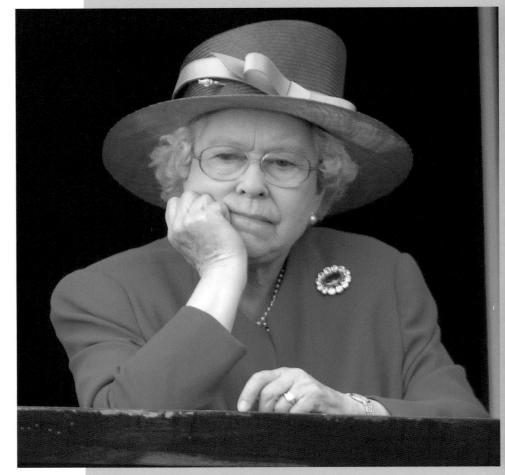

Right Just like anyone else, the Queen can have a bad day at the races. Here she is at Epsom in 2007, gazing glumly down from the Royal Box. A keen racehorse owner herself, one of her great ambitions is to see one of her horses take the top prize in flat racing.

Opposite: This is my favourite Derby picture, taken in 2005. The Queen was in the most beautiful green outfit and something made her smile. She looks so very, very happy.

144

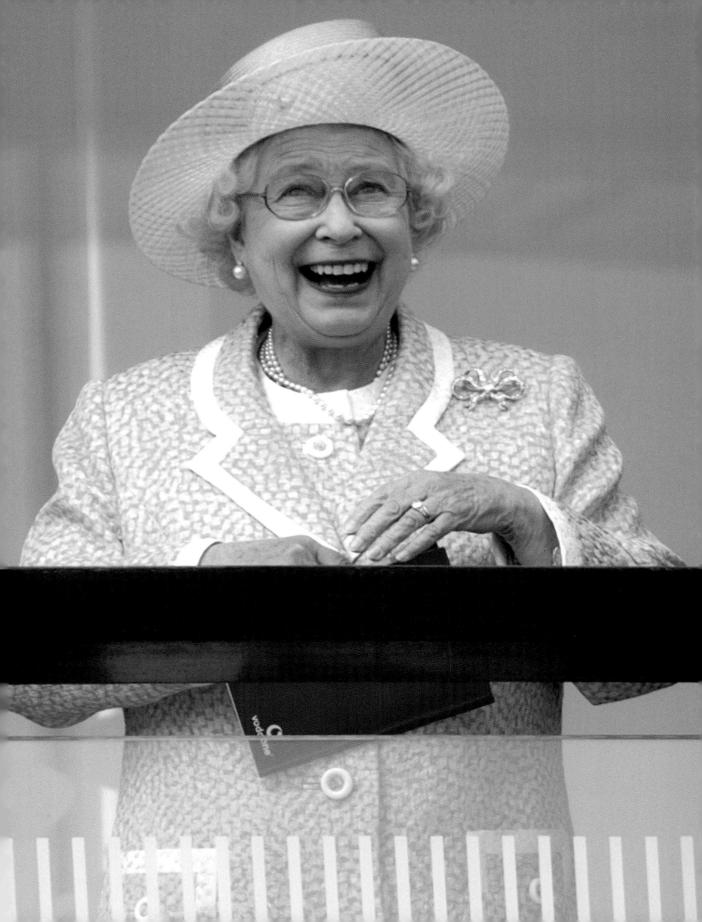

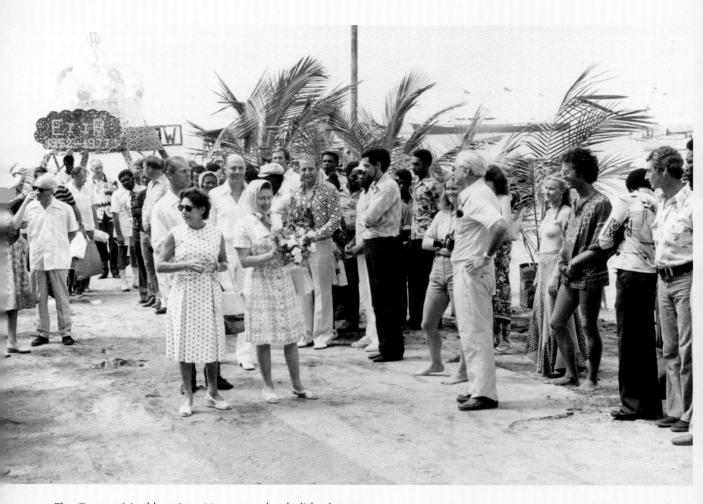

The Queen visited her sister Margaret at her holiday home on Mustique when the Royal Yacht pulled into the tiny private island in the Caribbean in 1977. Later the Queen and Prince Philip went to the local hotel and danced the night away.

Above: The Royal couple on the island of Sark during a state visit to the Channel Islands in 1995.

Below: This was a first. The Queen threw in the puck to start an ice hockey match in Canada in 2005 between the San Jose Sharks and the Vancouver Canucks.

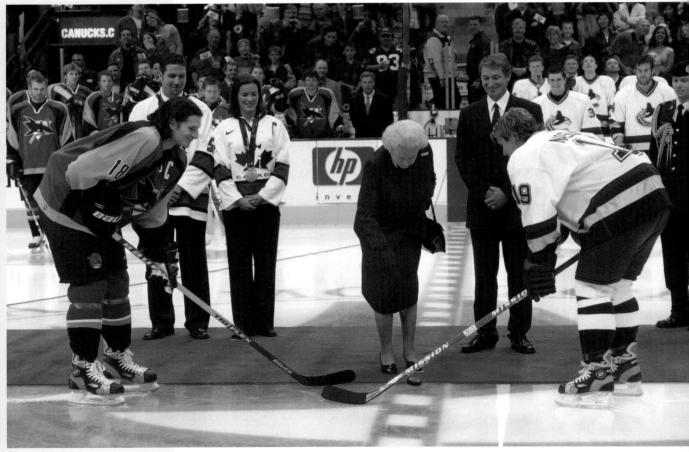

When the Queen is off duty she really lets her hair down. This was taken in 2004 in Windsor Great Park. She was in her casual country clothes as she watched her husband, the Duke of Edinburgh, compete in a carriagedriving dressage competition. He obviously made a mistake – and she's stifling a giggle.

Every year the Queen wears her crown as she opens Parliament. In all the years I have photographed the event I have never seen it slip once. This picture is from 2005.

As always when the Queen smiles, the picture bursts into life. This is at the European Institute of Design in Milan, Italy, in 2002. I think the Queen has an amazing complexion for a woman of her age. I don't know what face cream she uses but I wouldn't mind a bucket load myself!

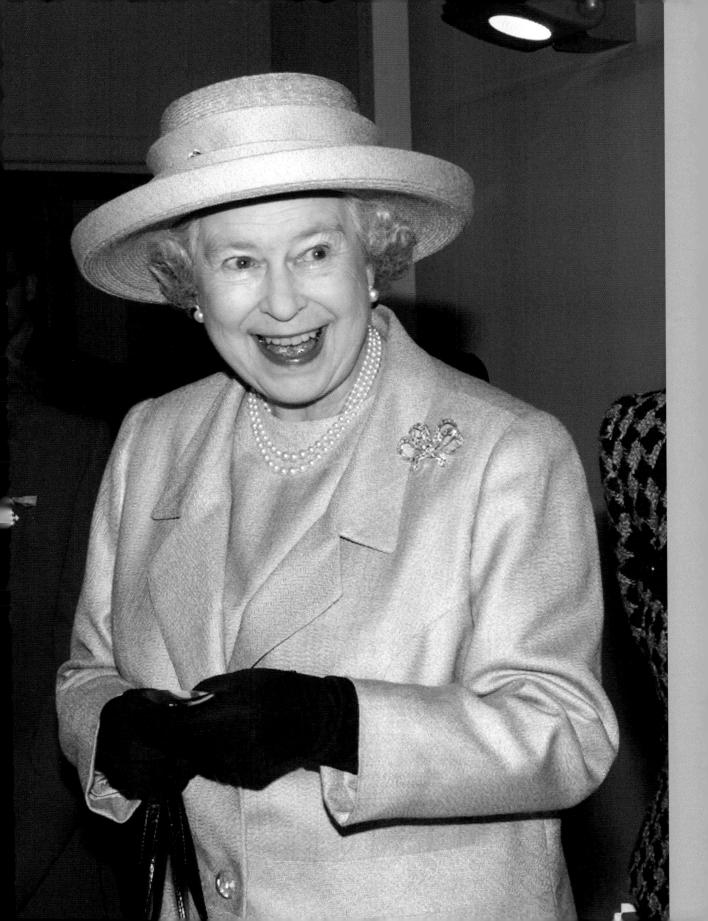

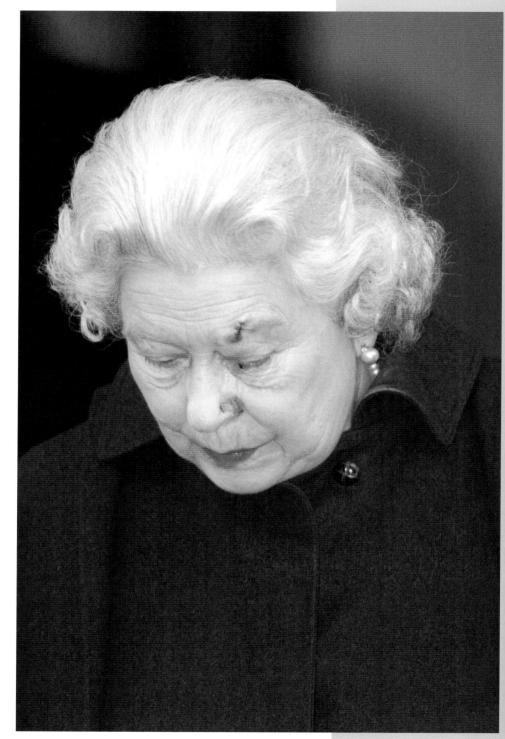

Here is the Queen leaving King Edward VII Hospital, West London, after an operation on her knee in 2003. While she was there they repaired some skin damage to her eye and nose. The picture of her stitched-up and bruised face was more important than the Queen walking with a stick.

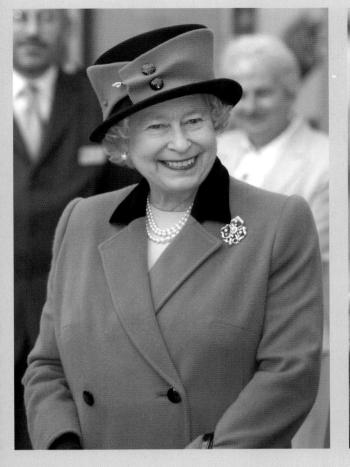

Above: Sheffield, 2005.

Above: Windsor horse show, 2004.

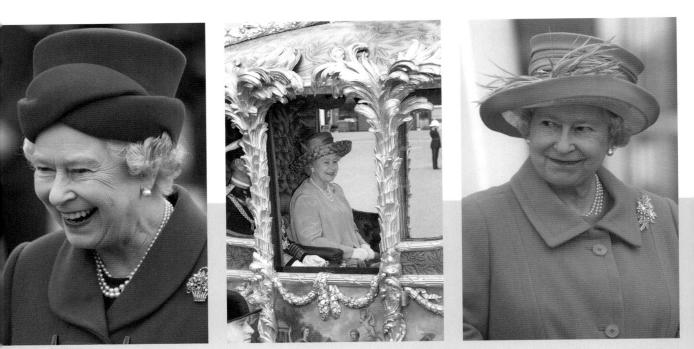

Clockwise from top left: Visiting the island of Skye on the Jubilee tour in 2002; in her gold state coach on Jubilee Day, 2002; at the Queen Elizabeth Hospital in King's Lynn, Norfolk, 2002; leaving Westminster Abbey after a service commemorating the 90th anniversary of the Gallipoli landings in 2005.

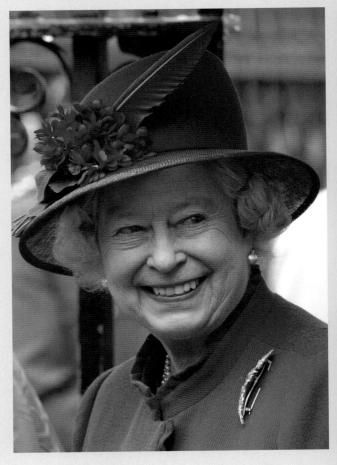

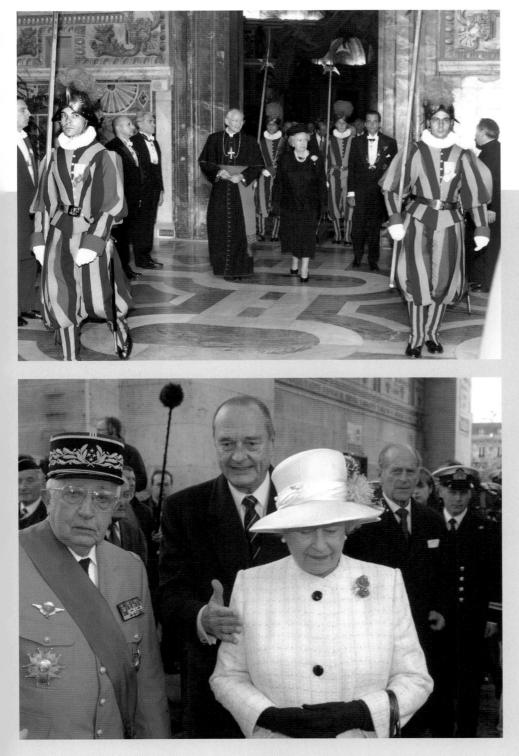

Above: Led by Vatican guardsmen, the Queen tours the Sistine Chapel on her visit to Rome in 2000.

Below: This was a slight breach of protocol by France's President Jacques Chirac. The Queen was visiting the grave of the Unknown Soldier at the Arc de Triomphe in Paris when the President tried to steer her in different direction by putting his hand on her arm. The Duke of Edinburgh did not look like he approved.

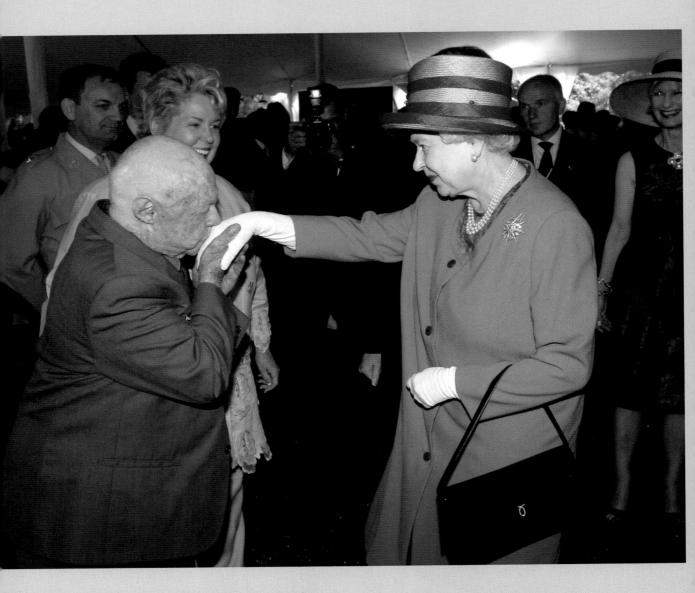

I always tell young photographers when they complain about a Royal reception or party being dull that there is no bigger A-list than the Queen or her family. Anything unusual will make a picture and a story. This was a run-of-the-mill garden party in Washington DC at the British embassy in May 2007. Screen legend Mickey Rooney, one of the few famous people shorter than the Queen, greeted her with a handshake and a kiss on her gloved hand. We used it in the paper the next day. Mickey wrote to me asking for a copy of the picture of the day he kissed the Queen of England's hand. Behind Mickey is Jan, his eighth wife.

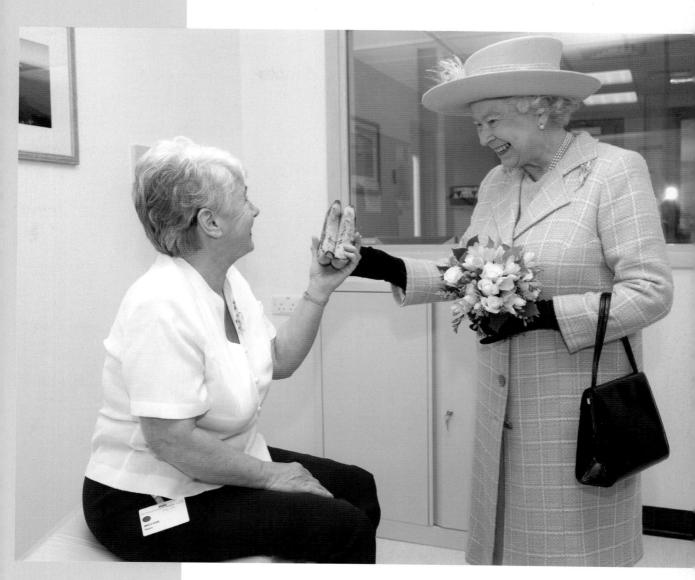

A great story, this. In 1943 Betty Hyde, then aged four, was recovering from shrapnel wounds from a German V2 rocket that fell on London. The Queen Mother turned up at the hospital and gave her two bananas from her daughters, one from Princess Elizabeth and the other from Princess Margaret. Bananas were very scarce during the war, so it was quite a gift. When the Queen visited the Queen Elizabeth hospital in Kings Lynn, Norfolk, in February 2008, Betty, now 69, returned the favour. I just wish they hadn't been past their sell-by date! The Queen accepted them graciously though.

One of my favourite pictures of the Queen, when she toured the McLaren racing team centre in Woking, Surrey, in 2004.

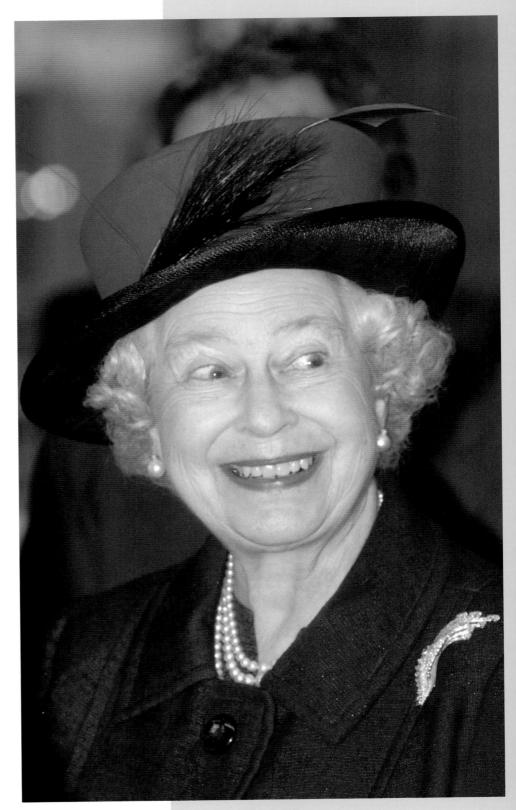

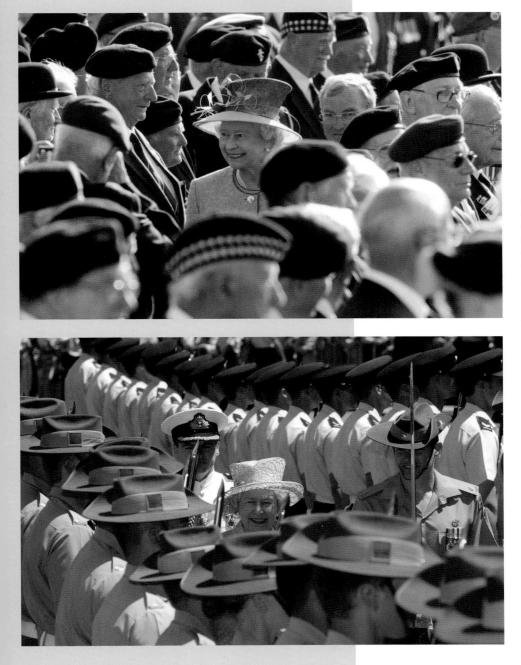

Above: The Queen visited Aramanche, on the beaches of Normandy, in 2004 and strolled among veterans who had been there 60 years earlier during the Dday landings. The band was playing wartime tunes like 'It's A Long Way To Tipperary'. The Queen was so happy to be among soldiers who gave our country such magnificent service.

Below: The Queen stands out among the ranks of Aussie soldiers, sailors and airmen who paraded for her in front of Government House in Adelaide on her visit to Australia in 2004. She wore an Aussie-style hat for the occasion.

CHAPTER SEVEN Prince Philip

CHAPTER SEVEN

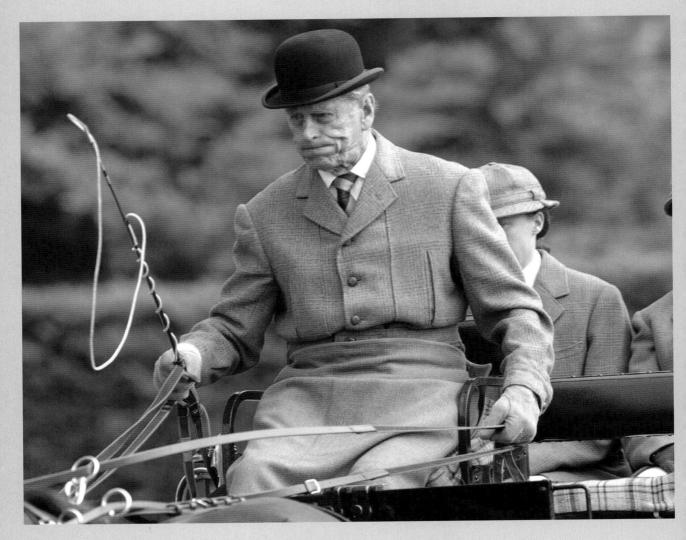

Determination is written all over the Duke of Edinburgh's face while competing in the carriage-driving dressage at Windsor Great Park in 2005.

PRINCE PHILIP

Philip wearing a panama hat to shield him from the Aussie sunshine at a reception in Canberra, capital of Australia, in 2004.

163

CHAPTER SEVEN

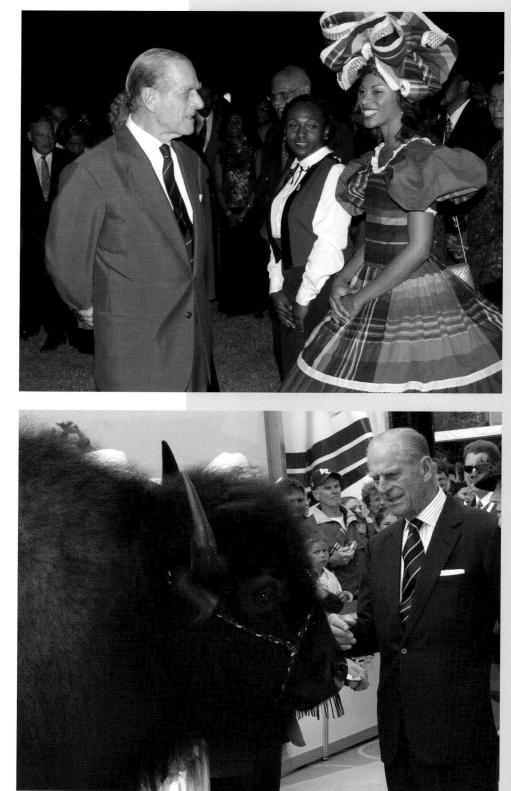

Above: Chatting to a couple of pretty Jamaican ladies in Kingston, 2002.

Below: Meeting a buffalo named Bailey on a walkabout in Edmonton, Canada, in 2005.

At Sandringham shooting school, 2003.

Charles gives wife Diana a tender pat on the shoulder in 1986 at the Braemar Games, near Balmoral in Scotland. Sitting next to Diana is Fergie, then a newlywed.

CHAPTER EIGHT Tender Moments

CHAPTER EIGHT

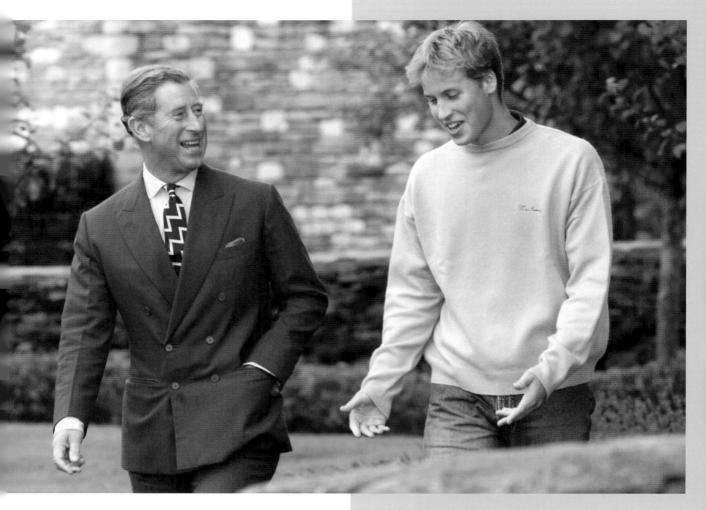

Prince William gave his first press conference in 2000. He was obviously very nervous as he spoke to his father beforehand, but the boy did brilliantly. After a couple of minutes he was confidently answering any questions fired at him.

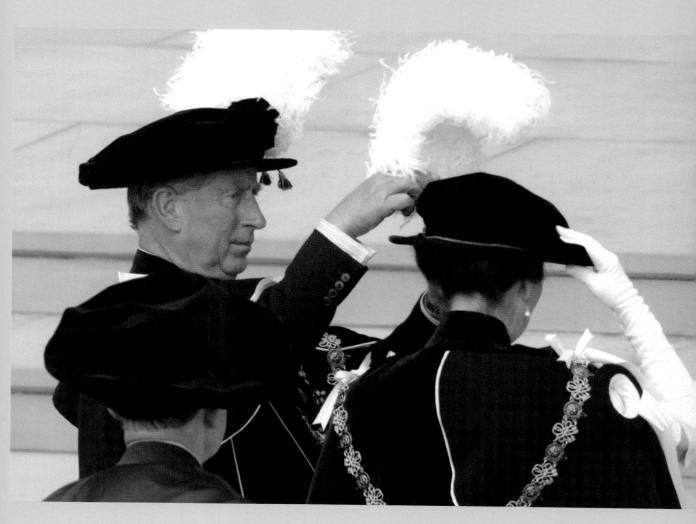

A very ordinary 'brother and sister' moment in 2006 as Prince Charles adjusts the feather in Anne's hat at the garter ceremony at Windsor Castle.

CHAPTER EIGHT

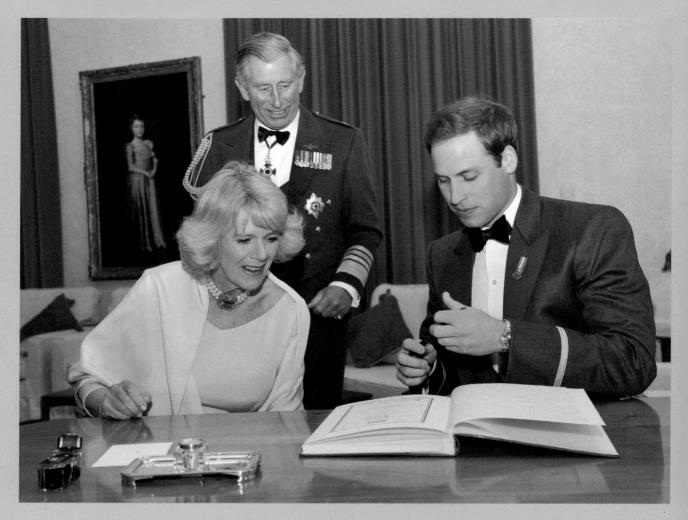

This has a great poignancy, I think. It's William signing the visitors' book at RAF Cranwell in April 2008. Charles and Camilla were guests of honour as the young Prince received his wings. Here, Charles is watching his eldest son and his beloved new wife together. You can see the delight and pride on his face. The picture brings home how, after all they've been through, the situation has become entirely normal for them all.

TENDER MOMENTS

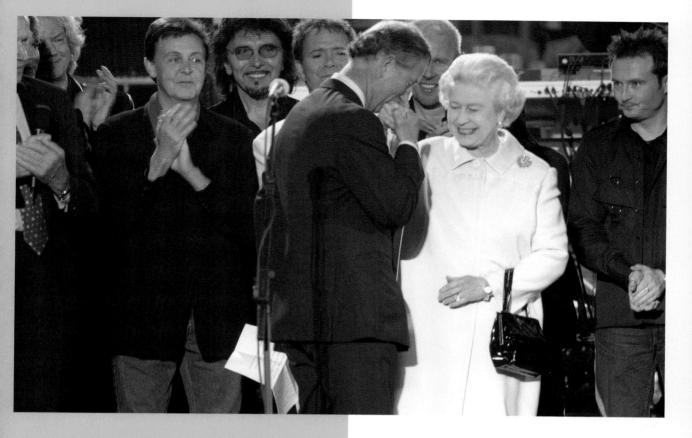

A fabulous moment at the Jubilee concert at Buckingham Palace in 2002, where Charles made a moving speech referring to the Queen as 'Mummy'. Here he is kissing her hand as pop stars Paul McCartney, Cliff Richard and Tony Iommi Iook on in amusement.

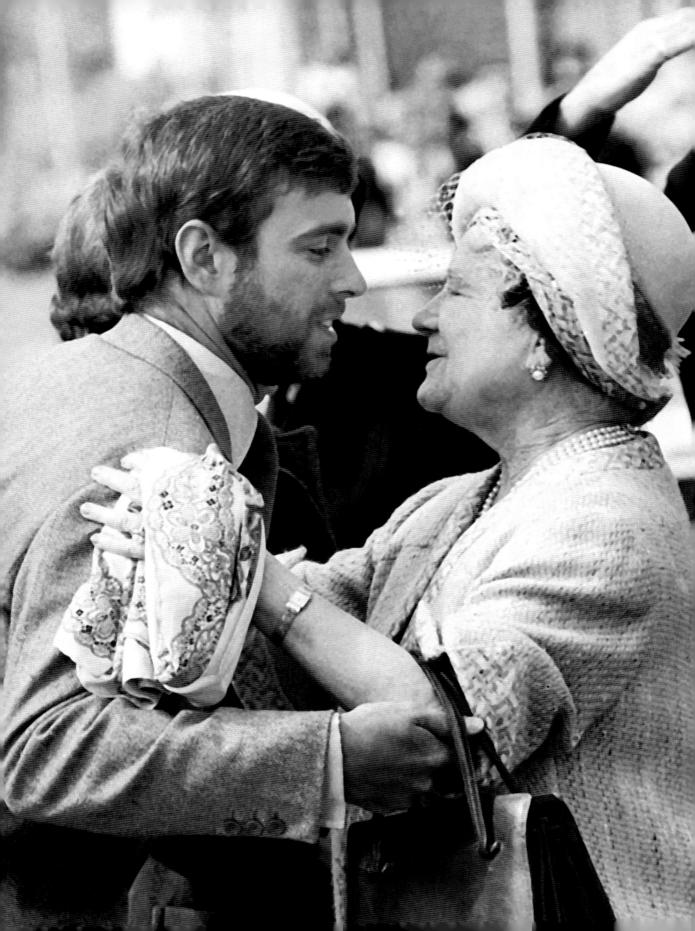

CHAPTER NINE The Queen Mother

CHAPTER NINE

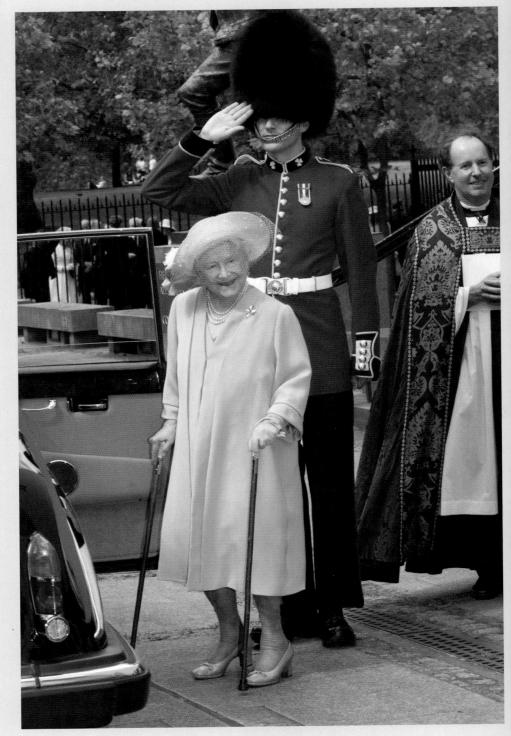

The Queen Mother led a thanksgiving service at Guards' Chapel in Birdcage Walk, London, in 2001. I love the fact that the guardsman saluting her before she gets in the car is almost twice her height ... if you include his bearskin hat!

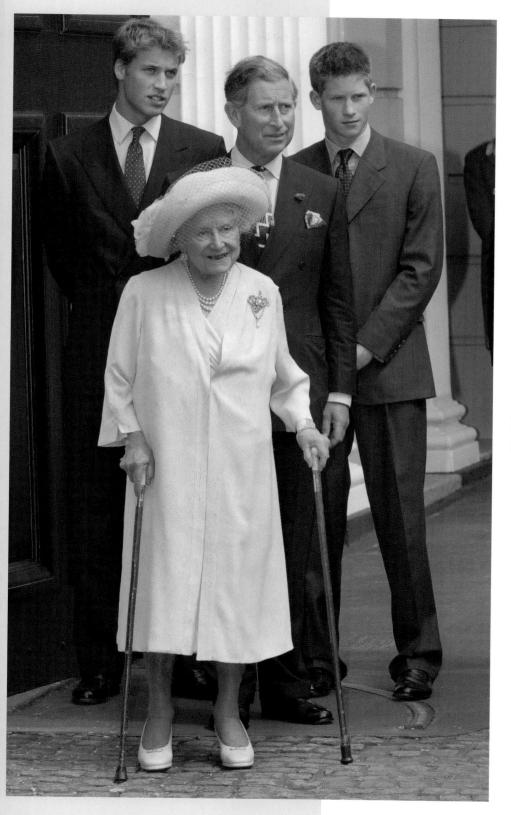

What I love about this picture from 2001 is how much taller William and Harry are than their father, and how tiny their greatgrandmother appears next to them. The Queen Mother was celebrating her 101st birthday at Clarence House in London. She was a very brave lady. Supporting herself on those sticks took great effort but thousands of people had gathered to wish her happy birthday and she didn't want to disappoint them. She died seven months later.

CHAPTER NINE

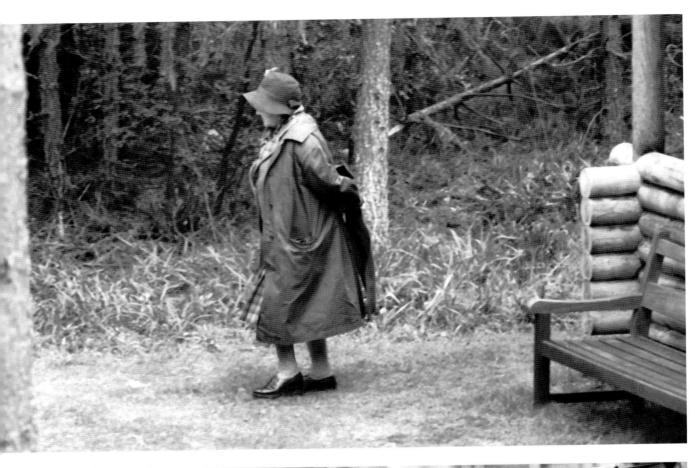

Above: The Queen Mother in 1982 strolling through the woods near her Scottish home – a fishing lodge on the banks of the Dee which the Queen gave her.

Below: Prince Andrew, who grew a beard after serving in the Falklands War, greets his grandmother the Queen Mother at Scrabster in the north of Scotland in 1983. He had arrived on the Royal yacht to have tea at her Castle of Mey in Caithness.

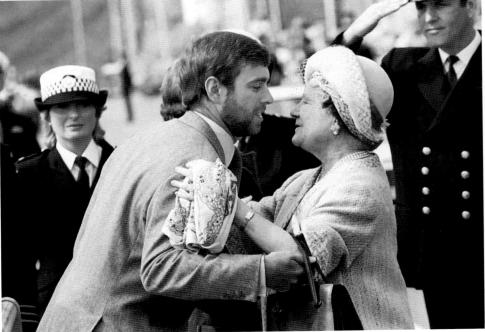

The Queen Mother

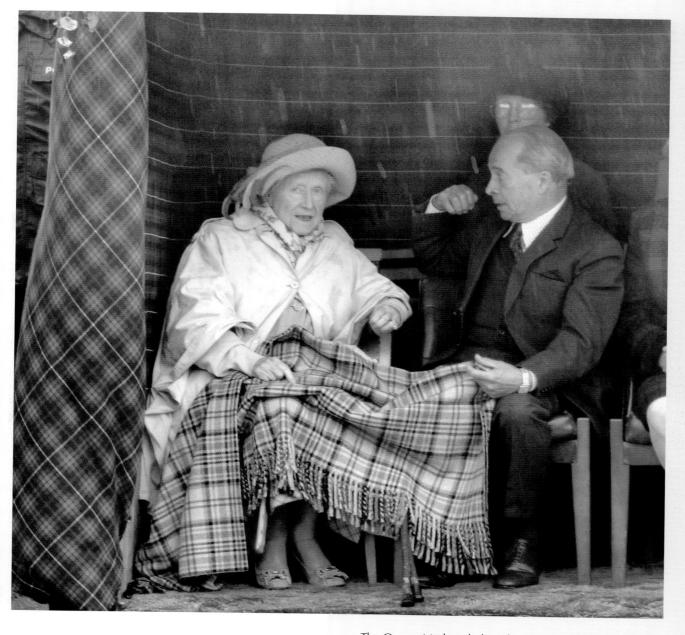

The Queen Mother shelters from torrential rain at the Mey Games at John O'Groats in 2001. The competitors were only tossing the caber and Highland dancing because they knew she was coming. And she only turned up to watch them do it! Rain was lashing in from the North Sea. It was mid-August but felt like mid-January.

CHAPTER NINE

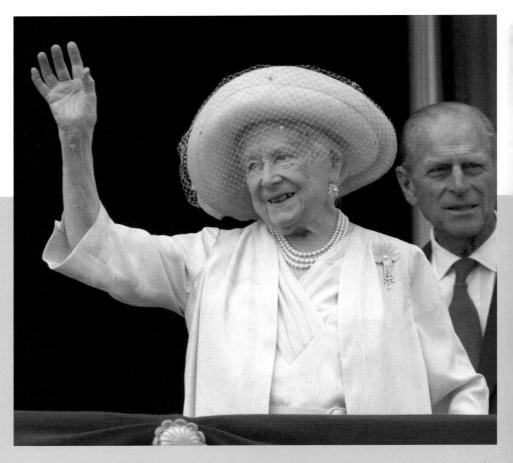

In 2000 the Queen Mother reached 100. She got a telegram from the Queen and thousands turned out in the Mall to see her. Even at her advanced years the Queen Mother had a two-hour makeover with a beautician before every public occasion. She was a wonderful lady and the photographers' sweetheart. She never ever refused us a picture. Here she is on the balcony of Buckingham Palace acknowledging the crowd.

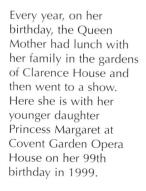

II.

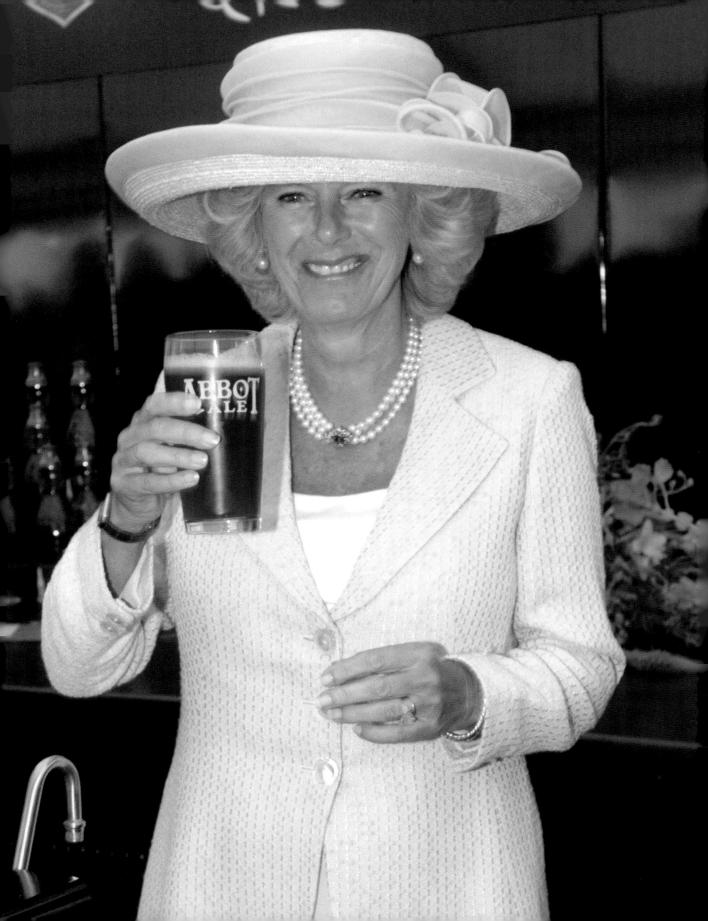

CHAPTER TEN Camilla

CHAPTER TEN

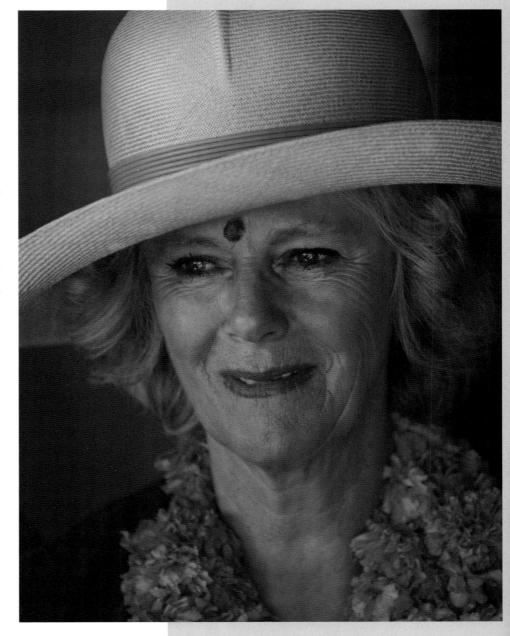

Camilla, Duchess of Cornwall, with a tilaka – the traditional mark Indian women wear on their forehead – on a trip to Jodhpur, India, in 2006. She was wilting, with temperatures in the 40s. If she hadn't worn the Panama hat I'm sure she'd have fainted.

Observing the Islamic dress code at a mosque in Lahore, Pakistan, which she visited in 2006.

CHAPTER TEN

What a fabulous ruby and diamond necklace Camilla wore at a concert in Philadelphia in January 2007. One American socialite said to me, 'The Duchess is wearing what we call "hot rocks"'. It is believed they were given to her by King Abdullah of Saudi Arabia when she visited there in 2006.

The necklace was estimated to be worth \$1million. Camilla wore a rubycoloured velvet evening dress to go with it.

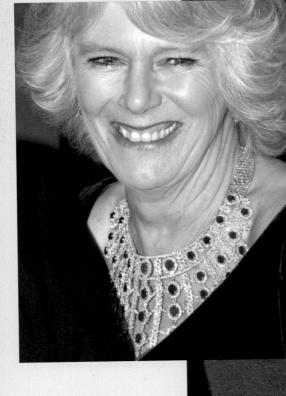

This was in Kampala at a concert for visiting dignitaries to the 2007 Commonwealth Heads of Government conference. Camilla looked like a woman half her age with her dazzling gold dress and matching earrings. *Opposite*: A typical Camilla moment. Visiting an organic market in Marin County, California, in 2006, she could not stop herself taking a bite out of a delicious apple. I instantly thought, 'Diana would never have done that – it would have spoiled her lipstick.'

Below: Camilla is patron of the Elmhurst Ballet School in Birmingham and in 2008 she and Charles watched a stunning performance by these young dancers. She posed with them afterwards. This picture has a 3D appearance because I used the available light from the window above. I hope those youngsters look at that picture in years to come and tell their grandchildren that was the day they danced for the Prince of Wales and the Duchess of Cornwall. This picture will be on display in many households, maybe even on top of the telly!

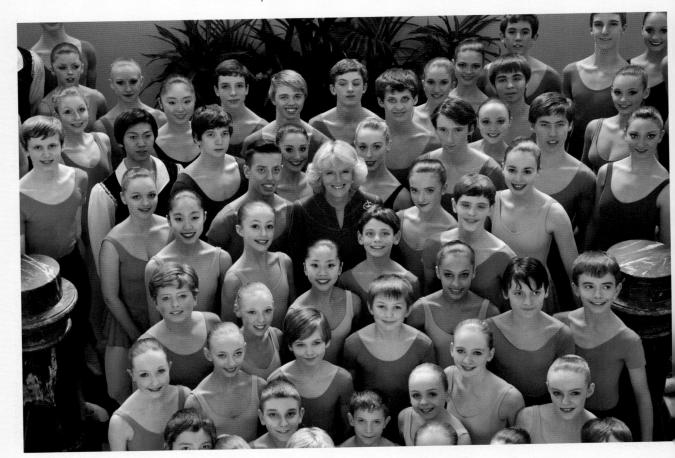

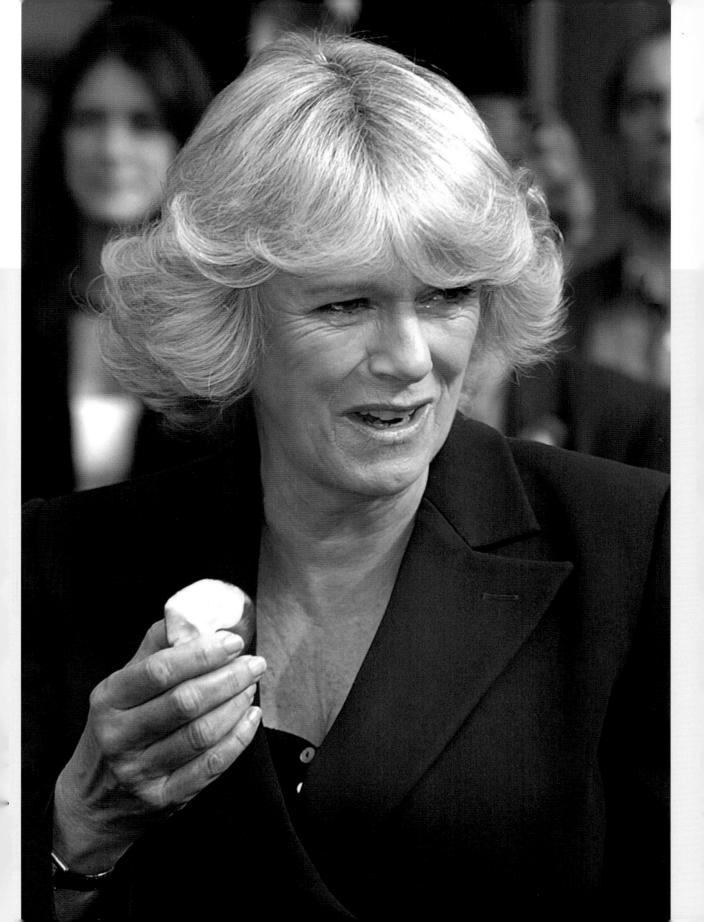

CHAPTER TEN

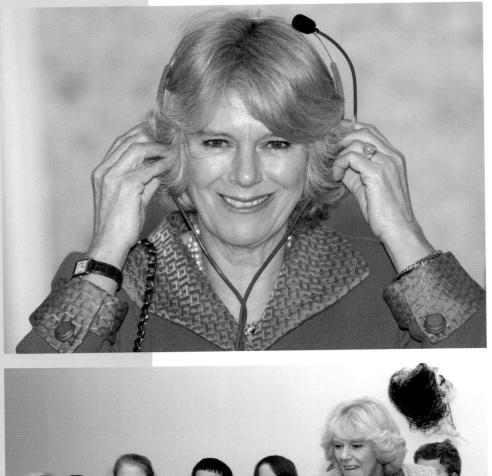

Above: Camilla listening in to police radio while visiting the Dorset Police HQ in 2006.

Below: The Duchess, on her first solo engagement, playing table tennis at a youth club near Chippenham, Wiltshire. She wasn't bad at it either, and played with great determination.

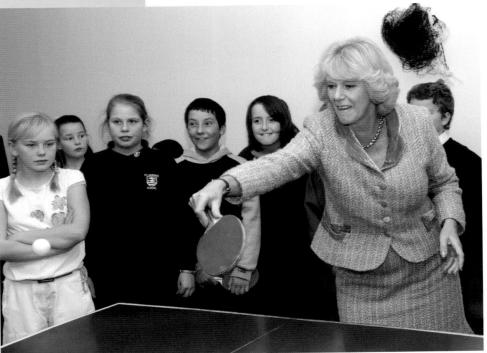

When Charles and Camilla landed in New York in 2006, the first thing they did was lay flowers at Ground Zero, where the World Trade Center stood before 9/11. Here, Camilla looks sombre as she stands in front of the cross that firemen erected on that dreadful day.

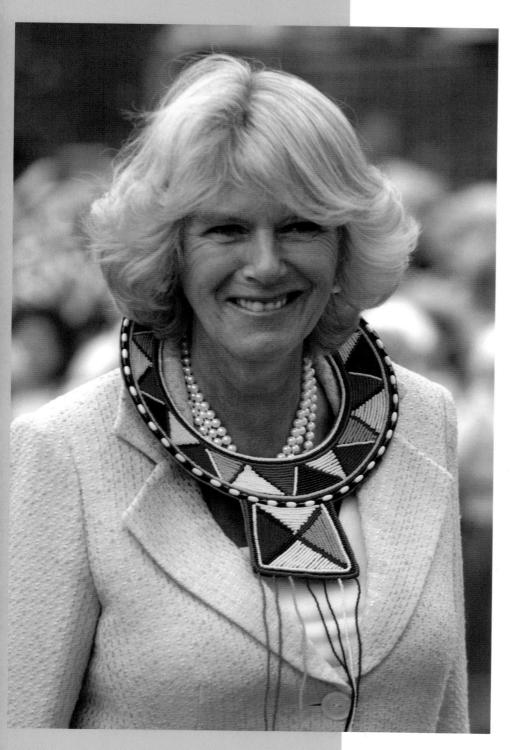

Visiting Suffolk in 2006, Camilla came across a dance troupe of Masai warriors performing in the area. They gave her a necklace. Not sure it goes with that outfit, Camilla.

Opposite: Camilla was anxious to show me her Union Jack handbag at a charity event in New York in 2006. She wants to fly the flag wherever she is.

CHAPTER TEN

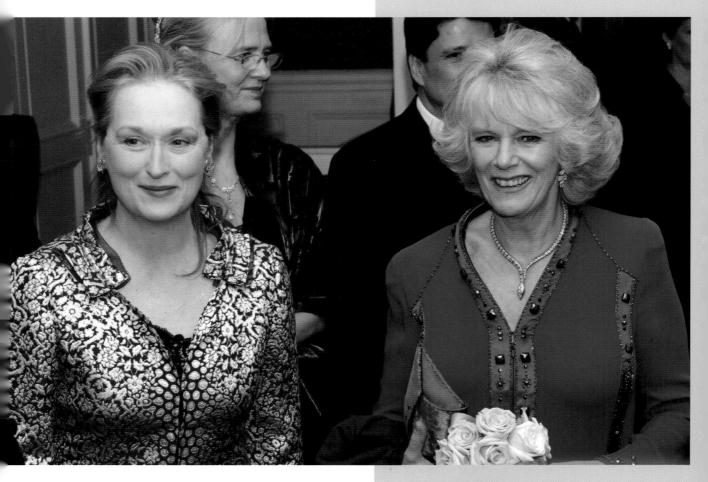

Camilla with Oscar-winning actress Meryl Streep at the Harvard Club in New York in 2007. Prince Charles and Meryl both gave passionate speeches about the perils of global warming.

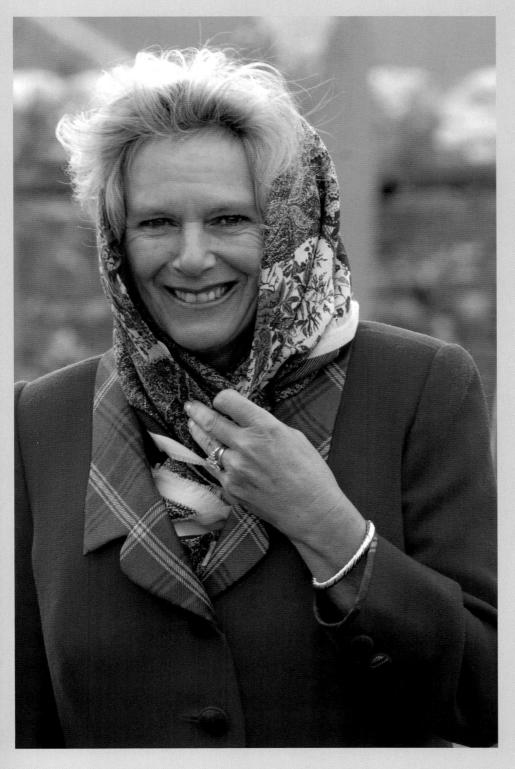

Camilla at church in Caithness during a stay at the Castle of Mey in 2005. The wind howls in at all times of the year there, so she quickly put on a headscarf.

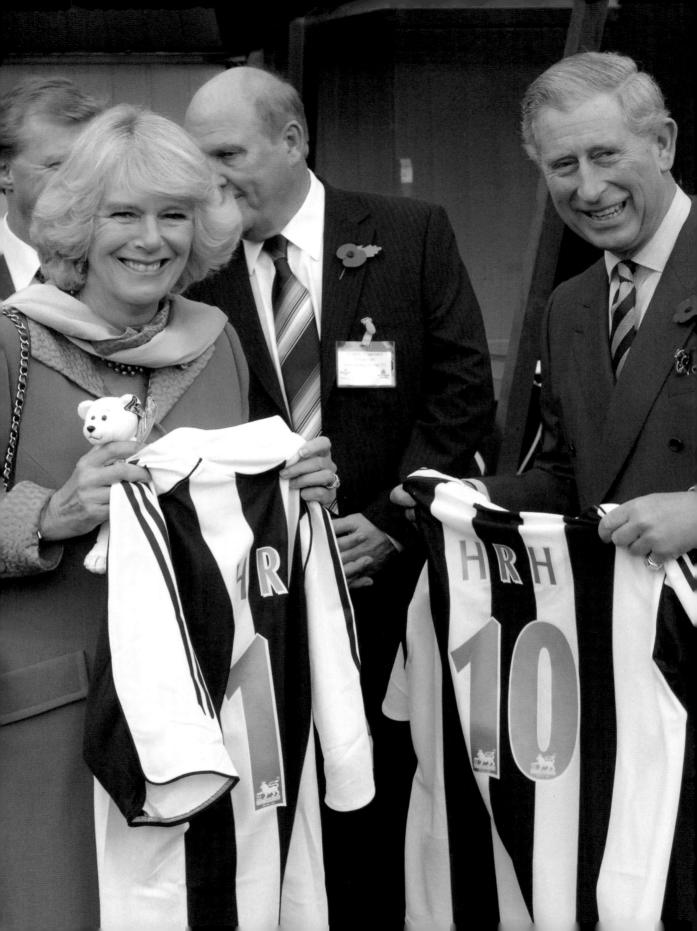

CHAPTER ELEVEN Charles and Camilla

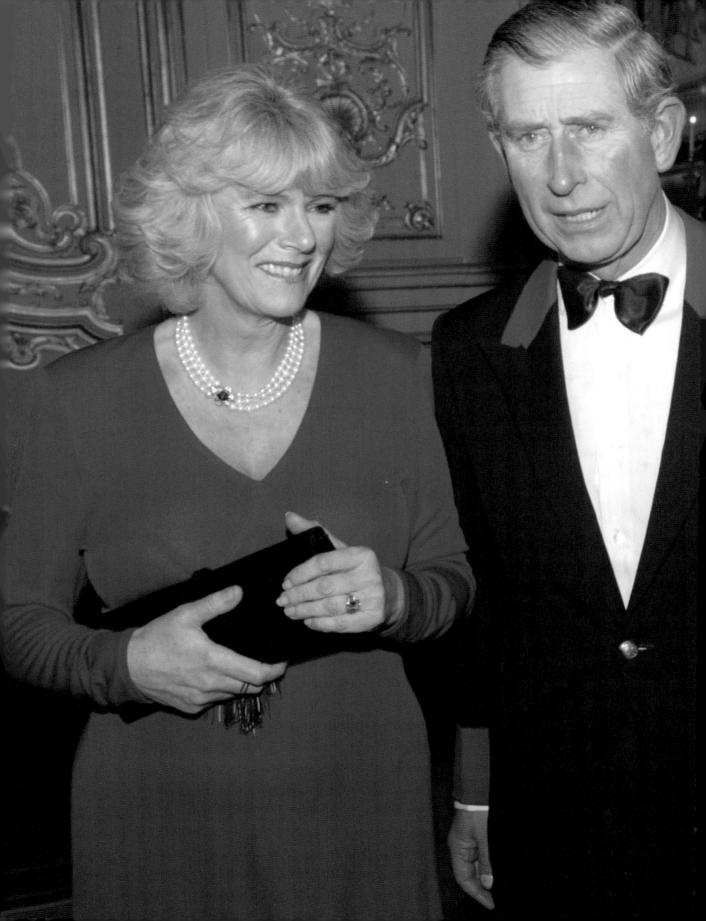

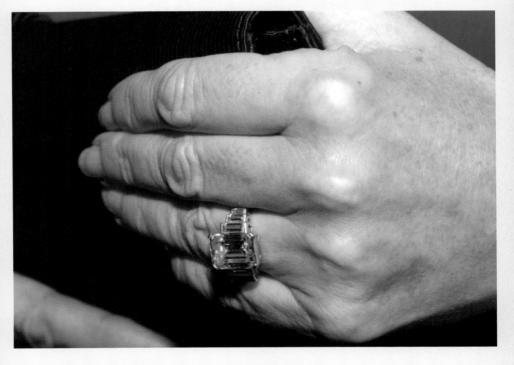

I was honoured when Charles's press secretary rang and asked if I would photograph the Prince and Camilla at Windsor Castle on the night they got engaged. The most important thing for me was to get a close-up of the ring, and when I asked Camilla she duly thrust it under my nose!

CHAPTER ELEVEN

Above: Charles and Camilla's first engagement after they were married in 2005 was to open a children's playground in Ballater, near the Balmoral estate in Scotland where they were honeymooning.

Below: Charles and Camilla went to Saudi Arabia in 2006 and met King Abdullah at his palace in Riyadh.

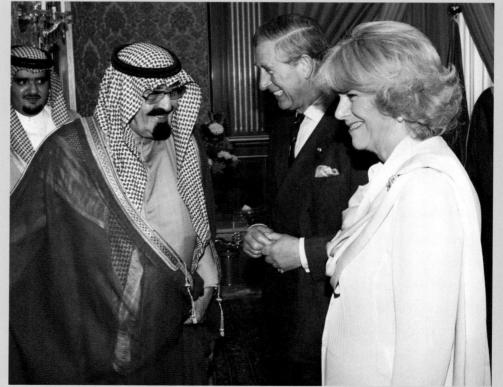

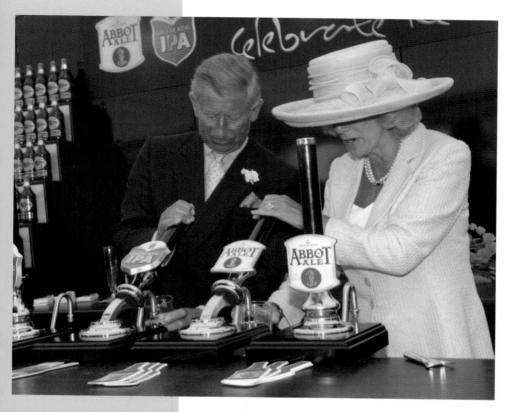

Pouring pints of bitter at a pub on a visit to Bury St Edmunds, Suffolk, in 2006 ... and sinking the same pints!

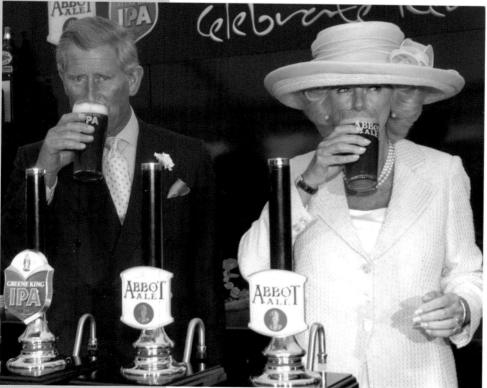

199

CHAPTER ELEVEN

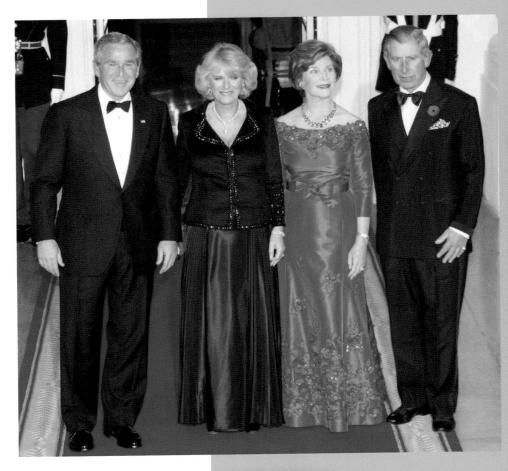

Above: This was in America in 2005 during Charles and Camilla's first overseas trip together. They posed with President George Bush and wife Laura at the entrance to the White House.

Below: Wearing their lifejackets, and obviously amused at something I'd said, Charles and Camilla on the Norfolk broads in the summer of 2005.

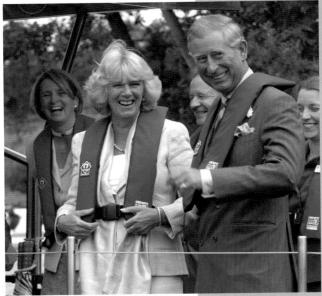

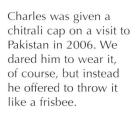

CHAPTER ELEVEN

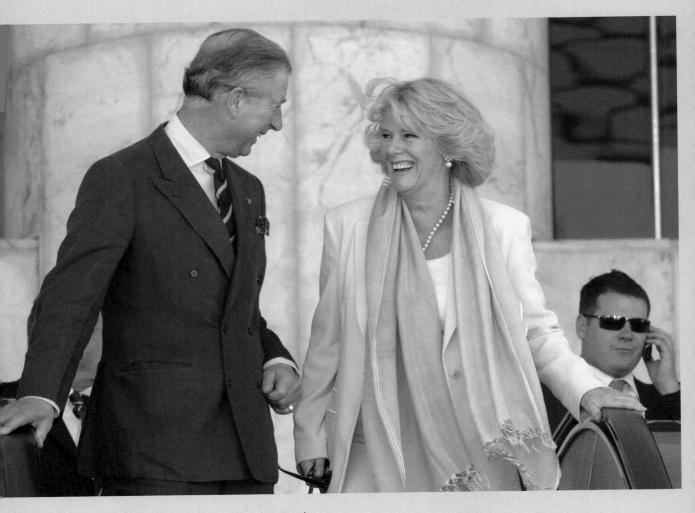

I love this picture of Charles and Camilla, taken on the escalator at the Royal Terminal at Riyadh airport as they left Saudi for India in 2006. They looked so happy together as they shared a little joke en route to the plane.

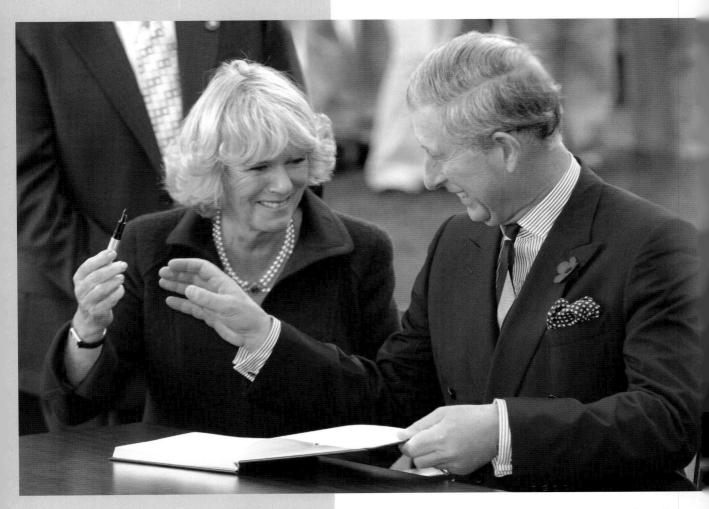

Here's another lovely picture which seems to encapsulate all the fun they have together. They were at a book signing at a school in Washington DC in 2005 – and after it was over Camilla jokingly refused to give Charles his pen back.

CHAPTER ELEVEN

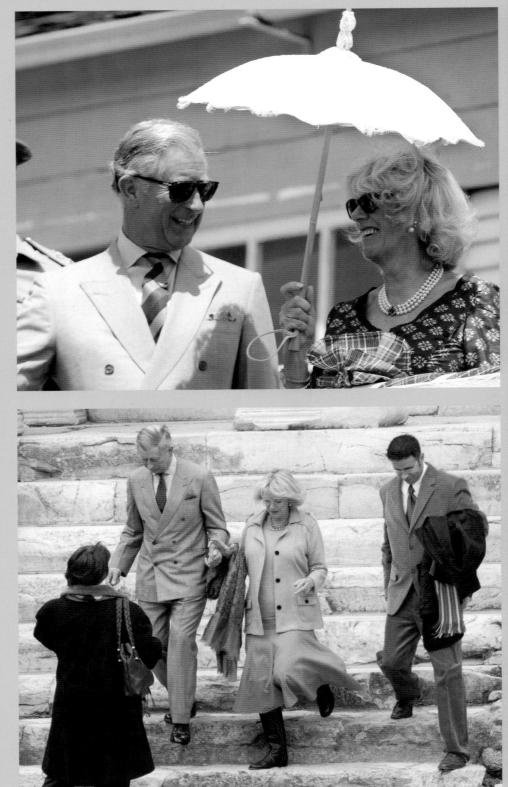

Above: Prince Charles always calls Camilla 'My darling wife' and their love is obvious to anyone who watches them. Here, at a concert in Jamaica in 2008, they still find a moment for each other. It reminds me how much he was prepared to sacrifice to marry her.

Below: Charles holds out a hand to help Camilla down the steps at the Turkish temple of Ephesus in November 2007.

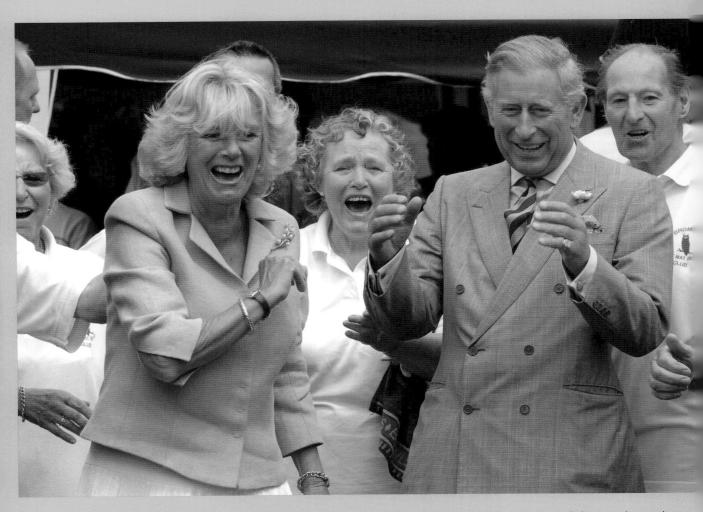

This is Camilla bowling in Bromham, Wiltshire, on her 60th birthday in July 2007 – but she was like a young girl as she showed her delight after knocking over all the skittles with her first ball.

CHAPTER ELEVEN

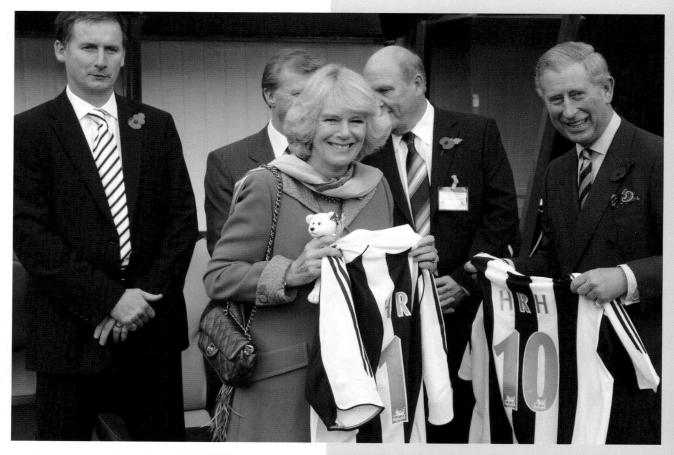

Above: The Royal couple were given Newcastle football shirts when they toured the club in December 2006. In the background is then manager Glenn Roeder and chairman Freddie Shepherd.

Below: Charles and Camilla share a laugh with rock veteran Rod Stewart at a concert in Philadelphia in 2007.

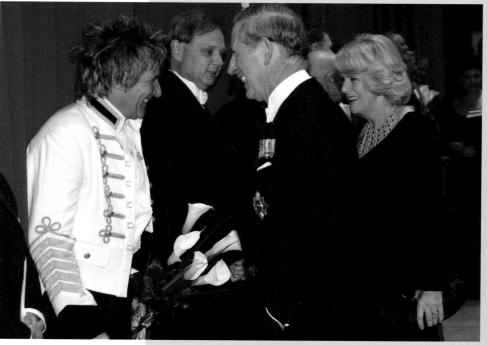

Camilla laying flowers at the grave of soldiers who served with her father in North Africa, during a visit to the Commonwealth war graves cemetery at El Alamein, Egypt, in 2006.

CHAPTER ELEVEN

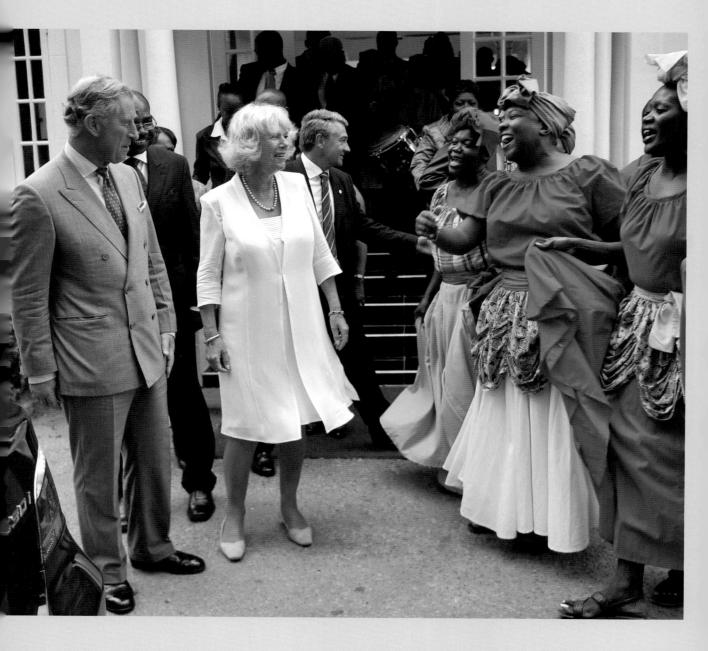

Charles and Camilla were serenaded by a dance group in Montego Bay, Jamaica, in March 2008. These amplyproportioned ladies were so keen to impress the couple they blocked out the guitar player totally.

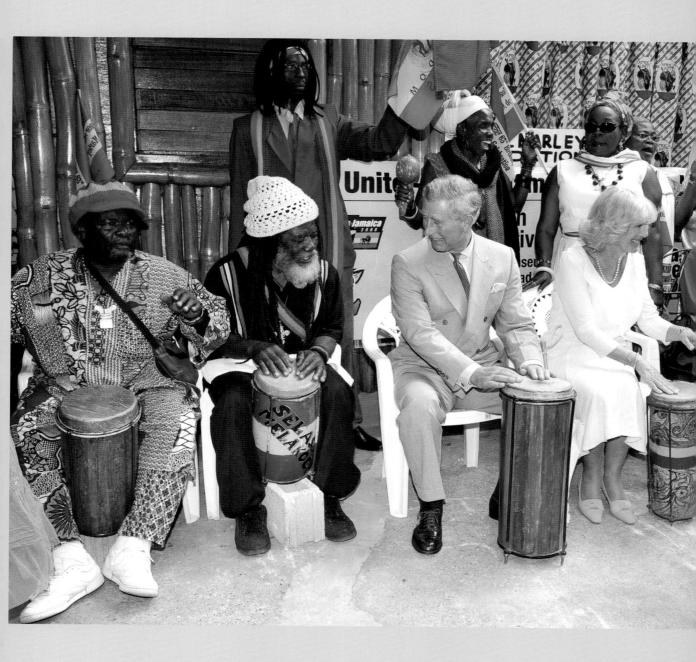

Charles and Camilla visited Bob Marley's house in Kingston, Jamaica, in March 2008 and were invited to jam on the bongos with the local Rasta band. When Charles does something, it's with 100% enthusiasm. He really got to work on those drums, with perfect rhythm. Bob's widow Rita is behind Camilla.

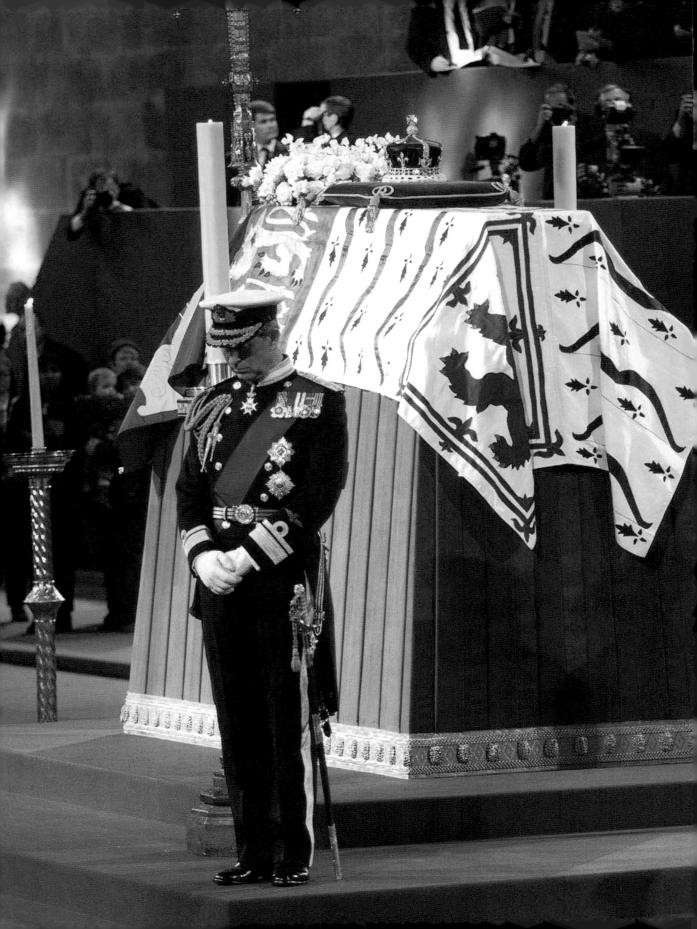

CHAPTER TWELVE Royals in Mourning

CHAPTER TWELVE

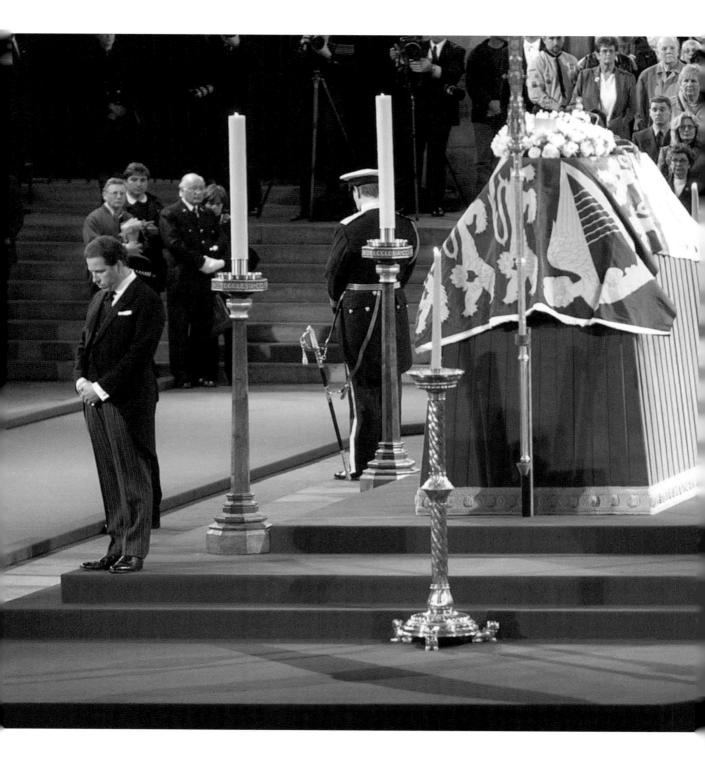

ROYALS IN MOURNING

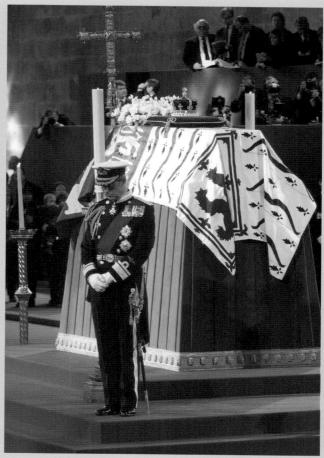

After the Queen Mother's death, her body lay in state at Westminster Hall and more than one million people filed past. Her four grandsons, Charles, Andrew, Edward and Lord Linley stood vigil at the coffin just before the funeral in 2002.

Top: Charles, standing vigil, in close-up.

CHAPTER TWELVE

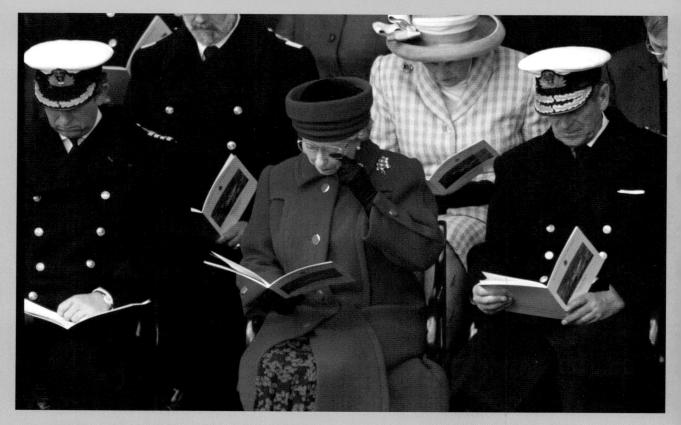

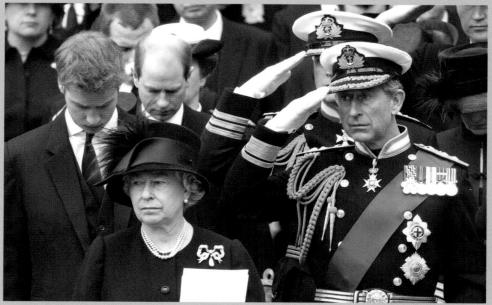

Above: Very seldom do you see the Queen tearful. I never saw it at the funerals of the Queen Mother or Princess Margaret because she remains very stoic on such occasions and never lets her feelings show. But when the Royal Yacht was decommissioned at Portsmouth in 1997 she shed a tear during the service and was clearly moved.

Below: Prince Charles, the Queen, Prince Edward and Prince William watch the Queen Mother's coffin being placed into the hearse after her funeral, for her final journey to Windsor.

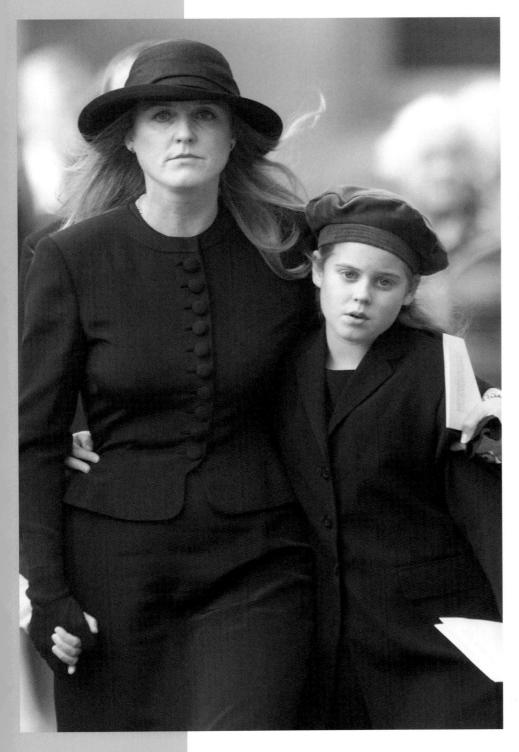

The Duchess of York, her eyes red with tears, and accompanied by her daughter Beatrice, attends the funeral of her dear friend Carolyn Cotterell in October 1999. It was her 40th birthday – not a great way to spend such a milestone, but then Fergie has always put her friends and family first.

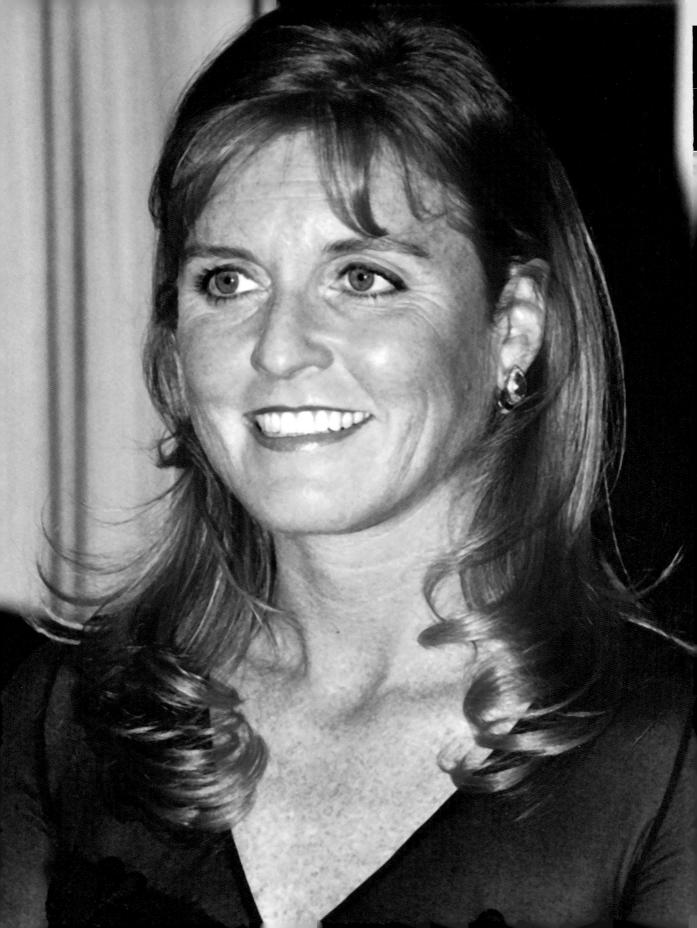

CHAPTER THIRTEEN The Yorks

It's amazing that even though Fergie and Prince Andrew are divorced they still get together for family holidays with Eugenie and Beatrice. Here they are on a snowmobile in February 1998 in Verbier, Switzerland. 3

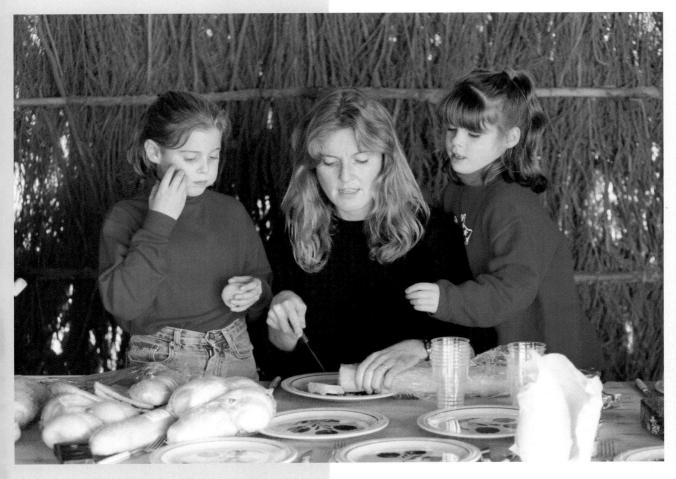

In 1997, I was sent to Italy to find the Duchess, who was on holiday with an alleged new boyfriend. When Fergie saw me she said, 'Come with me for lunch, Arthur,' and we went to a beach where she prepared a picnic with her daughters Eugenie and Beatrice. They let me take a magnificent exclusive set of pictures.

CHAPTER THIRTEEN

Every year the Duchess of York buys Christmas presents for motor neurone disease sufferers at the Surrey branch of the Motor Neurone Disease Association. This picture was in 2003.

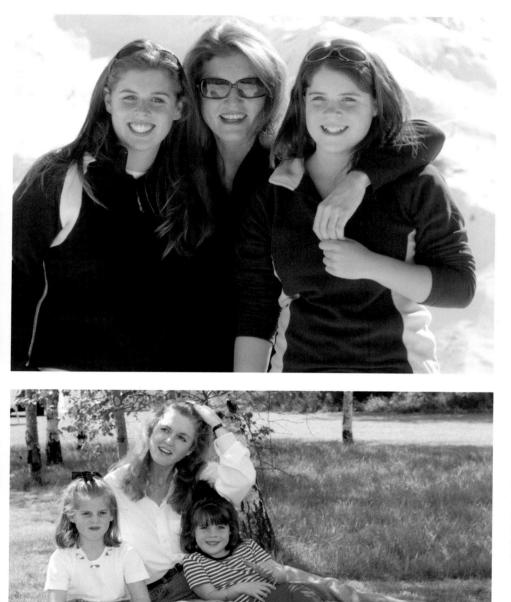

Fergie, Eugenie and Beatrice back on the slopes at Verbier, Switzerland, in 2004. This was a special trip – Eugenie's first skiing excursion since the operation to straighten her spine the year before.

Below: When Fergie's divorce became absolute in 1996, she was with her children at the Hickstead show ground in Sussex, watching her horse compete. Fergie knew I had taken pictures at her wedding ten years before and told me, 'It is right you should be here today. You were there at the beginning and you are here at the end on this very sad day.' She posed for me with the girls, then went off to see the jumping.

CHAPTER THIRTEEN

In 2000, Fergie asked me to photograph her daughter Beatrice with her showjumper whom she'd named Del Boy, a horse that had belonged to the Queen. Beatrice gave it her best shot, but I don't think she had the same flair for it as Zara Phillips.

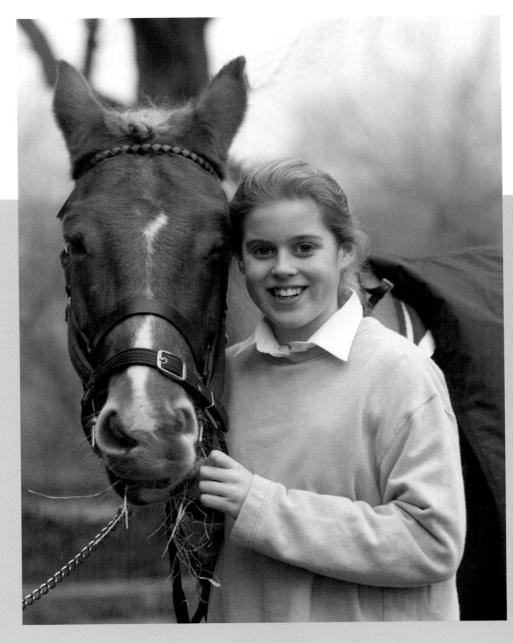

The Yorks

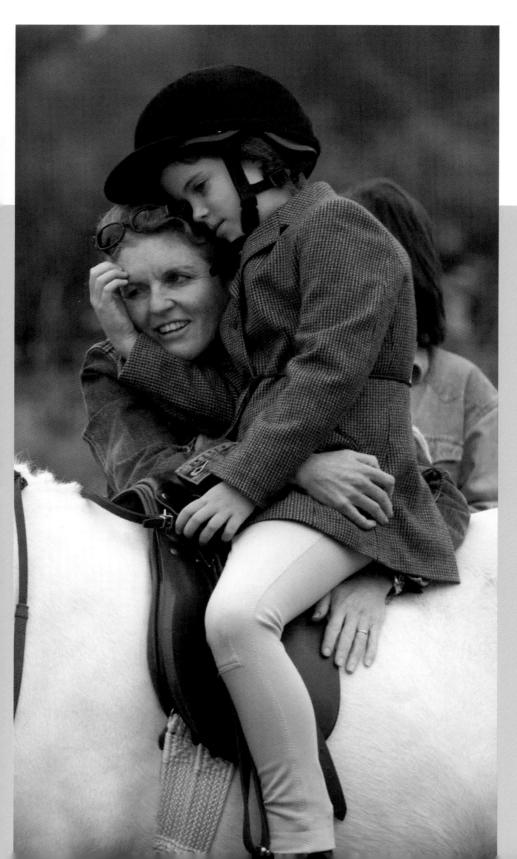

Fergie comforting younger daughter Eugenie after a disappointing round in the jumping at a horse show in July 2000.

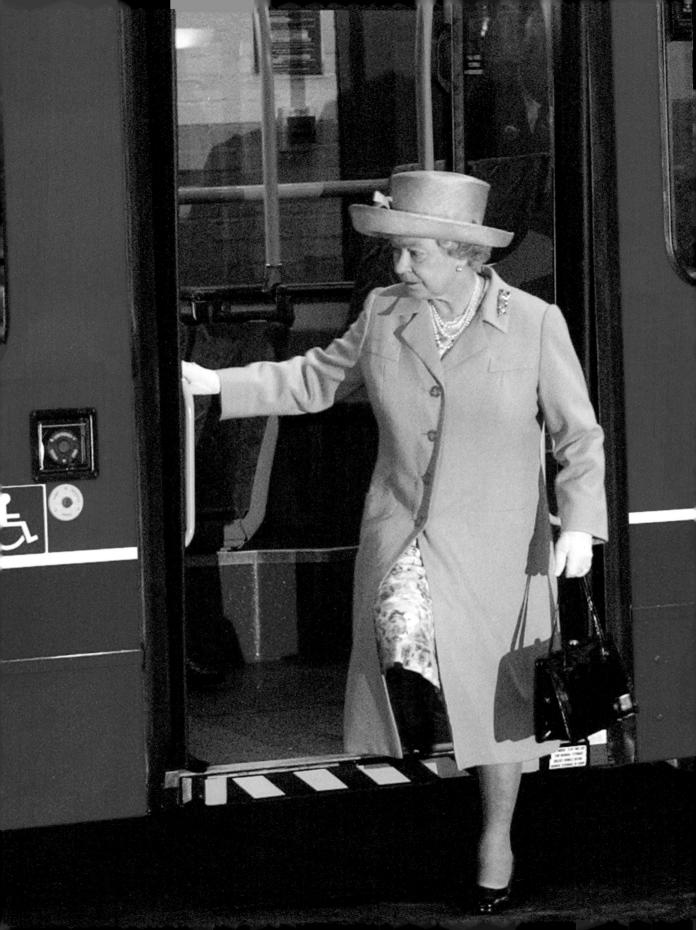

CHAPTER FOURTEEN You Don't Often See That!

CHAPTER FOURTEEN

This makes me laugh so much – just as I'm sure it made the Queen laugh too. In July 1999, she unveiled a statue of comic genius Eric Morecambe on the prom at Morecambe in Lancashire. Although you can't see the Queen's face, you just know she's smiling at the wonderful statue of Eric doing his 'bring me sunshine' dance.

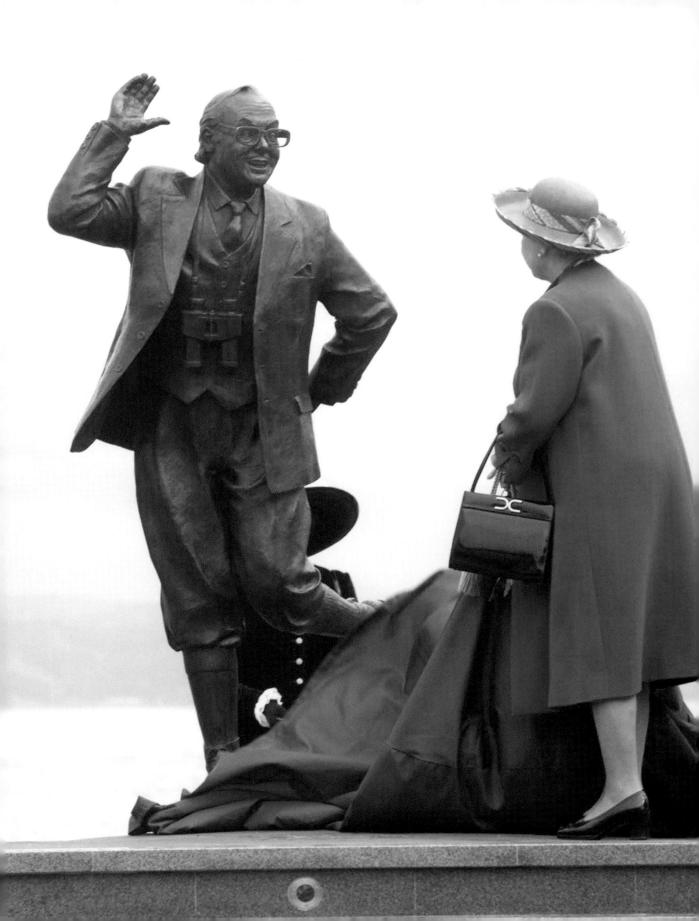

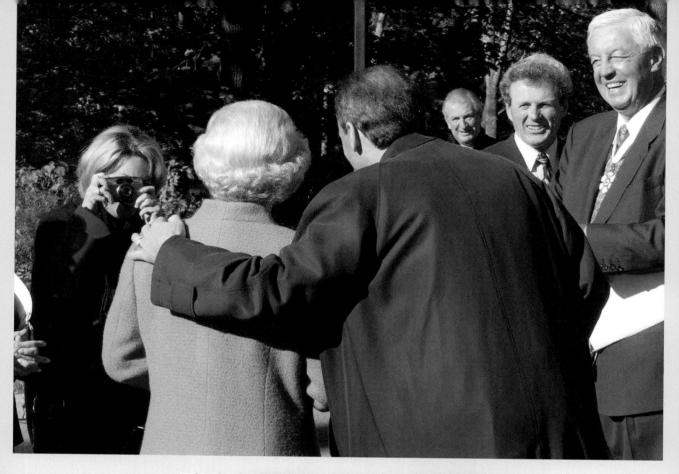

YOU DON'T OFTEN SEE THAT!

Above: A lovely, surprising moment. The last engagement of the Queen's millennium tour in 2002 was a tree planting at Government House in Ottawa, Canada. As she left, a former Canadian champion cyclist, Louis Garneau, came up and asked if he could have his picture taken with her. She agreed. Imagine my surprise as he then put his arm round her and gave her a squeeze, just as his wife Monique pressed the shutter. I guess it just seemed the natural thing for him to do, but it was a breach of the normal protocol.

Below: Here's the picture Monique took. Look carefully and you can see me in the background, looking rather portly, taking the snap.

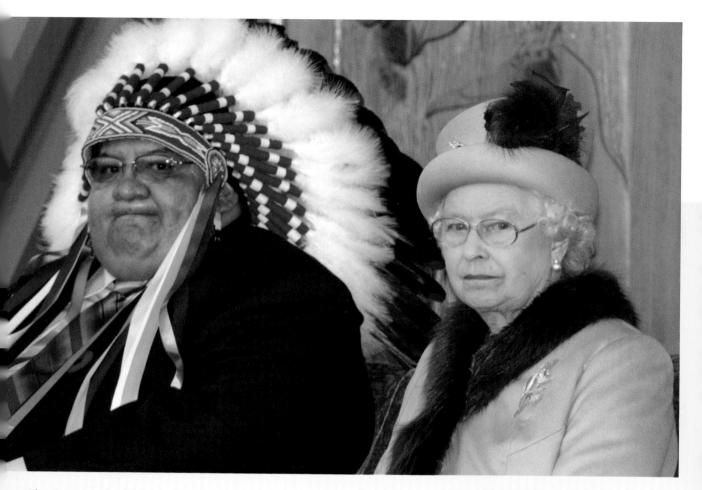

The Queen with Alphonse Bird, a Cree Indian chief, in Saskatchewan, Canada, in 2005. In one day the Queen, believe it or not, attended the state opening of Parliament in London, then flew to Canada to perform two engagements. At the end of it she looked all in, and she admitted she'd done an 18-hour day. That's a long one for an old age pensioner!

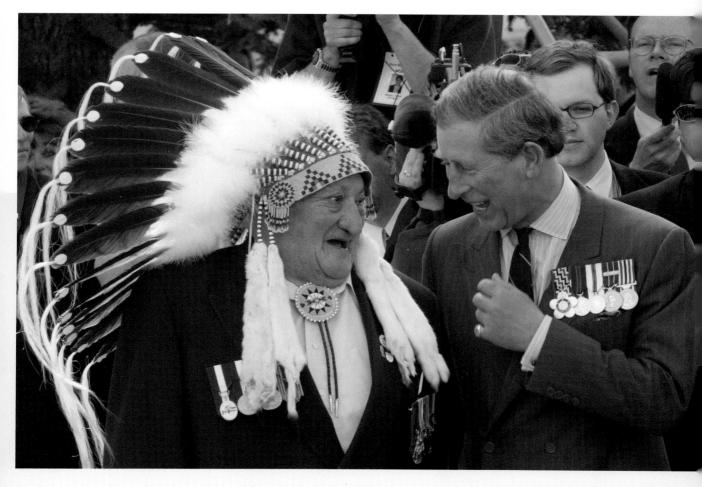

Charles with an Indian chief in Regina, Canada, in 2002.

CHAPTER FOURTEEN

Queen Liz at the Queen Vic! Her Majesty visited the *EastEnders* set at Elstree, Hertfordshire, in 2001 and was shown round by the two queens of soap: Barbara Windsor and Wendy Richard.

CHAPTER FOURTEEN

YOU DON'T OFTEN SEE THAT!

There are no large cars on the Channel island of Alderney, so when the Queen arrived for an official reception she had to force her way out of the small Renault Megane they laid on for her. They still managed to fix the Royal standard to the car's aerial to add some dignity to the occasion.

CHAPTER FOURTEEN

Above: In 2002, during the state banquet at King's House in Kingston, Jamaica, the lights failed due to a power cut and the Queen had to be led to dinner with the aid of lanterns and torchlight.

Below: What a good sport she is! In 1983 the Queen toured India and children at a school in New Delhi asked if she would take part in their parade, by pretending to sit in a Sedan chair. She's not sitting at all, in fact – she's walking along.

YOU DON'T OFTEN SEE THAT!

Images you don't often see. The Queen did many unusual things during her millennium tour in 2002 – here, getting off a London bus at the Willesden depot.

CHAPTER FOURTEEN

Her Majesty didn't look very happy on this shuttle train in 1998 on a tour of Malaysia, where she visited the Commonwealth Games. She had to get the train like everyone else because the traffic was so bad.

YOU DON'T OFTEN SEE THAT!

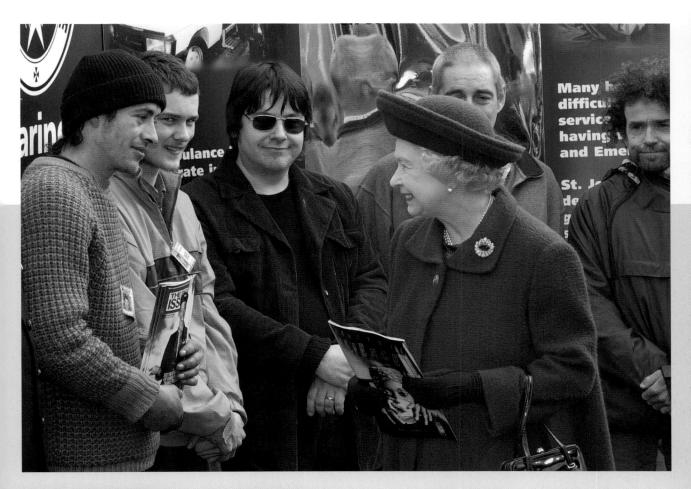

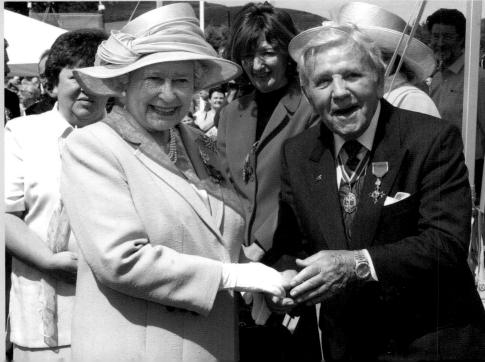

Above: Visiting Brighton during 2002, the Queen bought *The Big Issue* from seller Ivan Betson as she visited a homeless unit run by the St John Ambulance.

Below: Meeting the comic Norman Wisdom (again) in 2002, on the Isle of Man, where he lives. She knew him well, of course – she knighted him at Buckingham Palace the year before.

CHAPTER FIFTEEN Prince Charles

CHAPTER FIFTEEN

Above: Prince Charles was very keen on national hunt racing and was desperate to get fit to ride his horse Alibar at a meeting at Newton Abbot. A jockey needs strong legs and while I was waiting for him outside the stable in Lambourn, Berkshire, in 1981 he suddenly came hurtling past on a girls' bicycle. 'I'm trying to get my legs fit for racing,' he told me.

Below: I got this picture at 6.30 in the morning in February 1981. Charles was riding his cherished horse Alibar on to the gallops. I didn't think the picture was very interesting but I thought I'd take it anyway. An hour later it was a front page picture - Alibar had fallen and died of a heart attack on the gallops. The Prince was almost inconsolable. The lesson for any aspiring photographer being: If in doubt, take the picture. You can always throw it away if you don't need it but it could turn out to be priceless.

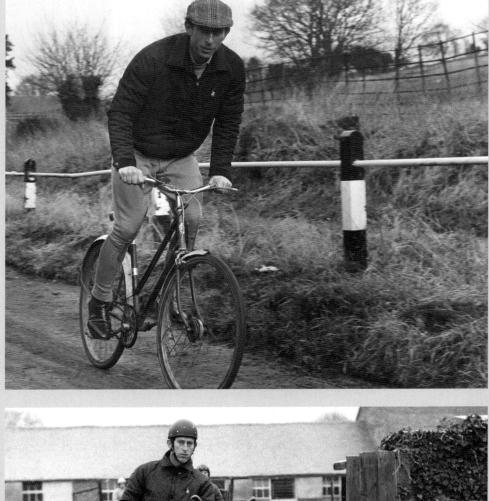

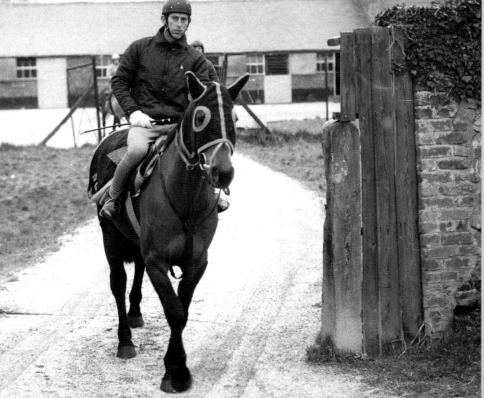

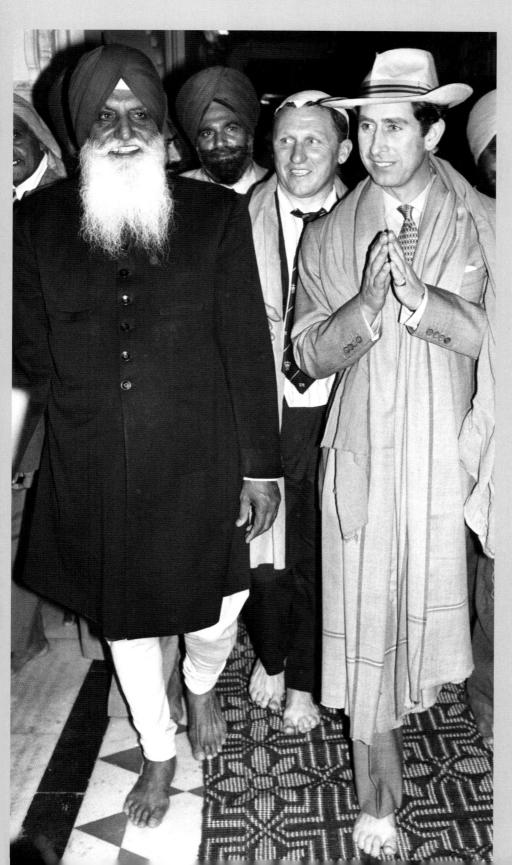

This was in the golden temple at Amritsar in November 1980. We were in India and Nepal for a month, one of my favourite tours ever. We hadn't been told we had to cover our heads and remove our shoes. I fashioned a makeshift hat from a soft camera case. After the Prince's visit we had to rush to the airport to catch a plane to Delhi so we could transmit the pictures. The chaos trying to find our shoes in the dark resulted in some language unbefitting of that holy place.

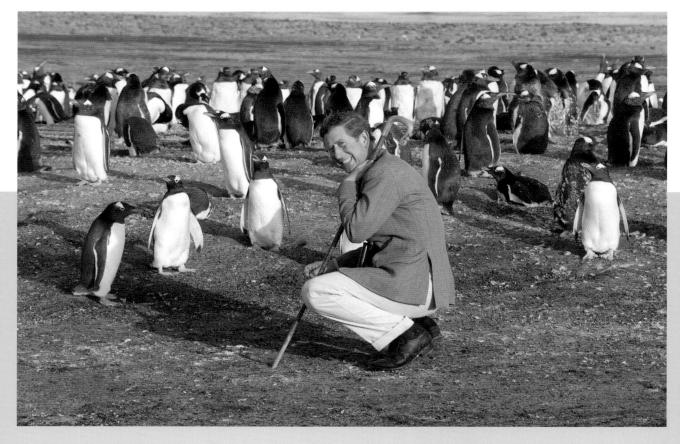

Charles with penguins in the Falkland Islands in 1999.

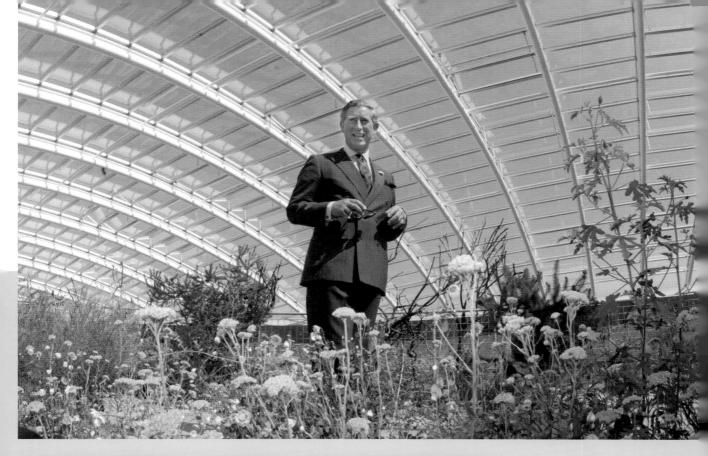

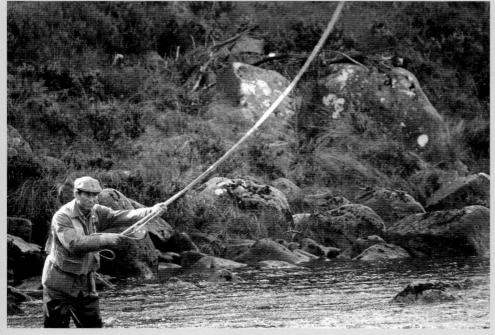

Above: The Prince is a gardening fanatic, so he was in his element at Cornwall's Eden Project in 2004. Once a disused clay pit, it is now one of Britain's biggest tourist attractions.

Below: Fishing in the River Dee on the Balmoral estate in 1980.

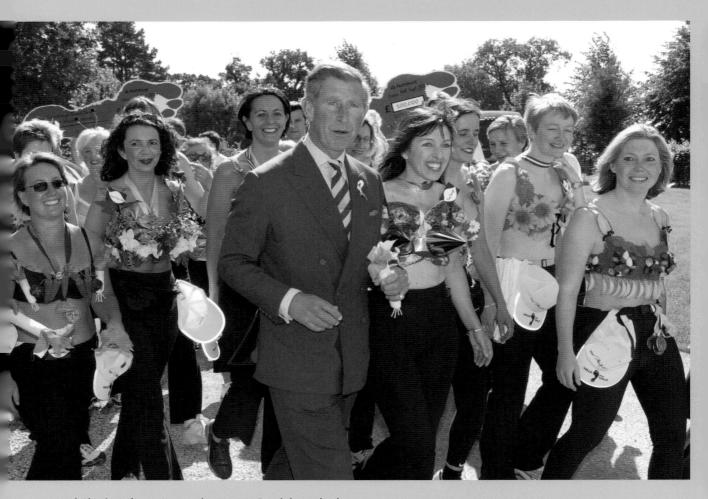

One of Charles's favourite good causes is Breakthrough, the breast cancer awareness charity. Each year hundreds of women raise funds with a sponsored walk wearing very fancy bras. Charles started the walk at his Highgrove home in 2001 and some of the creations the women wore were fantastic.

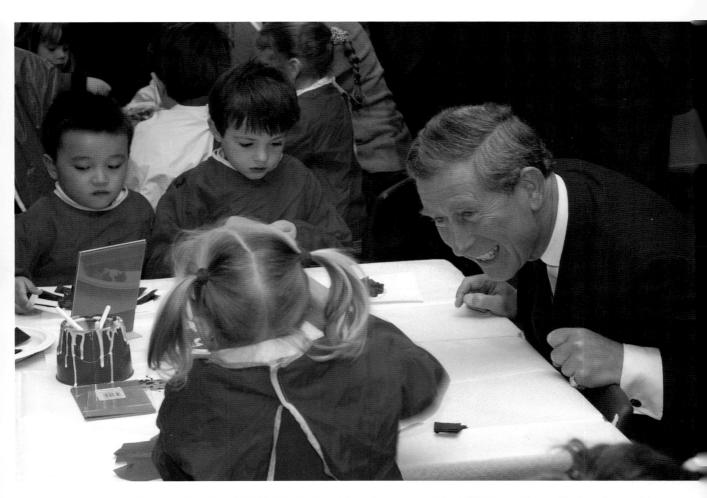

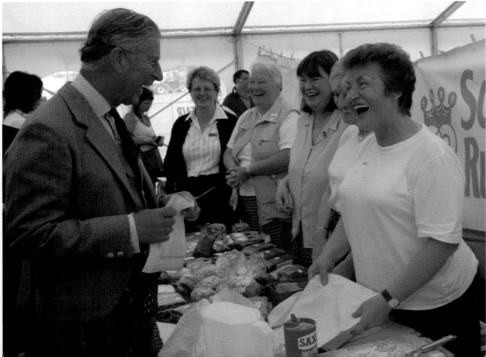

Above: Getting down with the kids in a nursery classroom at an East London school in 2002.

Below: Charles 'bought' a couple of soda bread scones from a cake stand at a country fair on the island of Bute, Scotland, in 2006. Needless to say, they refused to take his money.

Above: Burnley in Lancashire is a town with well-known racial problems. Charles chatted to young people about kicking racism out of society on a visit there in 2005.

> Below: Chatting in Burnley, Lancashire, to British schoolkids wearing the traditional Muslim hijab in 2004.

Anti-racism kick it out caring no name calling noviolence fun no hurting play together Make Friends Share smile excited Kind thous

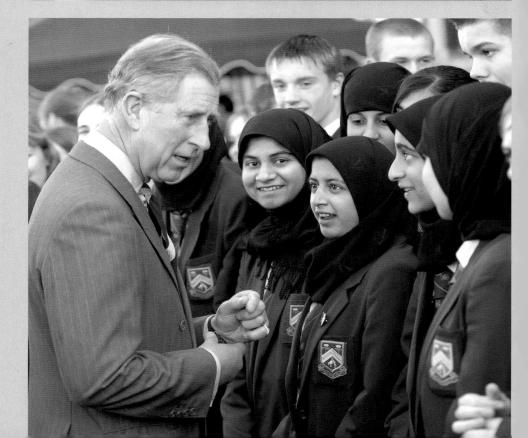

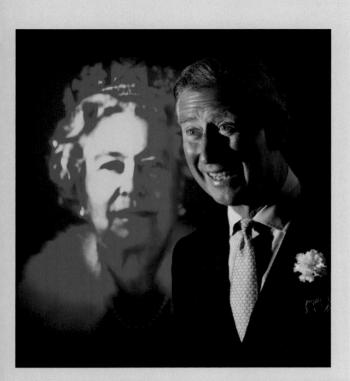

Above: I had to use special lighting techniques to pull this one off. Charles unveiled a hologram of the Queen when he visited Jersey in 2004. It's almost impossible to photograph a hologram using conventional lighting.

Below: A lighter moment in Kano, Northern Nigeria, as Charles chatted with a Nigerian chief who seemed to have rabbit ears coming off his turban!

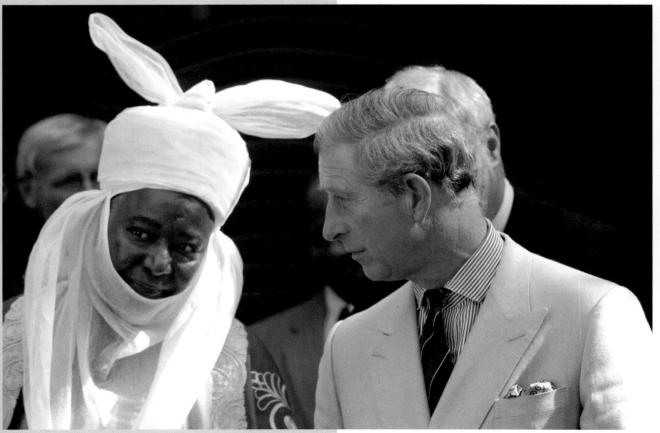

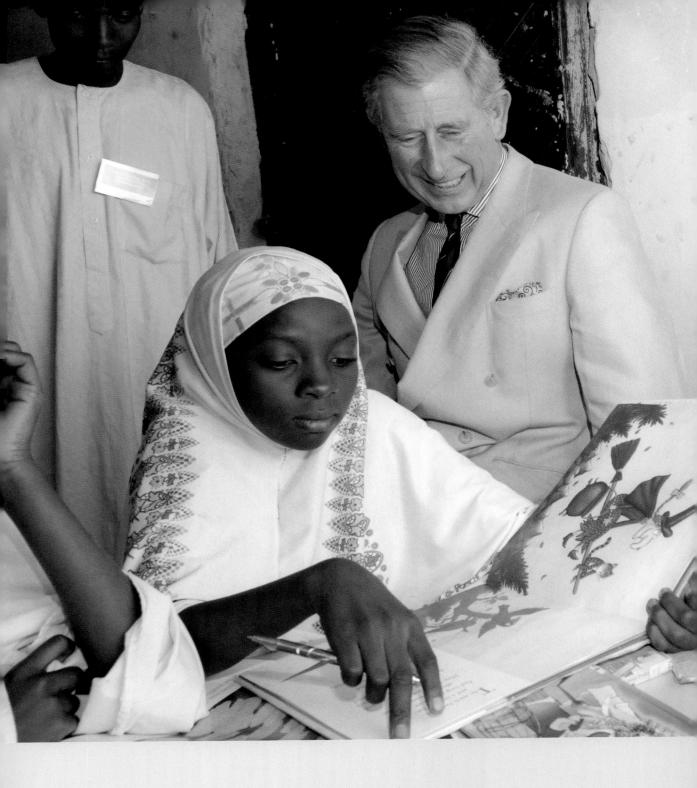

Charles visited a girls' school in northern Nigeria in 2006 to promote equal schooling for girls. Only 20 per cent of females in the country receive an education.

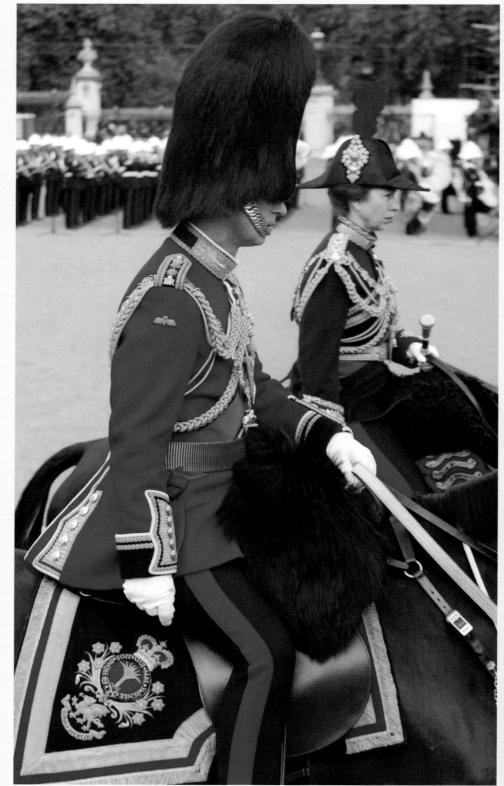

Riding alongside sister Anne in the procession for the Queen's Jubilee in the Mall in 2002.

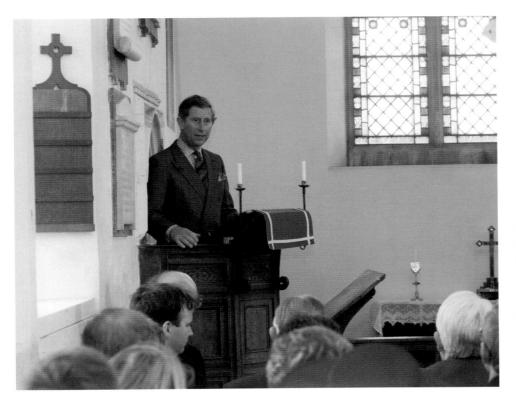

Above: It's unusual to see Charles in a pulpit. This was in 2004 when he visited a Norfolk church to speak to supporters of historic buildings in the area.

Below: Talking to Coptic priests on a visit to eastern Turkey in 2004.

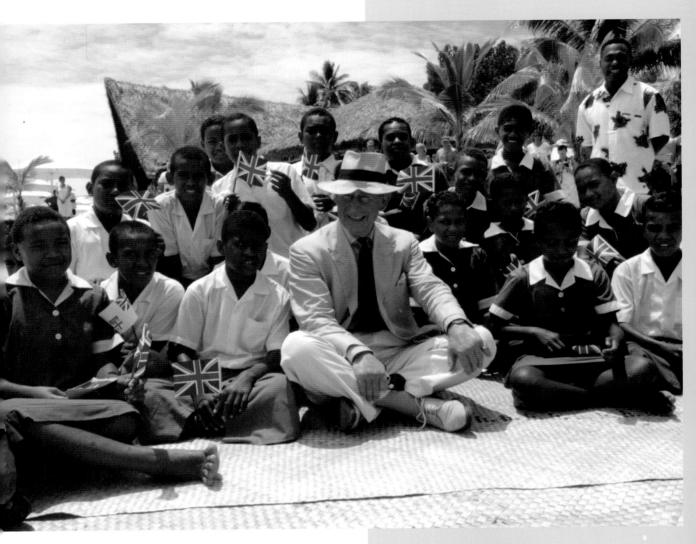

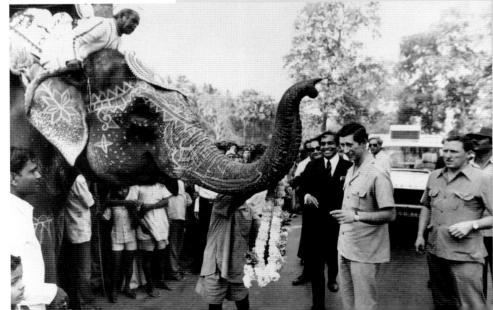

Above: With schoolkids in Fiji in 2004.

Below: Another good Sun headline sprang from this picture. Charles was touring India and Nepal for a month in 1980, and came across an elephant in North East India. Next day, the Sun headline read: PRINCE CHARLES TAKES A TRUNK CALL.

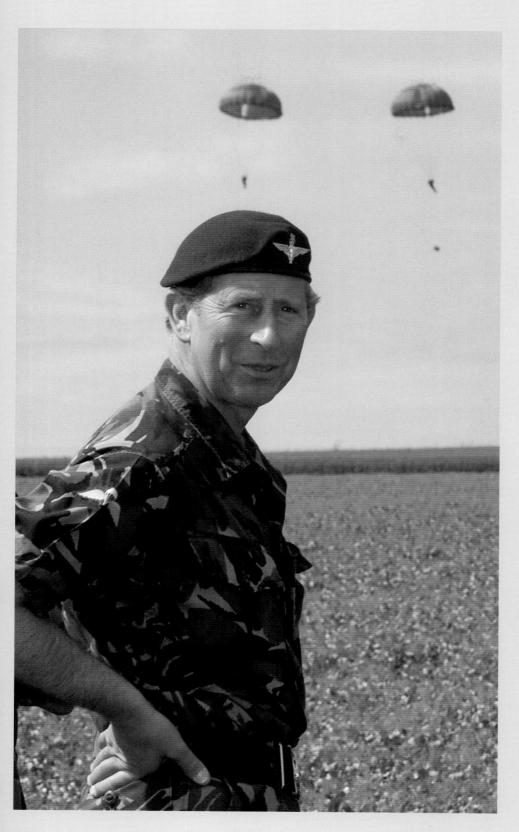

Watching the paras on exercise in Normandy in 2000.

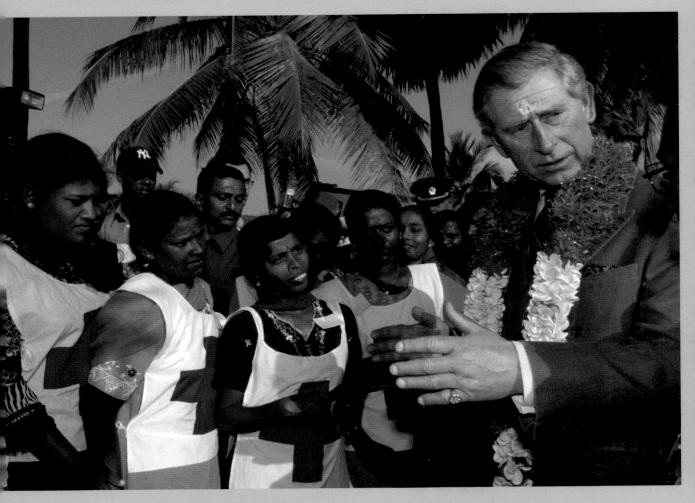

Visiting Red Cross workers in Sri Lanka in 2006. They were helping with the great clean-up following the devastating tsunami in December 2005.

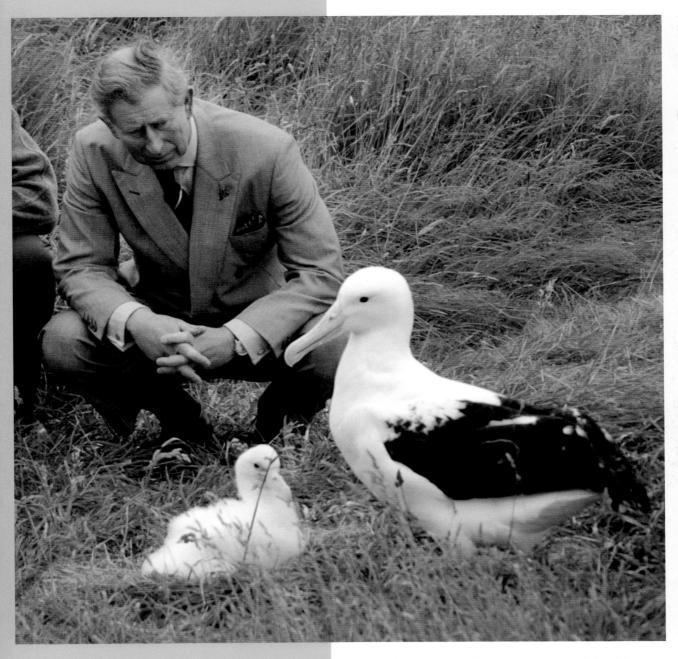

Charles is tirelessly battling to improve the plight of the albatross. The birds are dying in their thousands in fishermen's nets. Here he is at an albatross centre in Dunedin, New Zealand, in 2004.

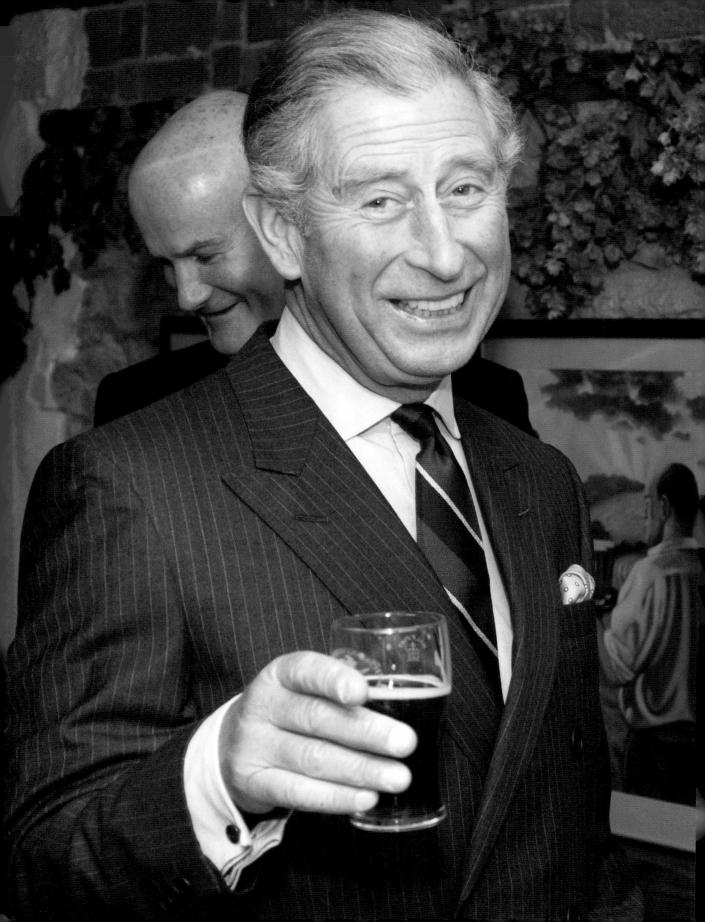

CHAPTER SIXTEEN Charles, Clown Prince

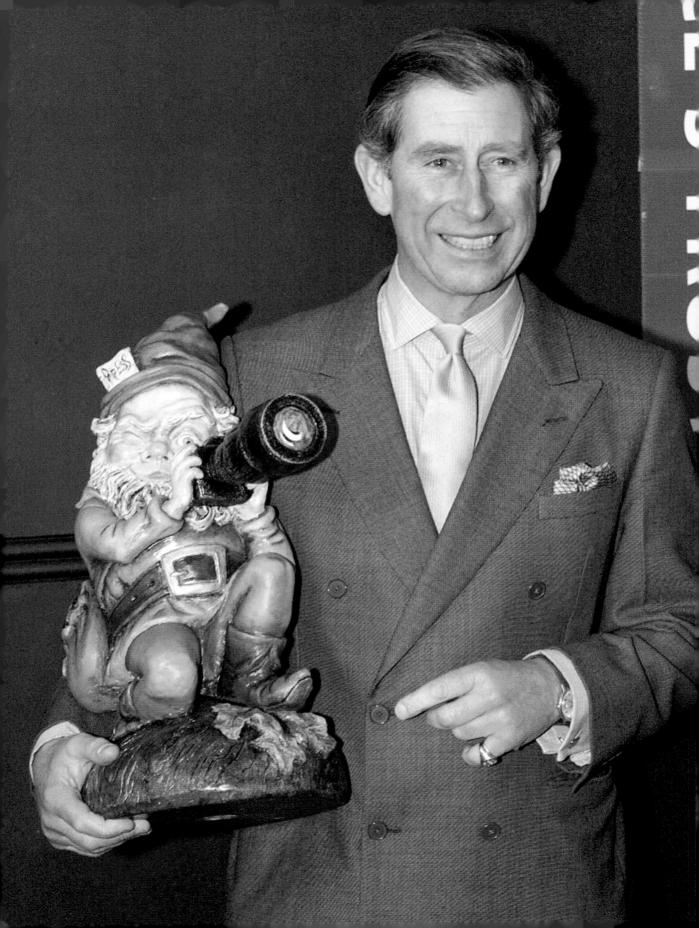

When Charles celebrated his 50th birthday in 1998, the press photographers who cover his engagements collected a tidy sum and had a garden gnome made – in the image of a snapper, of course! He was so thrilled he promised to place it in the gardens of his Highgrove home in Gloucestershire. Then he invited my wife Ann and I to visit him there, which we did.

CHAPTER SIXTEEN

Above: Charles was presented with this Indian headdress in 2004. I took the picture in a remote part of a rainforest in Guyana. Within ten minutes it was in London, thanks to me using a digital camera and a satellite telephone. It made the front page too.

Above right: Charles is showered with garlands in India in 2004 as he arrives in a village to look at how they solve their water problems.

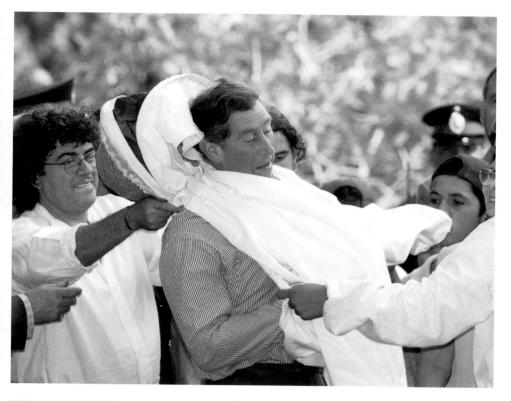

Above: Struggling into a beekeeper's uniform before visiting hives on the outskirts of Buenos Aires, Argentina, in 2002.

Below: In 2000, Charles visited Trenchtown, the tough district of Kingston, Jamaica, which was home to Bob Marley, and put on a Marley hat, much to the amusement of the reggae legend's widow Rita.

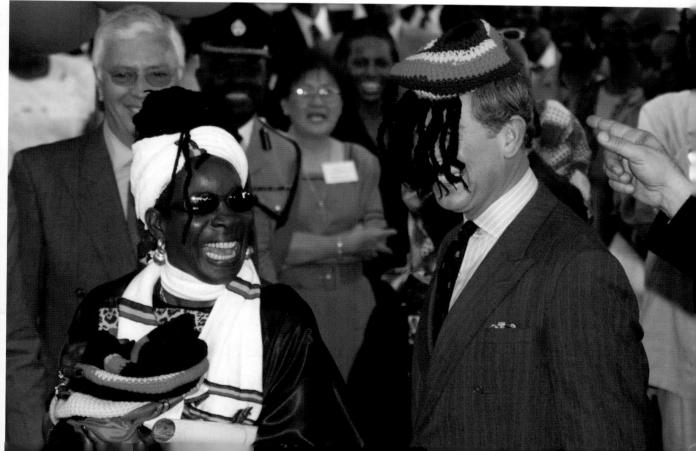

CHAPTER SIXTEEN

In 2000, Charles took the salute at the annual gathering of Dunkirk veterans – and first had a joke with the photographers, using a megaphone as a telescope.

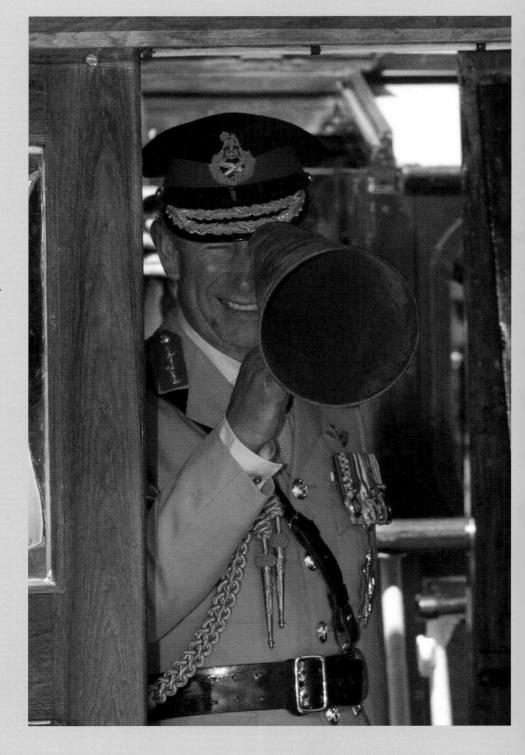

Posing with special goggles while visiting a cancer unit at the Royal Marsden Hospital in London in 2003.

the institute of Icancer research

Allow S Annon

CHAPTER SIXTEEN

I love the genuine expressions on the faces of these nurses. Charles was visiting a breast cancer unit at Nottingham hospital in 2004 when he said something funny. The girls just burst out laughing.

CHARLES, CLOWN PRINCE

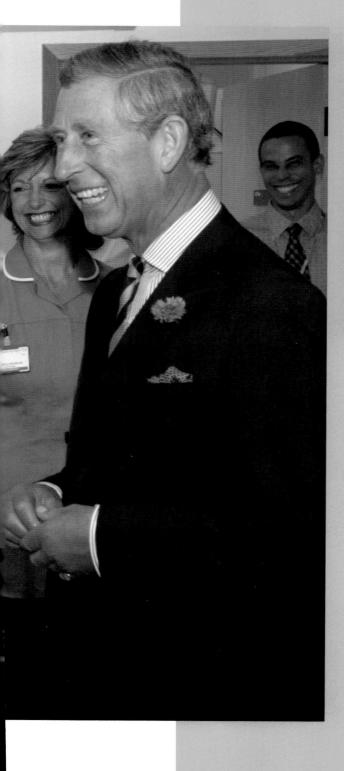

A spot of shearing on a sheep farm on New Zealand's South Island in 2004.

CHAPTER SIXTEEN

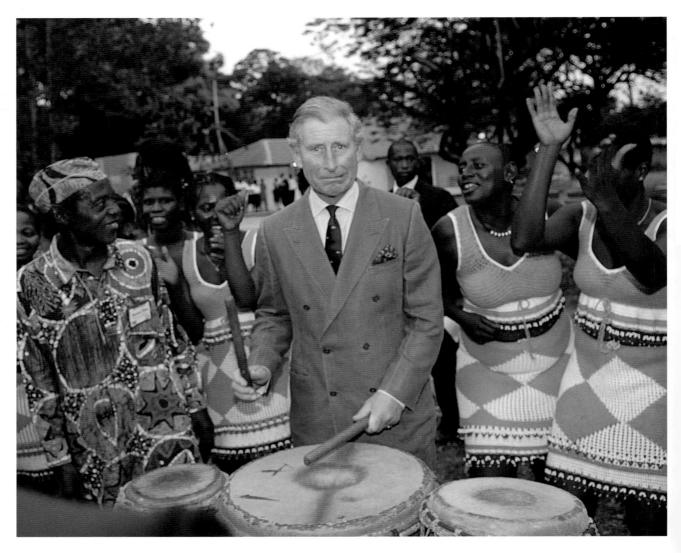

Above: Drumming in Sierra Leone, West Africa, in 2006. His rhythm was good enough for these ladies to dance to.

Below: Charles playing in a steel band in Trinidad in 2001. He throws himself into this kind of thing with great enthusiasm.

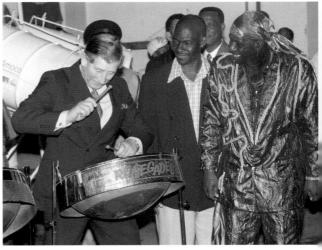

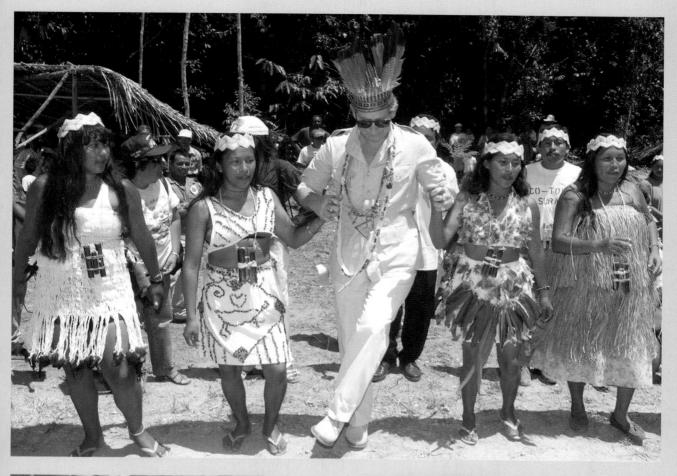

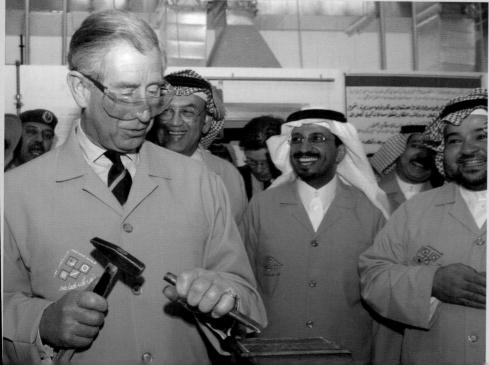

Above: Dancing in Guyana in 2004.

Below: Using a hammer and chisel at a training college in Riyadh, Saudi Arabia, in 2006.

I first noticed, and photographed, Charles's bald spot in 1977 as he left a polo match at Cirencester, Gloucestershire. About three days later he came up to me and said, 'Are you the man who photographed my bald spot?' I said, 'Yes, sir. Has it caused you much trouble?' He said, 'No trouble. But everywhere I go people are photographing the back of my head!' He's got a great sense of humour, and he saw the funny side of it.

CHAPTER SIXTEEN

Charles is blown away by fierce winds at Herm in the Channel Islands in 2004.

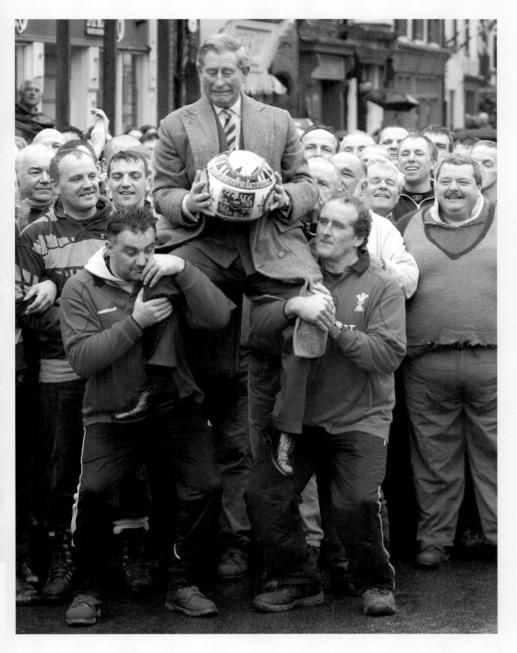

The expression on Charles's face is one of pure terror as he is carried aloft through the streets of Ashbourne, Derbyshire, in 2003. He was guest of honour and threw in the ball to start a traditional Shrovetide football match where everyone in the town takes part.

CHAPTER SEVENTEEN Other Royals

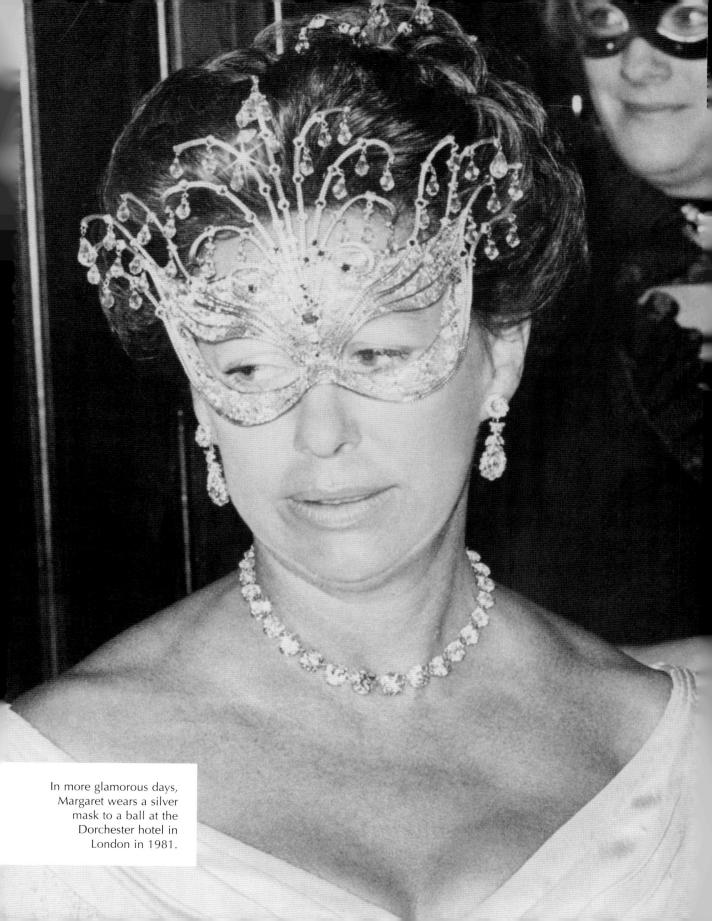

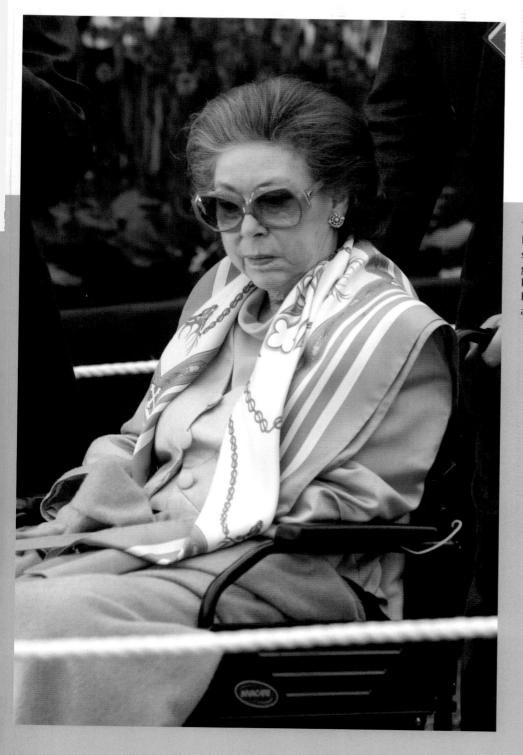

The last picture I took of Princess Margaret, being shown around the *Sun* gardens at the Chelsea Flower Show in 2001. By this time she was in a wheelchair.

CHAPTER SEVENTEEN

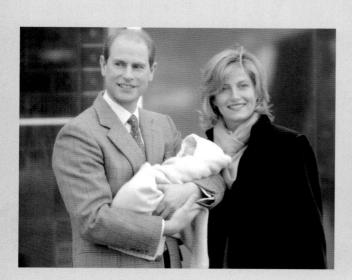

Above: Prince Edward and his wife Sophie, Countess of Wessex, leaving the NHS hospital at Frimley, Surrey, where she was rushed before she gave birth to their daughter Louise. Sophie looks fantastic for a woman who gave birth only a few days earlier and Edward looks proud as punch carrying his daughter. After this, they went back to their nearby home at Bagshot.

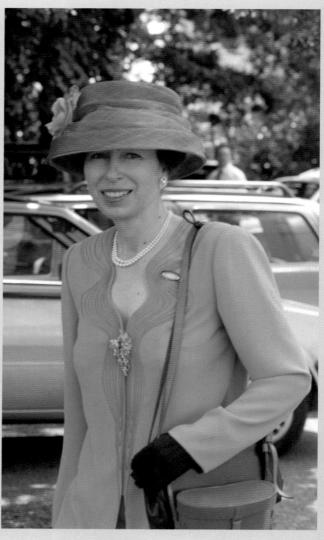

Princess Anne dressed up for Royal Ascot in June 1999.

OTHER ROYALS

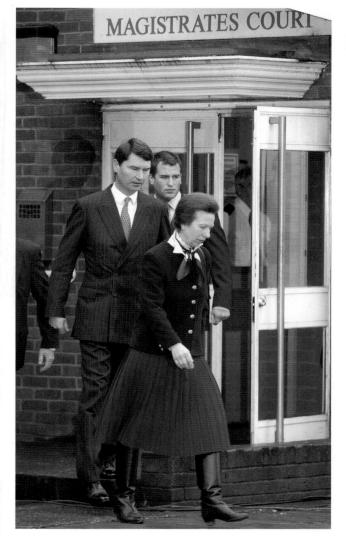

A sombre Princess Anne leaves court in Slough with husband Tim Laurence and son Peter Phillips after being fined £500 in 2002. Her bull terrier had bitten two lads out cycling in Windsor Great Park.

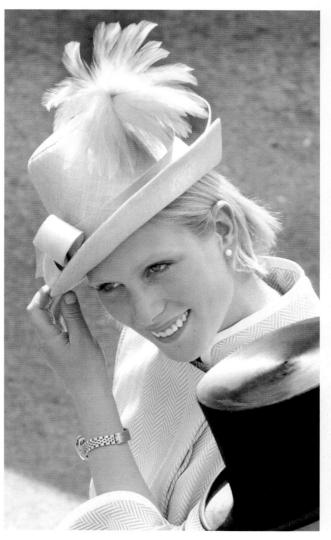

Above: A beautiful hat befitting a beautiful girl ... Zara Phillips at Ascot races in 2002.

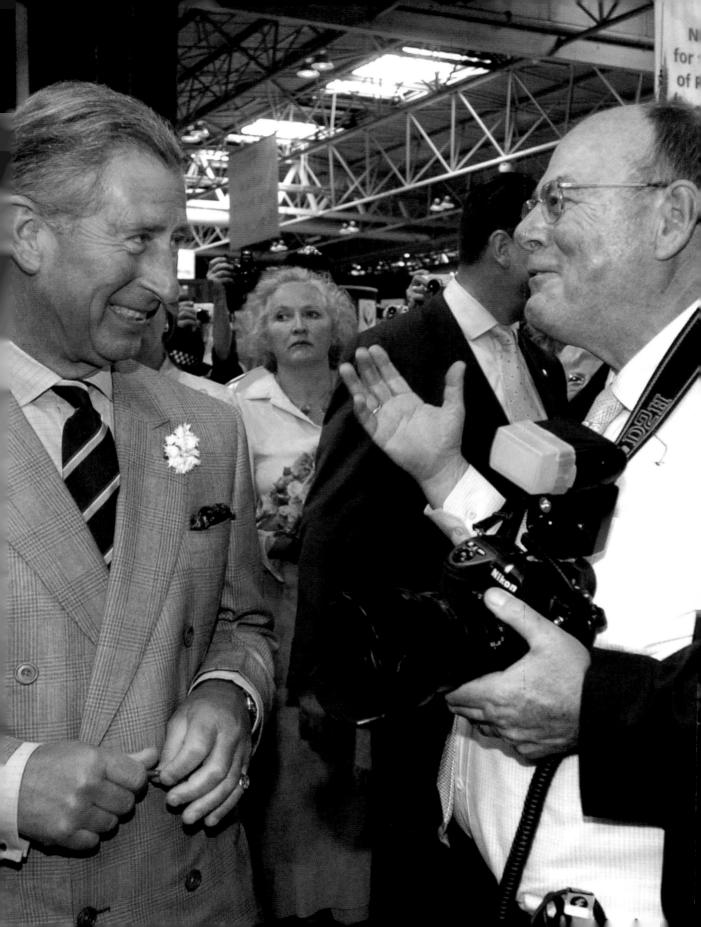

CHAPTER EIGHTEEN Arthur and the Royals

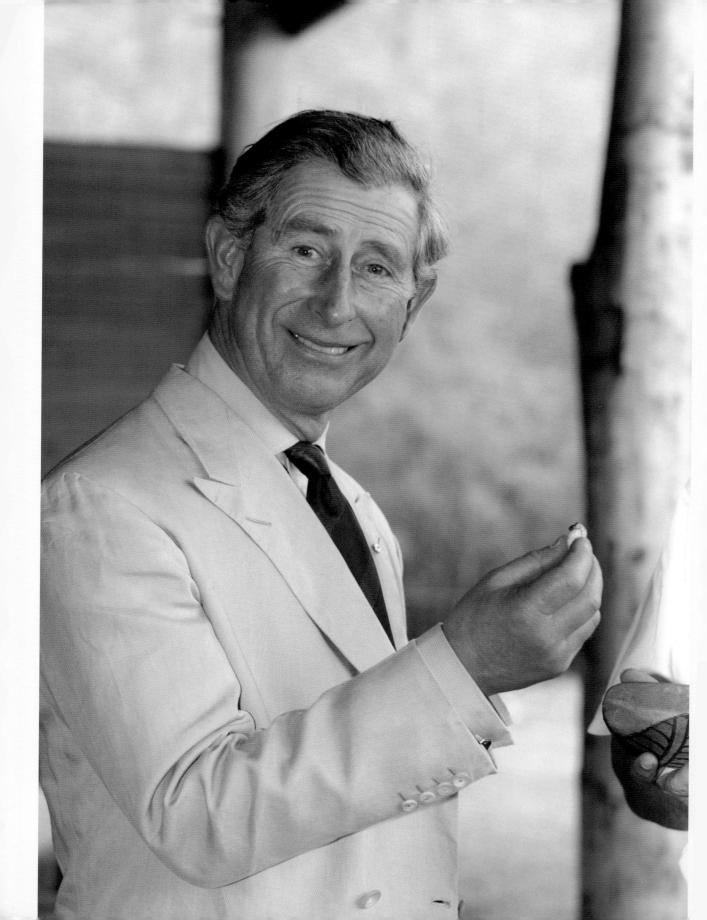

ARTHUR AND THE ROYALS

We were in Alice Springs, Australia, in 2005 when Charles turned down the chance to eat a wichety grub, a traditional Aborigine delicacy. Charles suggested the 'man from The *Sun*' should eat it, so I did. I quite enjoyed it, actually. A bit crunchy though!

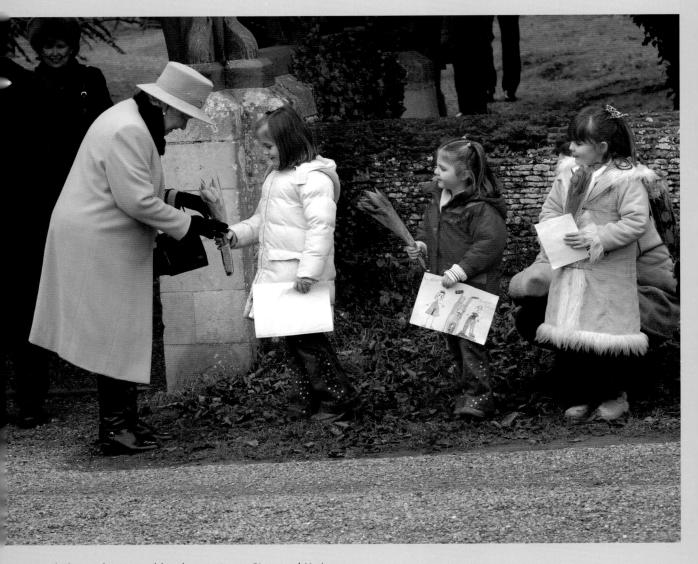

I took three of my granddaughters – Lucy, Ciara and Katie – to meet the Queen at Sandringham in 2006. They all made a little drawing and presented them to Her Majesty with some tulips. The Queen was charming, of course. But the funny thing was that the police checked the flowers for dangerous objects before the children gave them to her.

Above: In 1999, the Duchess of York was presenting gifts to motor neurone patients at Dorking, Surrey – and, to my surprise, she had one for me ... a small Christmas pudding.

Below: Charles chats to me during a visit to the Gardening Show in Birmingham in 2005.

I joined Charles, Camilla and actor Pierce Brosnan on stage at the Prince's Trust excellence awards in London in 2006 to present 18-year-old Shenica Williamson with the Young Achievers Award. It was backed by The *Sun*, and we'd made her a framed front page.

Chatting to Diana in 1991 at the Cairo Museum in Egypt. I'd been ill for several days and the Princess sent her doctor to give me some medicine. On my first day back she asked me how I was, and I told her I'd lost an awful lot of weight. She said, 'Yes, I can see that.'

Above: I was on a bus in India in 2004, sending my pictures back to the office by mobile phone, when we got stuck in traffic. It was such slow going that a camel overtook us!

Below: Children in Trinidad, fascinated to see pictures of Charles on my computer during his visit there in 2000. Even now, digital photography still amazes me... how you can take a picture and send it within minutes to an office thousands of miles away.

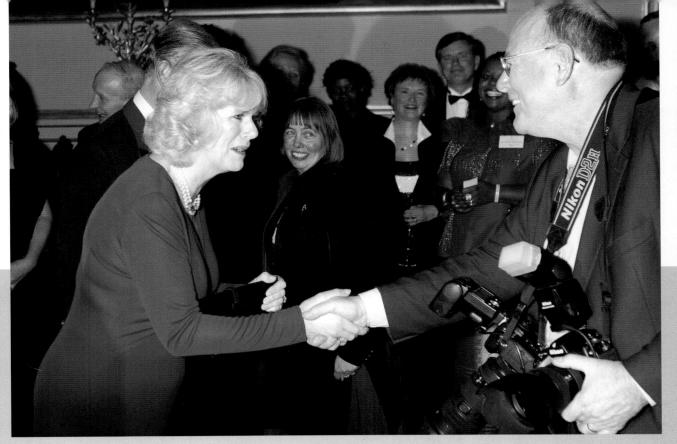

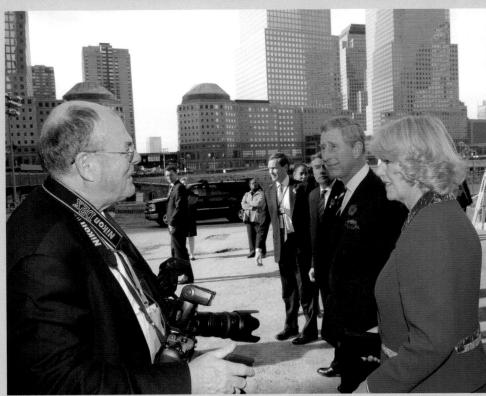

Above: On the night she got engaged to Charles in February 2005, I congratulated Camilla in the ballroom of Windsor Castle.

Below: Charles and Camilla came over to chat to me at Ground Zero in New York in November 2005. I was the only British photographer covering the event. They just wanted to say, 'How are you keeping, Arthur?'

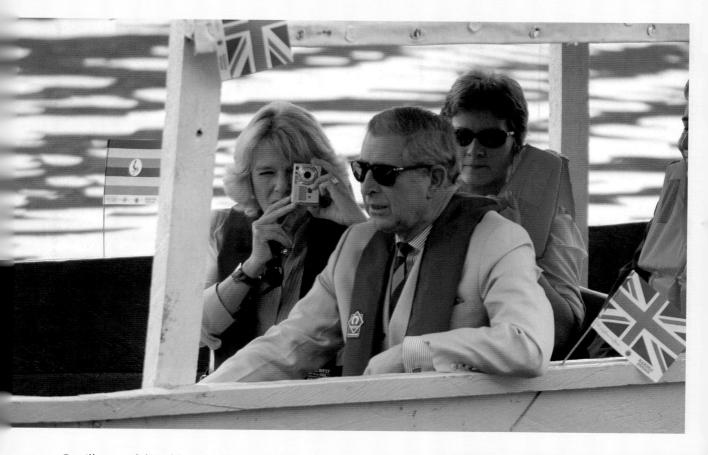

Camilla turned the tables on photographers as she crossed the Nile at Jinja, Uganda. She and Prince Charles were in the country in 2007 for the Commonwealth Heads of Government meeting in Kampala. Much to my surprise, two days before Christmas this photograph of me, accompanied by a hand-written letter from the Duchess, arrived in the post. What made it even more special was that she'd put it in a solid silver frame! You've got to hand it to the royals: they do things in style.

Camilla gave her permission for us to use this picture. She loved the first edition of *Magic Moments* and was delighted to be part of the second.

The Duchess turned out to be quite a good snapper, actually. She seems to have followed my two golden rules - fill the frame and hold the camera steady.

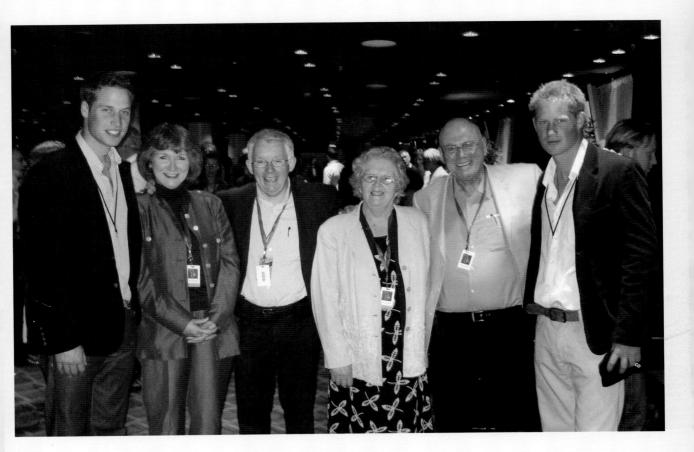

I supplied some pictures and wrote a tribute for the programme of the Wembley concert William and Harry held in their mother's memory in 2007. Imagine my surprise when they invited my wife Ann and I to the Royal box to watch it with them. At the lunch beforehand William and Harry spoke to everyone they'd invited, including my great friend Tim Graham and his wife Eileen. Tim had also supplied many pictures and written a tribute to Diana. I asked William if it would be OK to have a picture taken and he said 'Yes . . . who's going to take it?' I asked Harry's policeman – but Harry said 'Don't ask him . . . he'll mess it up.' He did a good job though. It brings back great memories for me.

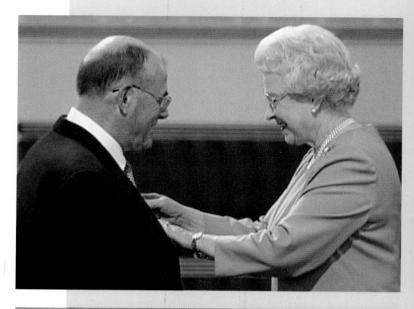

Such a proud moment. I got the MBE in the New Year's Honours List in 2003. When the Queen pinned on the medal in May of that year, she said to me, 'I can't believe I'm doing this. How long have you been coming down to photograph me at Buckingham Palace?' I replied, 'Twenty-seven years, Ma'am.' And she said, 'Well, let's have our picture taken together.'

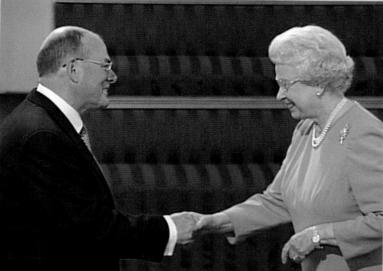

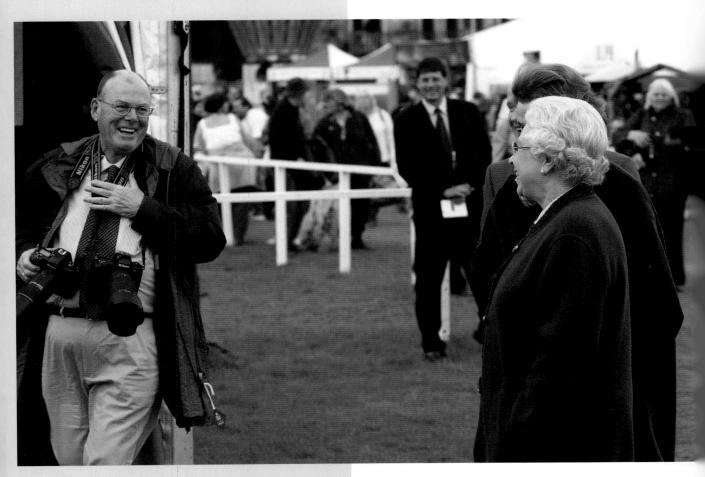

Only a week after the investiture, I was covering the Royal Windsor Horse Show, when the Queen approached me and joked, 'Why are you not wearing your medal? You are supposed to wear it all the time.' I replied, 'If I had known you were coming, Ma'am, I would have worn it.'